The Book is A ──── Live!

A follow up to the BOOKLIVE! international symposium
held over two days in June 2012 at London South Bank University.

Editors:
Emmanuelle Waeckerlé
Richard Sawdon Smith

We would like to dedicate this publication to the memory of
Martin Rogers, founder of RGAP, for his unwavering enthusiasm for and
support of independent publishing and for accepting to publish this work.

The Book is Alive!
First Edition of 500
Copyright © bookRoom 2013 and respective contributors.

Forward

BOOKLIVE! the international symposium and this publication have been a long time in (re)production. BOOKLIVE! was born out of a conversation between Emmanuelle Waeckerlé and myself back in 2008 after the University for the Creative Arts (UCA) awarded us a £150,000 of Science Research Investment Funding. The grant was to support the expansion of the bookRoom research cluster by setting up its own production facilities; bookRoom press, benefiting from resources that combine traditional craft with the latest digital technology, was subsequently launched in October 2010 with a remit to encourage research, experimentation and innovation.
In the intervening time I have moved to take up my role as Head of Department at London South Bank University (LSBU) whilst Emmanuelle remained to develop and establish bookRoom press as a pioneering and exciting centre of contemporary artist book production.

While the description of the process above sounds quite simple and clear-cut, easy even, it was anything but. Resistance to the artist book as a serious discipline in its own right and worthy of thoughtful study and research meant there was a struggle to acquire funding. Even in an old art school environment it was hard for some to understand the idea of the artist book beyond commercially published artist monographs. But arguments won, proposals accepted the success of instituting the press contributed to the generous support by both UCA and LSBU in funding the BOOKLIVE! international symposium: a collaboration between the bookRoom Research Cluster at UCA and the Centre of Media and Culture Research at LSBU. Beyond our personal histories it was a natural collaboration; CMCR was in part established to promote research that focuses on the significance and impact of digital technologies on existing forms of media production, including that of convergent media practices and the interdisciplinary nature of the book.

It is worth mentioning that Emmanuelle and I go back years, teaching together since 1994 when we were both part-time lecturers at Maidstone School of Art. We also realised that as hip young things we played on the streets of Kings Cross in London in the 1980s at the same time and we even shared lovers – although not at the same time. We have both been drawn to the artist book perhaps because as artists our practice has never sat comfortably with the mainstream art

Richard Sawdon Smith

Professor of Photography
& AIDS Cultures
Head of the Arts & Media
Department, LSBU

world and the artist book has allowed dissemination of our research by alternative means. We have progressed as academics in our own individual ways, we both rub up against the institution but also appreciate the structure it provides to explore our research interests and this is reflected in our titles, Emmanuelle as Reader in Photography and Relational Practices and me as Professor of Photography and AIDS Cultures.

So from our collaboration and history BOOKLIVE! came to life, and we were extremely excited that our first choice of keynote speakers, Joan Fontcuberta and Sharon Helgason Gallagher immediately accepted our invitation. We were also amazed by the quality of proposals and standing of the presenters who responded to the call for papers. The diversity of those proposals ranging from the traditional academic paper to readings, performances, interactions, artist talks are captured here in this book to provide an exciting reflection on the state of the artist book in the twenty-first century.

Contents

Emmnauelle Waeckerlé	A Few Introductiory Thoughts	07
Sharon Helgason Gallagher	What Shall We Want to Have Called a 'Book'?	12
Didier Mathieu	From site to (web)site	20
Arnaud Desjardin	The Book on Books on Artists Books	24
Susan Johanknecht & Katharine Meynell	Poetry of Unknown Words	30
Stefan Szczelkun	*Agit Disco*	38
Mark Sanderson	The Text that Reads Itself	42
seekers of lice	Invent the Present: Footnotes	54
Romi Mikulinsky	Reading and Writing in the Digital Age	64
Daniela Cascella	*En abîme*: a Reading	74
Marco Bohr	Appropriation & Voyeurismin Self-Published Photobooks	80
Joan Fontcuberta	A Bio-Optically Organised Knowledge Device Called 'BOOK'	86
Andrej Blatnik	Mass-Produced, Media-Promoted, Handmade: Books in the Twenty-First Century	94
Paul Soulellis	*Weymouths*	102
Matt Hulse & Barnaby Dicker	The *Dummy Jim* Cycloscope	112
David W. Speck	Brecht, George. (1961) TWO EXERCISES. Arr. Speck, David W. for Terminal in C. (2010). London: David W. Speck	118
Sarah Bodman	New Pages: Celebrating the Book as a Democratic Multiple in a Variety of Twenty-First-Century Forms	122
Andreas Schmidt	The Speed of Books	130
Peter Jaeger	John Cage, Chronobiology, and the Discourse of the Analyst	134
Annabel Frearson	*Frankenstein2…*	142
Nick Thurston & Sharon Kivland	Reading. Some Positions	150
Durational Works & Installations		
Sylvia Schimag	John Cage's *'Empty Words'*	162
Amanda Couch	*Reflection in Digestion*	164
Paul Jeff & Laura Jenkins	The IPCRES Reading Ensemble	168
Paula Roush & Maria Lusitano	*A field (of Interconnected Realities) or The Week of Mash-up Goodness (2010-12)*	172
Marcus Kaiser	A Possible 'Book-Work'	180
Rahel Zoller	*The Inner Monologue of a Book*	182
Christof Nicholas	*'garonne-für sich'*	184
Reference Images		186
Symposium Images		189
Biographies		195

INFORMATION		INFORMATION
LE LIVRE EST PARTOUT		**BOOK IS EVERYWHERE**
disponibilité		offered
médiatisation		mediated
distribution		distributed
DEMOCRATIQUE		**IN A DEMOCRATIC WAY**

LE LIVRE EST UNIQUE — **BOOK IS UNIQUE**
porteur des idées — supporting ideas
exploration des concepts — exploring concepts
matériaux divers — combining materials
EN UN SENS ORIGINAL — **IN UNUSUAL SENSE**

LE LIVRE EST COLLECTIF — **BOOK IS TEAMWORK**
communication — communicating
intégration — integrating
pratiques artistiques — art pratices
POUR LES PROJETS — **FOR FUTURE PROJECTS**

PRODUCTION / EN RESEAUX — PRODUCTION / ON NETWORK

[4] Nannucci, Maurizio. (1995).
Cover of Bookmakers.
Collections de collectionneurs 3,
cdla.

A Few Introductory Thoughts

On vanity (publishing)

This book, rich with reflections and experiments on the interplay between pixel and paper, constitutes a valuable and timely survey of fast-changing modes of making, reading, archiving and disseminating 'on the page' work.
In the 1960s making a book became a political as much as a creative gesture and independent publishing evolved as a holistic and critical practice supported by a fluid network. Artists often wrote essays and manifestos in their attempt to articulate or exchange ideas, demonstrating the kind of critical self-awareness that academic scholarship requires. Yet for some absurd reason, the academic definition of an artist book is 'vanity publishing', a derogatory label often synonymous with low standards of excellence that is hardly justified. Especially when you consider the big business in peer reviewed academic journals that are written by and for academics. The process of internal evaluation involved is as much about vanity as it is about knowledge since it may be considered as a way of mutually validating one's research and title. Furthermore for the past few decades, it is often within an academic context that the critical history and practice of the codex has been kept alive and up to date (Professors Johanna Drucker and Katherine Hayles are key references in the history of publishing). Many institutions in Europe and America have impressive collections of artists' books and are linked directly or indirectly to small presses. In England, CFPR (Centre for Fine Print Research) is based at The University of the West of England in Bristol and RGAP (Research Group for Artists Publications) initially started within Derby University.
In America, VSW (Visual Study Workshop) has links with Rochester University and the Art Institute of Chicago is the home of the Joan Flasch collection.
Editors and distributors of conventional publishing could equally be accused of vanity in the way they have become the gatekeepers of artistic excellence. A select few decide what gets printed and disseminated, and as such what will in time become part of history, and this largely based on commercial or financial concerns.

Emmanuelle Waeckerlé

Reader in Photography & Relational Practices, bookRoom Director, UCA Farnham.

[1] The BdeM hat label and collection (2007–current) is 70 percent wool, 30 percent adrenaline, and 100 percent original. www.ewaeckerle.com/projectbox/bdem

[2] bookRoom is a research cluster managing a number of interrelated activities. www.thebookroom.net

[3] Carrión, Ulises. (1980). *Second Thoughts.* Amsterdam: Void Distributors. p. 25

[5] Bodman, Sarah. (2012). *New Pages: Celebrating the Book as a Democratic Multiple in a Variety of Twenty-First-Century Forms.* p. 124

[6] Schmidt, Andreas. (2012). *The Speed of Books.* p. 130

[7] Soulellis, Paul. (2012). *Weymouths.* p. 102

[8] Bohr, Marco. (2012). *Appropriation, Surveillance and Voyeurism in Self-Published Photobooks.* p. 80

As part of this discussion I find myself wearing two hats, so to speak: that of an academic leading a thriving research cluster and that of an artist. One who literally knits hats[1] as part of her practice and uses the book to combine and share the various trends of her conceptual and performative work. I have always considered these two positions to be mutually inclusive, yet this has not always proven straightforward since most artists and academics coexist but rarely venture beyond a polite acknowledgement of their differences.

It has been one of bookRoom's[2] missions since its beginning in 2004 to foster working links between artists, academics and those in industry. This was part of the rationale in holding the BOOKLIVE! Symposium from where the pages of this book were first initiated. In trying to find commonality between the canons of the codex and the criteria of good scholarship it is worth referring to early defining texts by artists such as Ulises Carrión who wrote 'Book Works are books that are conceived as an expressive unity, that is to say, where the message is the sum of all the materials and formal elements.'[3] Or to the Mauricio Nannucci text piece *book is everywhere*[4] included here. Both clearly achieve, in a freer form perhaps, the rigour expected of serious research. Many bookRoom projects have managed to successfully pass the 'peer reviewing' threshold of excellence while also managing to exist as artefacts which are exhibited, reviewed and bought by various private or public collections (V&A, Tate Britain, Women Library, Poetry Library, Bibliothéque Nationale de Paris), thus doubly avoiding the dreaded label of *vanity publishing*.

With the recent digital mutation of printing and the birth of print on demand (POD), Blurb, Lulu and other online platforms have facilitated book production beyond what was imaginable in the 1960s but to such an extent that knowledge or understanding of the industry is no longer required. There are no more gatekeepers since it would go against digital printers financial interest to provide editing control. As a result photographers and writers are now able to turn into books their novels, poetry, diaries, family albums, portfolios and other photo stories. Commercial or artistic merit is not always the aim, self-published authors may simply be after some form of validation or gratification of their creative or technical abilities. POD has transformed the heavily-protected book into what Sarah Bodman calls a 'democratic multiple'[5] and, as such, has also benefited those who are concerned with artistic and commercial merit, allowing them to produce and disseminate their work with little investment – or to explore the creative potential of all aspects of digital publishing. Some are represented here; Andreas Schmidt[6] and Paul Soulellis[7], others like Mishka Henner and Joachim Schmid are discussed in depth by Marco Bohr.[8]

Both the artist and the academic in me would agree that, whether academic, commercial or artistic, published or self published, every

book should only come to be once careful consideration has been given to one question. (Why) does it need to be a book? And it is the answer to this question that will determine the amount of vanity involved.

Is it a book?

Generally speaking a book is a container of data, itself the result of a technological revolution. It is the invention of the printing press that made it so much part of our everyday. Why would we think that the move to digital could destroy it? Did photography kill painting? Or television, cinema? The technologies of production and dissemination have changed rapidly, not the object itself. As Umberto Eco wrote 'Alterations to the book as object have modified neither its function or its grammar for more than 500 years, the book is like the spoon, once invented it cannot be improved.'[9]

[9] Eco, Umberto & Carriére, Jean-Claude. (2011). *This is Not the end of the Book*, London: Harvill Secker. p. 4

We are in a transitional phase. Through a process of trial and error, experimentation and reflection, analogue and digital processes are slowly finding their place and ways to cooperate even. Heidegger writes in his essay *The Question Concerning Technology* that technology is both a means to an end and a human activity.

> Everything depends on our manipulating technology in the proper manner as a means. [...] So long as we represent technology as an instrument, we remain held fast in the will to master it. We press on past the essence of technology. [...] Because the essence of technology is nothing technological, essential reflection upon technology and decisive confrontation with it must happen in a realm that is, on the one hand, akin to the essence of technology and, on the other, fundamentally different from it.[10]

[10] Heidegger, Martin. (1977). *The Question Concerning Technology*. In: Krell, David (ed.). Basic Writings. New York: Harper & Row, pp. 288-317

Digital technology is a means to an end; an end that can be a book or an e-book – Sarah Bodman speaks of 'e-paper as opposed to paper'.[11] An e-book has no physical boundaries; it is not a book. It is a virtual container of data contained in a three-dimensional hardware object, which often emulates the form of a book. The same content can equally be found in one or other form, the same way that a film can be viewed in the cinema or on a various smaller digital screens.

[11] Bodman, Sarah. (2012). *New Pages: Celebrating the Book as a Democratic Multiple in a Variety of Twenty-First-Century Forms* p. 122

The mind has had centuries to become familiar with the book object; it doesn't know yet how to handle e-books. It is impossible for eyes or fingers to reach beyond the flatness of the screen image,

[12] Helgason Gallagher, Sharon. (2012) *What Shall We Want to Have Called a Book?* p. 12

to flick through content or reach the end. A different form of reading is required, one that would provide a virtual compass for digital navigation to allow the mind to wander without becoming disorientated, and above all one that could limit the risks of information overload. The essence of the book is not the book itself or the technologies that were used to produce it, analogue or digital. For an essence to be released from the content of pages, it needs surfaces to rub against and a certain physical choreography of eyes, fingers and mind to unlock it. Sharon Helgason Gallagher, in her keynote speech, spoke of the 'extraordinary symphony of movement that is a great art book, photo book or artists' book'.[12]

[13] Mathieu, Didier. (2012). *From site to (web)site.* p. 20

Perhaps the e-book can learn from its ancestor, as it has already done with the Kindle and other digital readers, but it cannot replace it entirely. In the 1960s the artists' book had to redefine itself and chose to place itself willingly 'in the margins', (Didier Mathieu[13]) of its commercial and institutionalised other. It is now the turn of the e-book to find its place. It has to evolve from the unfathomable 'technological monsters' that Joan Fontcuberta talked about in his presentation. It remains to this day untamed and somewhat untamable, lacking interiority, unable to provide comfortable boundaries for our eyes and mind to hold on to and unable to release much digital essence.

[14] MAPP (2011), digital publisher founded in London by Michael Mack, John Koh and Jean-Michel Dentand. MAPP has just published another successful e-book NYLPT by Jason Evans, a great exercise in randomness bringing together Jason's in camera double exposure street photographs with an evolving soundtrack.

Yet there are some interesting experiments suggesting that the e-book is on its way to become a virtual 'concept object' with its own structure, history and economy. A successful example would be *Titanic Calling* developed by MAPP Editions[14] to commemorate the one-hundredth anniversary of the Titanic's sinking, using the extensive record of wireless transmissions in the Marconi Archives at the Bodleian Library, Oxford University.

We can witness the disaster on screen via the radio messages sent by all involved, which are synchronised to the slow progress of the boat on a map of the Atlantic, from collision to the rescue of the lucky survivors. The bringing together of visual, verbal and geographical data creates a virtual space-time continuum for the inevitable unraveling of the chain of events. The effect is mesmerising and could never be achieved via the pages of a book.

This BOOK is ALIVE!

The aim of the BOOKLIVE! Symposium was to stimulate a dialogue on the current and rapid 'transforming' of the book – instead of the virtual disintegration that many have been complaining about for many years, often confusing the various industries and power structures surrounding the book with the object itself. There is no doubt that the publishing industry is sometimes struggling to

integrate the digital age. Yet, as a result, the book has had to become more valuable, as a way to compete with the rise of POD, but also because it has been declared, rightly or wrongly, an endangered species.

We were aiming for an active and optimistic looking ahead rather than a passive, nostalgic or distressed looking back. We thought that academics, artists and industry people who rarely have the occasion to come together except on a competitive or commercial level, could gain a lot by sharing their various understanding and experiences of contemporary publishing. The number and quality of responses to the call for papers was overwhelming and we were lucky to attract some of the key players in the field, both on and off stage, as well as some fantastic durational performances and readings including the full twelve hours of *Empty Words*, John Cage's epic work on the 'demilitarising' of language.[15]

Right from the start, heated discussions took place – often overflowing from presentations and into the night – leading to fruitful connections in the true spirit of collaboration and exchange normally associated with independent publishing. A few of the outcomes include, Stefan Szczelkun donating his complete 'working press'[16] imprint to bookRoom, prompting a new research project on digital archive and oral history. Sam Francis, Arnaud Desjardin and Stefan Szczelkun sold their publications to the Tate collection; Didier Mathieu was introduced to the work of Joachim Schmid by Marco Bohr; Andreas Schmidt and Joachim Schmid are now represented in the centre des livres d'artistes (cdla) collection and included in the Spring 2003 exhibition. I was even invited by Joan Fontcuberta to write a review for Issue 003 of *Aperture PhotoBook Review*.

It is a great pleasure revisiting all the contributions to the symposium before committing them to print. Some projects have evolved others have been concluded. In time we will be able to tell how far or close we were to grasping the essence of the e-book or dismissing the demise of the printed page. What is important is that the content of these pages and those responsible for them, as much as those reading it, keep the debate alive.

[15] Cage, John. *Empty Words* (1973-1974) performed by Sylvia Alexandra Schimag, produced by Wandelweiser. 'John Cage said in a radio interview, in August 1974: 'So what we're doing when we make language un-understandable is we're demilitarizing it, so that we can do our living' p. 162

[16] *'working press'* books by and about working class artists' 1986–1996: unfunded self-publication imprint started by Stefan Szczelkun and Graham Harwood in 1985

Sharon Helgason Gallagher

What Shall We Want to Have Called a 'Book'?

Art book publishers inhabit a no-man's-land bordered by the commercial publishing industry, the art world, and the vibrant archipelago of the artists' books community. The artists' books natives generally regard us as distant relatives who emigrated to the richer climes of the mainstream economy and who can sometimes be counted on to send monies back 'home.' The 'art worlders' turn to us as trusted outside professional experts who can be of assistance by publishing scholarship and documentation for the historical record. Our largest neighbour, the trade publishing industry, is largely baffled by our business model, for the art book is never completely at home in the world of mainstream publishing.

Visual, expensive, laden with something called 'production values,' and often physically indescribable in the data language of the industry, the art book is always the exception in the bestseller-driven publishing marketplace. As mainstream trade publishing adopts and adapts to digital platforms, the outsider status of the art book has been even further amplified as the industry marginalises books that are so, well, 'bookish' in their sheer physicality. To speak knowledgably about the art book – about its content, design, production, and distribution – is to speak a language foreign to the one spoken by my friends in the trade publishing world.

However, when the publishing parties are over and the day is done, as we take off our respective academic caps, conference badges, and industry hard-hats, we find that we all share dumb amazement at the historical moment in which, by strange biographical accident of birthdate, we happen to find ourselves: a once-in-a-half-millennium tectonic shift in how culture reproduces itself, in how ideas are not only communicated across space but also – and more importantly, I suggest – transmitted over time. We are in the midst of a mediological change, to use Regis Debray's term, one that is huge in itself and more enormous still in its aftershocks. The change of the book.

A Few Notes on the Pre-History of the Digital Book

It's important to understand both the scale of the changes brought on by digital publishing as well as the extraordinary speed with which they are taking place. Since the U.S. tends to do things bigger and quicker – and, one could add, with less care and forethought – a brief history of the American publishing industry will tell us about how digital publishing happened to us, and happened so fast.

Amazon's Kindle e-reader was launched to the US public on November 19th, 2007. That's less than five years ago, but ancient history in digital time. In the spring of 2012, the Pew Survey looked at e-readership before and immediately after the 2011 Christmas holiday – a mere four years after the introduction of the Kindle. In that December of 2011, 17 percent of Americans had read an e-book over the last twelve months. Over the holiday weeks, both e-reader and tablet ownership essentially doubled. Immediately after the holiday, that 17 percent of respondents who said back in December they had read an e-book jumped to 21 percent – nearly a 25 percent increase in the space of a month. Meanwhile, many trade publishers are reporting that e-books now make up 20 percent of their sales volume, not simply in one or two categories, but across the board.

The speed of this adoption of the digital has been arguably made possible by earlier changes in the book industry that were more pronounced in the United States than elsewhere: the economic rationalisation of the bookselling business and the accompanying

[1] Bekken, Jon. (1997). *Feeding the dinosaurs: Economic concentration in the retail book industry.* In: *Publishing Research Quarterly* 13.4 pp. 3-26

commodification of the book. These changes began much earlier than many digital doomsayers today seem to realise. According to a 1997 study of economic concentration in the retail book industry by Jon Bekken, 'In 1958, one-store book firms accounted for nearly 80 percent of book sales; by 1982 that figure had fallen to 26 percent even though single-store retailers continue[d] to account for a majority of all bookstore outlets.'[1] Note the terminus date of the study: 1982 – this is well before the so-called 'bookstore wars' of the 1990s.

Looking at other studies of reading behaviour, we also find statistically remarkable changes that precede the hyper-expansion of the chains in the 1990s. Two dramatic shifts that take place in the 1980s are documented by Gallup polls: first, a doubling between 1978 and 1990 of respondents who say that they read no books at all over the last 12 months, from 8 percent of the population in 1978 to 16 percent of the population in 1990; and second, a drop of almost 50 percent at the other side of the bell curve: heavy readers, from 13 percent of respondents in 1978 who said they read more than 50 books over the last twelve months to just 7 percent in 1990.

[2] Spiva, Bruce. (2005). *Comments of The American Booksellers Association to The Antitrust Modernization Commission* [online source].

These changes were already 'history,' as it were, by the time of the chain-versus-independent bookstore wars that occupied so much of the publishing discourse in the U.S. in the 1990s. In 2005, the American Booksellers Association testified to the Antitrust Modernization Commission: 'The American Booksellers Association [...] has gone from a membership high of 5,200 in 1991 to 1,791 members today, a 65 percent decline in less than fifteen years. The decline in [the] ABA's membership is indicative of a general decline in the number of independent bookstores, whose share of the market has dwindled from a third of the entire consumer book market in 1991, to approximately 9 percent today.'[2] Meanwhile, the dynamics of logarithmic e-commerce growth were afoot: by that very same year of 2005, Amazon's media sales in North America (including books, music, and DVDs) had reached $3 billion dollars annually; Barnes & Noble, the dominant chain, still led at roughly $4.5 billion in 2005. But by 2010, Amazon's media sales had ballooned to just under $7 billion, while Barnes & Noble's were stagnant and dipping below the $4.5 billion mark.

In other words, digital publishing was born into an already changed and changing world, one that had already had a lot of the friction bred out of it – the friction of the hard-to-categorise, the local, the personal, the odd, the quirky, the difficult, and the simply different. The friction that slows things down and gives you time to think and reflect. These changes in bookselling and reading went hand-in-hand with 'Big Six' bestsellerdom and the growth of genre fiction: in a rationalised 'modern' retailing and logistics environment, books could now be conceived, marketed, distributed, sold, and consumed as commodities.

The gold standard of the book-qua-commodity is, of course, the so-called 'page-turner.' It's the book that 'hooks' you, that you 'just can't put down,' and, importantly, that makes you want to read another one pretty much just like it. We consume books of this ilk the way we do episodes in a long-running TV series. Whole swaths of the publishing industry have become 'content farms' designed to output the words for each category of commodity publishing: the summer beach book, the bodice-ripper, the post-Cold War thriller, etc., etc., etc.

Fast-forwarding to the digital present, it turns out that it is precisely these 'page-turners' that fare best as e-books read on e-reader screens. The drill-down statistics on what genres people are reading as e-books is revealing. E-books have captured the largest share of sales in the following genres: Romance, Crime, Thriller, Mystery, Science Fiction, and Fantasy. Notably in the Romance category, many publishers report that a full 60 percent of their sales are in e-book (as opposed to print book) form. Furthermore, according to the February 2012 Harris Poll, many e-book readers are reading more titles than comparable print readers. Why? Because it's easier and cheaper to get your next fix. Perhaps the truth was there all along: that the pages in page-turners just get in the way? Maybe page-turners are better without pages? Maybe they are better off not being books at all.

More generally, maybe there are many kinds of content that we used to think of as books, that are in fact better suited to publication as e-books, as apps, as web pages, as databases. We know this, for example, about encyclopaedias. But sometimes we know something abstractly and it doesn't truly hit home until we have a personal experience. Let me share this story with you. I live in one of the very last unrenovated lofts in SoHo, New York. We don't have what you'd call a lobby, but we do have an entrance area with mail boxes and a 'give a book/take a book' shelf. One day, a complete set of the 1992 Encyclopaedia Britannica materialised in the nook next to the mailboxes. Stacked vertically, it was just a little taller than I am. The stack sat there for several weeks, untouched. Then one evening, while helping my eleven-year-old daughter on her science report on capuchin monkeys, I said, 'remember that big stack of books downstairs? Let's see what the encyclopaedia has to say.'
I went downstairs and brought up Volume 2 'Bayeu to Ceanothus' of the Encyclopaedia. 'This,' I said, with a degree of awe, 'is the Encyclopaedia Britannica. I'm sure it will have an excellent long article on the capuchin monkey.' I placed the august volume on the coffee table and carefully paged to the entry. What we found were three short paragraphs. My daughter had already read much more thorough and up-to-date information on Wikipedia and had followed the Wiki hyperlinks to more detailed research.
The Encyclopaedia with its gold stamping held no authority, no lustre for her. A few days later the stack disappeared, missing, unfortunately for its new owner, the volume covering Bayeu to Ceanothus, which

remains upstairs in our loft as a strange momento – more of my own childhood than of my daughter's. Several months later, in March of 2012, the Encyclopaedia Britannica company announced that, after 244 years of continuous publication, no new editions would be printed. Jorge Cauz, president of Encyclopaedia Britannica, Inc., noted in the press release: 'I understand that for some the end of the Britannica print set may be perceived as an unwelcome goodbye to a dear, reliable and trustworthy friend that brought them the joy of discovery in the quest for knowledge, [but] today our digital database is much larger than what we can fit in the print set. And it is up to date because we can revise it within minutes anytime we need to, and we do it many times each day.'

From encyclopaedias to bodice-rippers (as editors used to call romance novels back in the day). Two very different kinds of publishing – but for us they were without doubt both what we called 'books.' When they become digital publications, whether as online databases or as e-books, are they still books? Should we keep calling them that? What do we miss about their 'bookishness' when they become, in their different ways, digital? Not much at all when it comes to content. Indeed, in many cases there is more in the digital editions. But we do lose connotation and context. For the encyclopaedia: the connotations of a library, of seals of authority. For the romance novel: past summers at the beach; a book hidden under the bed, perhaps. But my daughter learned from Wikipedia online, and as for the romance reader, the statistics show that most reading on e-readers happens in bed and most new purchases of e-books are made after 9 pm.

Digital forms (e-book, web, apps, and emerging hybrids) do some things—many things, in fact—that we used to associate with the book just as well and in some cases better: search, update, transport, archive, reference other material, and encode data about its reading and use. But digital publications are radically new in this history of publishing in providing geolocation, video and audio enhancement, dictionary definitions, hyperlinked citations, social reading platforms, accessibility for the visually impaired, and the ability to zoom in on images to see greater levels of detail. From an economic perspective, they offer zero marginal production cost, near-zero marginal transaction cost, immediacy of delivery, and a far greater selection of titles available to individual readers, regardless of location.

With DRM-free digital publications, readers can also anthologise, excerpt, comment, and even bowdlerise their own editions. Indeed, readers can now move the production process backwards, as it were, to create their own custom print editions of books originally purchased digitally.

In some sense, the digital form gives the reader more control over the experience of reading. With the emerging digital forms, the reader

takes on – or is technologically enabled to take on – many functions that, until very recently, were the exclusive province of the publisher, who alone had the authority and tools to fix and embed his or her editorial decisions into the print form.

Is It Just Semantics?

If it turns out that certain kinds of content can survive just fine and, indeed, might even thrive in their digital incarnations, then what shall we want, now, at this juncture in our cultural history, to have called a book? What, looking back from the future at our present as the past, shall we want to have defined as a book, in order to create a legacy upon which that future can build? What we insist upon now as the defining qualities of the book will determine the Wittgensteinian 'river bed' guiding the flow of meaning that continues as 'book,' while other kinds of content will fork off and create their own river beds of digital forms.

Is there a kind of meaning conveyed uniquely in the book form? And if so, how are we in the publishing community doing at articulating what is special, distinctive, and unique about the book form? When I listen to talks and read blogs by publishing colleagues who have either embraced the digital with enthusiasm or accepted it as a dreadful but inevitable reality, I am not satisfied by their answers to this question. Instead, I am struck by how often the 'smell' of the printed book is what they say they'll miss and find so distinctive. Given that the olfactory is the sense most strongly identified with memory, this strikes me as a kind of pre-emptive nostaligising, an anticipatory mourning that only barely masks defeatist cynicism – especially when followed by the predictable coda professing great personal 'fondness' for bookshops, bookshops which, filled with the thus noted smell of musty books, are now rendered in digitally enhanced sepia-tone in the mind's eye.

Even the skeuomorphism of the visual design of the e-book space is musty. The 'virtual' bookshelf that houses the icons for e-books on the iPad and other devices calls to mind a school library shelf circa 1965. This skeuomorphic digital design might be mirroring more truth to ourselves than we'd like to admit – that the book is done and over with, while at the same time contributing as visual meme to this historicising of the book as 'ye olde book.'

When did the aesthetic of the book become so rearguard? When did the book take on the patina of 'vintage'? Was it perhaps in that period I mentioned earlier, when the commodification of the book got underway? Is the Hunter Green colour scheme of Barnes &

Noble not just a Disneyfication of the Ivy League library?
Is an ersatz musty tome in a dusty Victorian bookshop what our generation will bequeath to the future as the exemplar of the book?

I think we can do better. Surely we shall want the book to evoke more than mustiness and nostalgia. And won't we want also to have left to the future a more vibrant image of the bookstore than that of Flourish & Blots in the Harry Potter stories?

What, then, are the kinds of bookish books we ought to be publishing today as exemplars of the book for the future? What is the enduring legacy of 'bookishness' that we want to transmit to the future? What kinds of meaning are transmitted uniquely in the book form? What is the 'bookishness' of the book that does not survive conversion, translation, adaptation, or reformatting as a digital publication? And what kinds of books even possess this quality?

[3]Drucker, Johanna. (2004). *The Century of Artists' Books.* New York: Granary Books.

The artists' book field is notable for its obsessive reflection on self-definition: an outsider to the world of artists' books can't help but be struck by the intensity of the debate within the field about just what an artists' book is and isn't, about what does and doesn't merit the name 'artists' book.' At a time when the mainstream publishing community is struggling to define what the book might be in the digital future, I reckon all of us can learn from not only the inventiveness of artists' books themselves, but also from the very structure of this debate about definition and naming.
Why the artists' book field takes its own naming so seriously is not, I think, just semantics, but a genuinely political struggle for a 'just semantics,' motivated by a fierce desire to create and articulate kinds of meaning and experience that have been rendered mute by the commodification of the book over the course of that very same twentieth century in which the artists' book has developed. This is one way of understanding Johanna Drucker's ambitious dual claims that 1) the artists' book is the quintessential twentieth-century art form and 2) that '[w]hat is unique about artists' books is that, with very few exceptions, they really did not exist in their current form before the twentieth century.'[3] The artists' book is by definition other to the commodified book that came into existence in the last century. It plays itself out in an on-going dialectic and agon against its dark commercial twin. And by that logic the artists' book is necessarily, like philosophy, a late-comer: Hegel's owl of Minerva which begins its flight only at the dusk of an era. Or perhaps the owl of Terpsichore who dances at night in Ulisses Carrion's space-time.

I speak of dance because I believe it is the reader's distinctive somatic experience of the physical book that most resists translation into the digital form. Indeed, I question whether there is any equivalence, any translation whatsoever of the somatic experience of the book into the digital – and whether it would be a category mistake even to try. In the process of grappling with the digital form, I find that

what I miss most is not, in fact, the smell of the printed book, but rather the extraordinary symphony of movement that is a great art book, photo book, or, of course, artists' book. By somatic, I don't just mean the movement of the arms and hands and head and neck and shoulders and eyes as I page through a book. Nor even, the beauty of the evolved scale and proportion of the book page to the human face and hand. What I insist upon is a somatic experience far more powerful: I mean the awesome, truly distinctive choreography of movement in my brain from left to right, from right back to left, from spatial to temporal processing, from visual to verbal and back again; the thick temporal symmetries of the dance steps my brain takes as it progresses through the book. I was fortunate once to spend uninterrupted time with one of Dieter Roth's two-handed sketchbooks in Ira Wool's collection – I can only describe the experience of it as brain dance.

The simple feature of bound sequenced pages with fronts and backs and openings and closings turns out to be not simply a tool but a remarkable space-time forum, in which one of the most distinctive features of the human brain – its bilateralality – can experience itself. To those who liken the printed book to the horse and buggy (and there are many, I'm afraid), I say, no, the book is more like the bicycle. And as enduring. The bicycle: a simple but ingenious design harmoniously suited to the bipedal structure of our human body. The book: a simple but ingenious design harmoniously suited to the bilateral structure of our human brain. When, in the future, we speak of the book, I want us to think of that object which so effortlessly affords the reader a structured self-experience of the bilateralism of the brain.

We are at a truly unprecedented moment in cultural history. I believe an important question at a time of such vast change is how to have agency. By 'agency' I mean something old-fashioned and humanist: an action founded on the belief that the outcome of the action matters; that acting makes a difference in the sense of rendering the future different than it would otherwise have been; that action can have effect not just as communication across space, but also as legacy transmitted over time to the future. Agency makes a difference by making a new past for someone else's future. And therein lies the responsibility.

More important perhaps than our initial forays into the realm of digital publishing are what we are making now as exemplars of the book to transmit to the future. Let us not leave the future with the smelly nostalgia of musty books. What shall we want to have called a book? With the books we make today, we have a historic opportunity to define the book as a muscular, energetic, distinctive form of meaning transmission dancing into the future, beautifully scaled to the human body and the human brain.

Bibliography:

Bekken, Jon. (1997). *Feeding the dinosaurs: Economic concentration in the retail book industry.* In: *Publishing Research Quarterly* 13.4 pp. 3-26

Drucker, Johanna. (2004). *The Century of Artists' Books.* New York: Granary Books.

Spiva, Bruce. (2005). *Comments of The American Booksellers Association to The Antitrust Modernization Commission*

Didier Mathieu

From site to (web)site

On site

The *centre des livres d'artistes* (cdla) is both an archive of artist's publications and an exhibition space.

Lieu unique en France, le cdla fonde son activité sur une collection de près de 6000 œuvres: livres, revues, affiches, estampes, cartes postales et autres documents appelés 'ephemera', éditées et diffusées à partir du milieu des années 1950 jusqu'à aujourd'hui, tant en France qu'à l'étranger. Environ cinq cents artistes internationaux sont représentés dans cette collection, et au fil du temps, des ensembles remarquables consacrés à une trentaine d'entre eux ont été constitués (herman de vries, Bernard Villers, Hans Waanders, Lefevre Jean Claude, Eric Watier, Edmund Kuppel, Claude Rutault, Paul-Armand Gette, Simon Cutts and Coracle Press, Jean-Jacques Rullier, Mirtha Dermisache, Endre Tót…). Les artistes pionniers du genre 'livre d'artiste' (Ben, Henri Chopin, Jean Le Gac, Jochen Gerz, Robert Filliou, Didier Bay, Daniel Buren, Peter Downsbrough, Edward Ruscha, Maurizio Nannucci, Ian Hamilton Finlay, Hamish Fulton, Richard Long, Dieter Roth…) côtoient ceux de la jeune génération (Pascal Le Coq, Claude Closky, Yves Chaudouët, Marie-Ange Guilleminot, Hubert Renard, Jean-Pascal Flavien et Julien Bismuth, Derek Sullivan, Sophie Nys, Peter Liversidge, Colin Sackett, Sharon Kivland pour ne citer qu'eux). La collection compte également de nombreuses publications de deux des mouvements artistiques majeurs des années 1960/70: Poésie concrète (John Furnival, Jiri Valoch, Emmett Williams, Hansjörg Mayer…) Fluxus (George Maciunas, George Brecht, Dick Higgins…). Fluxus artists, so many years before the world wide web, worked with the idea of a network (see Mieko Shiomi's 'spatial poems', precisely spatial poem n° 2 – a fluxatlas).

Même si deux thématiques – enfance, paysages – irriguent la collection, celle-ci se développe à la manière d'un rhizome, au gré des rencontres avec les artistes et les éditeurs, et le plus important pour nous a été Herman de Vries.

An example of the kind of relations between site and website is the fact that the archive grows on the model of a tree diagram.

It is yet a form of network. The *centre des livres d'artistes* is situated in the centre - in the middle - of France. Have a look at maps of French railways and motorways and you'll see that the centre seems to be - physically - in brackets. Located and isolated. It doesn't matter.
The most important fact about a network is that there is no centre. What happens, happens in the margins. And we work in the margins - in more ways than one. Even if we say and have repeated for years now that artists' books or artists' publications are artworks in themselves, they are still in the margins of the so-called art world.

On website

For us a website is a complementary space to our space in Saint-Yrieix. The walls are different and one visits us differently on site and on website (we have probably more visitors on the website). The website site is not an exhibition space, it is more of an up to date living memory of what happens in Saint-Yrieix.

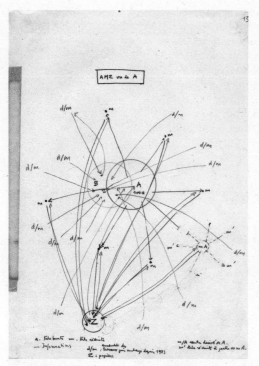
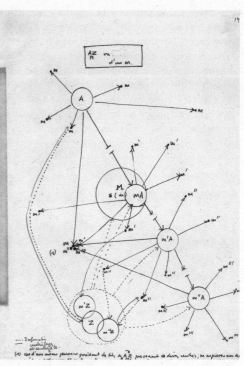
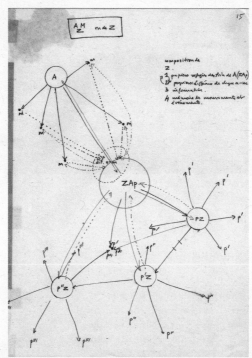

And it is the best and cheapest way to disseminate information. Last year French artist Claude Rutault has deposited his archive of a work titled *AMZ ou le soleil brille pour tout le monde (1986)*. This archive consists of three ring binders and a box of various documents.

AMZ is complex enough, but briefly we can say that it is a work in three parts: A, M and Z. Part A is composed of 100 raw canvases on stretchers of different standard sizes actually stored in Carquefou. Part M is dispersed in nineteen places (institutions or private collections). Part M consists of nineteen canvases chosen from part A. These canvases are painted in the same colour of the wall on which they are hung. The size of these canvases is smaller than the size of the original canvases stored in Carquefou. The percentage of reduction is determined by adding two parameters: the distance between Carquefou and the place of installation, and the order of installation in the course of time. Part Z is both: a set of papers, showing the difference of size between the 'original' canvas from Carquefou and the size of the canvas located in part M; and the 'archive' of the work.
We plan to create a website related to the materiality and content of the archive. First all the documents will be digitalised. Then it will be a sort of a 'site specific' project, a record of the 'movements' and the 'life' of the work. See the three first drawings showing not the artwork but its process. It seems evident through these tree diagrams that the 'form' of a website is suitable.

La politique éditoriale du Cdla consiste en la publication de catalogues raisonnés d'artistes ou d'éditeurs (herman de vries, Lefevre Jean Claude, Paul-Armand Gette, Bernard Villers…)
In a way, by publishing catalogues raisonnés we create a sort of an archive in the archive (see Arnaud Desjardin *The Book on Books on Artists Books*. The French connection!).

Some years ago we published a herman de vries catalogue (quite out of print now). For me it is still a pleasure to look at it, turning the pages… but when I need to work with it I use the files stored on my computer, it is easier. The hard copy of Paul-Armand Gette's catalogue appeared some weeks ago. The digital copy (an updated and more complete version) will be available in autumn. To get the digital copy, one must buy a hard copy.

I don't know precisely how the new technologies to generate and read text and images will change our experience of reading. But I am sure that new printing technologies will modify this object called a book. It will no longer be closed on itself for eternity. You can print 100 or 2,000 copies and then modify the text, the images, add text, images, new information, or erase text and images and again print 200 or 1,000 more copies, and again and again. Identical yet different.
A work in progress.

Arnaud Desjardin

The Book on Books on Artists Books

This short text attempts to quickly present and describe a bibliography of sources on artists' books and reproduces part of the introduction of the book itself.

An important aspect of the project was the production of the book in real time during an exhibition of the material it contained and detailed. In that sense *The Book on Books on Artists Books* re-materialised an actual collection of published material being displayed as part of an art installation. The exhibition comprised a number of wall-mounted vitrines for the display of rare books, some tables and chairs with reading material available to the visitors and desktop equipment necessary for the printing, binding and trimming of the book itself. Inasmuch as the show and the book produced there operated a *mise-en-abime* of books (containing books, themselves containing artists books etc.) it also somewhat collapsed the book production with its own dissemination. The public was welcomed to apply for a free copy of the book that they then had to come and retrieve a couple of weeks later.

Here is not the place to make explicit the complexity of the project as a whole, it should just be necessary to point out a few of the reasons that pushed me to collect, compile, accumulate and research printed material production related to artists books. I felt that those publications were often overlooked and not always referenced in books on the subject, and what might be a contradiction, they were also rare and hard to find. Another point of interest was the fact that a lot of ephemeral literature on the subject of artists' books had migrated online over the course of the last ten years. The dealers' catalogues are now circulating in the form of PDF files via email and their circulation is no longer operating along similar lines to the material books they are advertising.

The radical impact of electronic media into the field of artists' books is not yet fully measured as artists, publishers, collectors etc. have adapted to new modes of production and dissemination and have embraced a tidal wave of change sweeping the whole industry of publishing. If at first hand *The Book on Books on Artists Books* does not seem to be preoccupied with those specific changes it nonetheless offers an insight into an aspect of artists publishing crucial in disseminating information and giving visibility to books produced

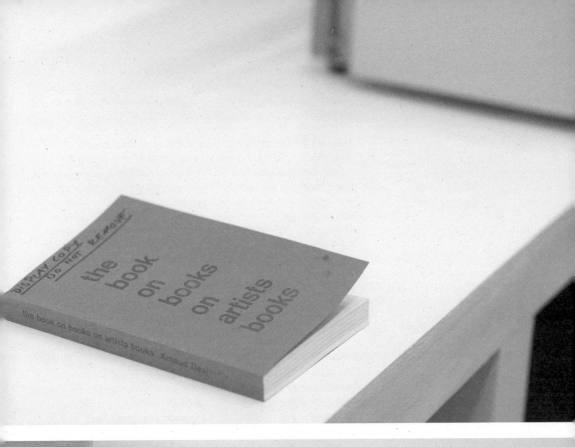
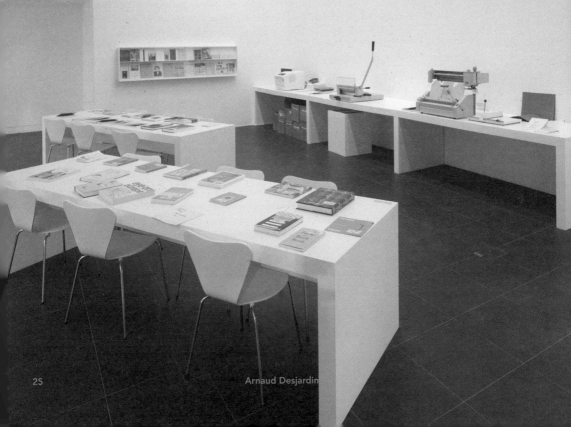

Arnaud Desjardin

by artists. If that metadata now takes an electronic form it is all the more important to question its current status compared to the previous printed forms that resonated with the very artists' books they were describing.

This said the specificity of the book rests with the networks connected to a certain sort of art production of the last fifty years, namely artists' books. That field is as vibrant as ever with more books being produced than ever before, what is less certain is the kind of documentary evidence left behind to appraise and understand this very contemporary form of art production. In putting *The Book on Books on Artists Books* together I hoped to produce a helpful marker towards a reflection on how those very peculiar books ever circulated and were first received by a small public of interested parties.

From the introduction to the book:

The Book on Books on Artists Books is a bibliography of books, pamphlets and catalogues on artists' books. It takes stock of a wide variety of publications on artists' books since the early 1970s to draw attention to the kind of documentary trace of distribution, circulation and reception they represent. It aims to be a source book of exhibition catalogues, collection catalogues, monographs, dealership catalogues and other lists published to inform, promote, describe, show, distribute and circulate artists' books.

With a focus on books containing bibliographic data, this volume proposes an overlooked history of the printed traces left by the practice of exhibiting, publishing, disseminating and collecting artists' books during the last forty years. The main criterion for inclusion is information on books rather than critical writing or texts on artists' books. These documents were gathered and compiled in order to give visibility to an aspect of the field that is often ignored: the networks of promotion and distribution of artists' books, as art as well as material books.

The traditional bibliographic hierarchies organise different types of publications on any subject according to the format's authority, from periodical article to pamphlet, to book, to monograph, to bibliography. What follows is a bibliography of reference material, books, pamphlets, catalogues and lists of artists' publications, published since 1972 until today. If some of these established bibliographical classifications have been retained in the book, it does not follow that all books fit their respective category. A pragmatic decision was made to try and make the volume of information more palatable.

The selection criteria is first of all the quality and quantity of bibliographic information included in the selected titles and their focus on books published by artists. Having to make decisions about what books were to be included was not always easy. The field of artists' books frays at the edges: when unique book objects, numbered multiples, fanzines, vinyl records, video tapes and other printed, pressed and processed material are artists' books, the volume of information simply becomes overwhelming and the task endless. Although it is not concentrating on specific aspects of artists' books production the present bibliography includes some titles that may be seen as marginal to the field or may include information extraneous to it. As an example, a survey of books on art fanzines would probably contain over fifty titles and could not be included here for practical reasons. When is an artist's magazine a fanzine? There are many crossovers with other ad-hoc small publications in terms of form if not content. The volumes related to fanzines included in the present bibliography have a clear link to art and artists' books, at least in parts. The same could be true of multiples, limited editions, ephemera etc. Despite the inevitable exclusion of some books, I would hope nothing significant has been purposefully excluded. The seminal exhibition catalogue *The Book as Artwork*, curated by Germano Celant (with a bibliography compiled by Lynda Morris) at Nigel Greenwood Inc. Ltd, London in 1972, has been chosen as the significant starting date for that bibliography. It is the first significant theorisation and exhibition of books as a direct art form relating to the radical developments of art in the 1960s. A few publications predating *The Book as Artwork* have been included in that bibliography, they were either monographs on individual artist/publisher like *edition hansjorg mayer* catalogue of 1969 or exhibition catalogues including information on publications like the Stanford University Art Gallery exhibition of Jeff Berner's collection in 1967, or the *3 → ∞: new multiple art* at the Whitechapel Gallery in 1970. The first version of the essay contained in *The Book as Artwork* was published in Italy in the journal *DATA* in late 1971. It was then translated into English for the purpose of the show in London, it then appeared in French in *VH101* magazine. It was eventually published in German in 1974 in *Interfunctionen* magazine issue 11.

The polarisation of the debates regarding the definition of the term artists' books often only reinforced the visibility of known and acknowledged books and practitioners associated with the canonical against the still invisible and obscure. All commentators agree on the fact that there are simply too many artists' books to produce a complete picture of the field. To provide an overview of the secondary literature is a start to uncovering darker corners of as yet little charted productions.
It is the quantity of bibliographic data contained in those publications rather, than any critical argument made for the selection within each publication, that produced this bibliography.
The exclusion of most magazines and magazine articles except for

some special issues was decided in order to be able to better focus on publications that are not often referenced in critical bibliographies such as dealers' and publishers' catalogues. A large critical survey on the topic like *Esthétique du Livre d'Artiste* by Anne Moeglin-Delcroix (one of the most respected writers on the subject) cannot be considered equivalent to a mail order catalogue from Printed Matter (one of the most important bookshop distributing artists' books since 1975). Their respective purpose and aim is different, one is critical and analytical, the other seeks to distribute and sell the books. What they share is information on existing books, in one instance as exemplars belonging to a category defined critically, in another instance as de facto items available for purchase from an outlet defined by the fact it specialises in artists' books. What is left out in the critical survey has been considered marginal to the category, what has been left out of the mail order catalogue is no longer available or in print. Viewed in association they can allow a wider historical and critical perspective on the phenomenon of artists' books.
One can highlight availability and dissemination at a specific time and place, the other assures the books have a lasting context of reception and are understood as artworks. Together, the bibliographic descriptions of existing artist's books amount to what the field contains, or at least to what the field has ever acknowledged as existing in printed 'secondary' material. The blind spot of existing artists' publications not reported or described in any publications constitute the as-yet-unknown of the field. Those yet-to-be-acknowledged limits of the field are where the contemporary publishing of artists' books takes place, in advance of any recognition either commercial or critical. This is where The Everyday Press operates as a practical endeavour to publish art.

The Bibliography has been organised in sections that inevitably have crossovers. These bibliographic categories have been used in order to hopefully make the whole easier to navigate:

Exhibition Catalogues: Those are books that were compiled on the occasion of an exhibition of artists' books, they can contain involved critical essays explaining and arguing the selection of books on display and the particular historical point made by the show.

General Reference: Those were often produced as authoritative surveys attempting to define the field of artists' books, often by choosing deliberately representative books to fit the critical criteria of a series of definitions.

Collection Catalogues: Books included in this category were sometimes produced for an exhibition of a collection or on the occasion of the dispersal of a collection at auction. They usually take stock of an existing collection and its outlook.

Artist Monographs: That section focuses on publications looking in the detail at the book production of individual artists.
General monograph on specific artists, even if including information about publishing activities, have usually been excluded except when the book contains a detailed and informative section on the books published by that artist.

Publisher Monographs: Those are distinct from publishers' catalogues as they usually provide an overview of a period of production of one specific publisher involved in artists' books. This category is also distinct from the Artists Monographs as a publisher, although maybe lead by an artist, will tend to work with lots of different individual artists.

Artists' books on books: Most artists' books make more or less overt references to other existing books. It is their critical prerogative.
It was felt that the addition of section on artists' books specifically making reference to bibliographies of artists' books or previous artists' books production should figure if only as an indicative section. This section does not include pastiches or reprints or reissues but rather publications that should be considered part of the secondary literature on artists' books but are also in effect primary information, that is artworks in book form.

Periodicals: Only special issues and periodicals wholly dedicated to artists' books figure in this section. The emphasis is on special issues rather on specialist periodicals although a few of these are included albeit not in complete runs.

Publisher Catalogues: Some publishers of artists' books regularly produce brochures or lists of their publications to aid commercial distribution of the titles still available. Those booklets often incorporate interventions by an artist, for example specially commissioned covers.

Yearbooks & Fair Catalogues: Usually produced for trade fairs and other events, these publications give useful information on publishers and their production.

Dealerships: The term dealership covers both private and public enterprises, both new and second hand. It details the lists that were produced and circulated for distribution and sales purposes.
These are usually ephemeral and regular publications that can vary enormously in form and edition. Some would have been produced in a small quantity, a couple of hundred copies privately distributed. Others will have been produced as trade catalogues to be sent to thousands of potential customers.

The Book on Books on Artist Books,
The Everyday Press
2011, Softback, 290 pages.

Susan Johanknecht
& Katharine Meynell

A printed project tipping our hats towards the many women reflected in our practice (rip-off, homage and transcription) in five sections, first exhibited at the Poetry Library, Southbank Centre, London, March – May 2012

Poetry of Unknown Words

[1] *Poésie de mots inconnus*, Paris: Le Degré 41, 1949

This collaborative book *Poetry of Unknown Words*, is a development, transcription and homage to Iliazd's *La Poesie de mots inconnus*.[1]
In particular the format of our project references Iliazd's illustrated anthology of (mostly men's) concrete and experimental typography and sound poetry, in folio form.
In our use of title, simply translated, we contain a more modern sense of an 'unknown' which plays on feminist concepts of 'hidden from history', and it is from this position that we are examining content through materiality, both past and present.

We are taking Iliazd's format and applying it to a new series of works that, in themselves, directly reference and quote already extant works by a group of women artists and writers and thinkers. Our overall structure is bundling into subject areas, chronologically referencing works made between 1700 and 1970. These printed sheets pay attention to a particular individuals' relationship to their

contemporary technologies and the consequent scientific and artistic applications. We are not trying to create facsimile – but to respond to existing artifacts, making new works.

Poetry of Unknown Words explores an expanded notion of the book and the archive socially, culturally and politically. Using a number of libraries and archives (including the National Art Library, the Hepworth Wakefield, Henry Moore, British Library, Saison Poetry Library, the Women's Library, RHS Lindley Library, and Yale Special Collections) we reference what we understand as key works, in a variety of technologies moving between the digital, letterpress and hand made mark. We are responding to existing artifacts, making new works, through which we examine issues of material values and shifting meanings. This interest in the artifact itself, rather than the signifying text/image alone, gives us the opportunity to understand historical context through material means. Work aware of it's history allows what Caroline Bergvall refers to as: 'a re-emergence of (that) history through detail' to not replicate or eradicate history but to keep the origins as visible traces.

Iliazd's *Poésie de mots inconnus, Paris: Le Degré 41, 1949,* is an exemplar of avant-garde typography and design and is the structure we have chosen to transcribe – this is a series of folded folio sheets written and illustrated by prominent writers and artists. Five bundles are wrapped in a vellum folder, the outer appearance of which is a squat thick volume with embossed title. Johanna Drucker describes this as:

[2] Drucker, Johanna. (1994). *The Visible Word*. Chicago: University of Chicago Press. p. 227

one of the more remarkable productions of book arts and literary history in the 1940's [...] the first exhaustive anthology of concrete and experimental typography and sound poetry [...] Printed in a fine, limited edition, the work has not had the historical recognition it deserves as a landmark piece of anthologizing or for the actual substance of material it contains.[2]

In our transcriptions we are reworking the 'thingness'. If the medium is the message, and the site and location also carry meaning, these must be accounted for in a re-rendering – the physical qualities of the paper, ink or fustiness of the rare books collection - being mindful that what is left out is also of consideration. Implicit in this is our acknowledgement of the untranslatable, the lost nuances, and the stains collected by the shifting of context within a new language, or medium. In both translation and transcription there are taints, residues and colouring, both lost from the original, and acquired in re-forming a work in a new guise.

In considering the difference between translation and transcription it is useful to remember that one is notionally linguistic, and the other moves between modes of expression such as in music or in painting, or between movement and reenactment. What we understand we are doing in *Poetry of Unknown Words* incorporates both. For us these are open and moveable concepts, responsive and pragmatic.
The primary source has been structurally examined for Iliadz's radical disruption of normal conventions of print, image, and text.

In *Poésie de mots inconnus*, the text frequently suggests odd utterances, Dada texts and extensive breaks with the semantics of language. The dual format of the pages (folded in two, or flat sheet in four) allows different readings that, however, keep a close relationship between them. The fold thus choreographs a series of actions in the handling and revealing process, prompting embodied engagement that cannot rest on a single meaning.

The philosophical resonance of the fold or *pli* is perhaps aptly invoked here as the suggestion of a 'structure of ideas'. A structure of ideas that could be applied to our *Poetry of Unknown Words* as it does not imply doubt or hesitation but im*pli*cation, ex*pli*cation and re*pli*cation. Our use of the folded sheet in un-sewn form enables us to keep an open research and production methodology, moving between source, historical context and contemporary reworking. It is vital to keep the means of production within our control. Our research is through making and handling of processes - the knowledge of what is learned through the hand as well as the theoretical. Keeping a plurality between concept and object, folding, unfolding and refolding.

Poetry of Unknown Words is our personal anthology accounting for women's ideas - of which this is the first part – to eventually be formed into five bundles (literary, horticultural, painterly, scientific, structural). The completed project is being published as a *Gefn Press*[3] imprint in an edition of twenty.

The points of reference we use in *Poetry of Unknown Words* are driven by an accumulation of our own histories of interests and the processes of discovery within the archive. There are things we seek out knowingly and things we stumble across fortuitously. We bounce ideas back and forth and use our collective selves to reflect upon the material we are using. We have by chance similar experiences of the world, both coming from transatlantic families and a combination of artistic, literary and artisan milieus. As mothers and academics we see similar shadows lurking just out of view. Our choices of material to reference are those that hold significance for us. The plundering of the archive provides influx, chance, harmony and dissonance. Thus this work is in part anthologising our perception of what has been formative for us as artists and makers, and crucially, what we wish to re-circulate and bring back to the surface. The first section was shown at the Saison Poetry Library, Southbank Centre, 2012. It celebrates and responds to writings by HD, Emmy Hennings, Gertrude Stein, Valerie Solanas and Mary Wollstonecraft. This use of archive (library) addresses the collection and places back into that archive new material. This literary section included:

[3] The Gefn Press imprint was established in 1977 by Susan Johanknecht, in Vermont USA. It has been located in London since 1981.
www.gefnpress.co.uk

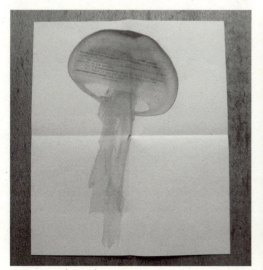

HD's notes on thought and vision (written 1919, published by City Lights in 1982) takes the jellyfish as an erotic symbol of creative force. Our response is printed on thin photo paper to evoke 'flimsy' a typewriter paper, and the visceral qualities HD refers to within her text. The verso text, written by Jae Rossman (Assistant Director Special Collections, Yale University Library) describes HD's original manuscript in response to an exchange we had with her. It was this exchange of interest and information that prompted the original HD manuscripts to be digitised and made available on line.

The serpent – the jellyfish – or to use the terminology of the modern psychologists – the subover-conscious mind.
The realization of this subover-conscious world is the concern of the artist.
But theis subconscious world is there for everyone.
The minds of men differ but the over-minds or sub-conscious minds are alike.

[4](ed. Huelsenbeck, 1920).

Emmy Hennings was a poet, performer and co-founder of the Cabaret Voltaire. In the spirit of Dada and non-sense, we have used Google translate to transcribe her poem Morfin with performance instructions on recycled paper. Verso is a 'found' dance image with a fragmentary account of Hennings work from the *Dada Almanach*.[4] From Gertrude Stein's *Tender Buttons* (1914) we formed the basis

of a digital transcription from words to buttons, using her text to generate system and order. Scanned buttons represent words, set out as 'Type' in InDesign leading to a new typography and code, with colour and shape as equivalents for the speech/sound dynamic of the original words. The buttons used are from our mothers and grandmothers button boxes to give a sense of subjective chronology. We used boot-buttons for punctuation and large glossy coat-buttons for words such as 'glees' and 'capable'. On the verso, Stein's vegetable is handset and printed letterpress.

VEGETABLE
What is cut. What is cut by it. What is cut by it in.
It was a cress a crescent a cross and an unequal scream, it was upslanting, it was radiant and reasonable with little ins and red.
News. News capable of glees, cut in shoes, belike under plump of Wide chalk, all this combing.

Valerie Solanas' *SCUM Manifesto* (1967) originally hammered out on a Remington typewriter, mimeographed to sell on the streets, $2 to men and $1 to women, prompts us to consider the form of manifesto as a literary work, where we visually mirror Solanas' contempt for men and capitalism (in place of Marinettis 'scorn for women'). We consider the form of manifesto as a work, which linguistically

proclaims a struggle against oppressive forces. Printed on Mohawk Superfine, we used 'Chicago' typeface designed by Susan Kare in 1983. On the verso it is printed as a loss of information, without the font loaded, forming a series of dots in default mode.

For Mary Wollstonecraft's *Vindication of the Rights of Women* (1792) we have used her fabulously précised contents page to invoke the range and depth of her writing, produced across disciplinary boundaries, which still feels pertinent. A piece of Payhembury marbled paper and the use of Caslon type, suggest the materiality of earlier book production methods. Employing letterpress and random inking, we presents her contents page with a digital facsimile library stamp.

CHAP.1.	The rights & involved duties of mankind considered
CHAP.11.	The prevailing opinion of a sexual character discussed
CHAP.111.	The same subject continued
CHAP.1V.	Observations on the state of degradation to which woman is reduced by various causes
CHAP.V.	Animadversions on some of the writers who have rendered women objects of pity, bordering on contempt

Poetry of Unknown Words is part of a wider initiative of our collaborative work in transforming and expanding the book, along with the earlier projects *Volumes of Vulnerability* and *Cunning Chapters*. The small editions we produce enable us to make materially complex work that would be prohibitive in larger numbers because of time, expense and the sheer tedium of hand fabricating in greater numbers.

Poetry of Unknown Words delves into the archive, resurfacing ideas. There is the implication of the degeneration of material and the retention of old concerns reshaped anew. We shamelessly quote and ransack to construct a cannon of personal and shared histories and experience, hinted at though image, text and material readings. This is an artist's use of archive that is simultaneously scholarly in interest and playful in intent.

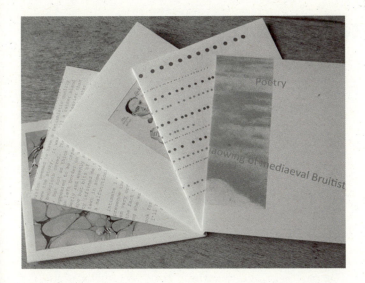

The notion of the *archive at play* is designed to intervene in the prevalent view of the modern archive as being merely an instance of technology, a technological memory who's functioning is guaranteed by its rational foundations.

[4]Spieker, Sven. (2008). *The Big Archive*. MIT Press. p. 15

We combine linear time and historical process (dipping in and out and inserting interpretations) that operate in non-linear ways. Which has in our life times been influenced by the access to digital media and ways of retrieving knowledge.

With all these methodologies we have a feminising project, a gathering of women from the archive, giving them pride of place.

Stefan Szczelkun

Agit Disco

Szczelkun, Stefan & Iles, Anthony (eds.). (2012). *Agit Disco*. London: MUTE Books.

Agit Disco selectors: Sian Addicott, Louise Carolin, Peter Conlin, Mel Croucher, Martin Dixon, John Eden, Sarah Falloon, Simon Ford, Peter Haining, Stewart Home, Tom Jennings, DJ Krautpleaser, Roger McKinley, Micheline Mason, Tracey Moberly, Luca Paci, Room 13 – Lochyside Scotland, Howard Slater, Johnny Spencer, Stefan Szczelkun, Andy T, Neil Transpontine, Tom Vague.

Agit Disco collects the playlists of its twenty-three writers to tell the story of how music has politically influenced and inspired them. The book provides a multi-genre survey of political musics, from a wide range of viewpoints, that goes beyond protest songs into the darker hinterlands of musical meaning.

whistling in the street…
having a sing-song

whistling in the street
sing-song

SELECTION
of most tasteful

"shed loads of political music"
unheard on mass media
….but not on the r a d i o

My age old problem with
The Men of Letters

CECIL SHARP to LORD REITH
Singing Together (NOT)

very little political music
on the mainstream media

its a matter of
good taste

Culture's pur
The continua
evaluation of

BOWDLERISATION
of oral culture

BOWDLERISATION
of oral culture

My Grandfathers
violin on the wall silent…
my family can't sing
My Grandfathers violin
hangs on the wall -
my mother and father
"can't sing"

http://szczelkuns.wordpress.com/

A Mute book!

La Pensée de en Bas

http://www.youtube.com/user/AgitDisco

http://www.stefan-szczelkun.org.uk/agitdisco/

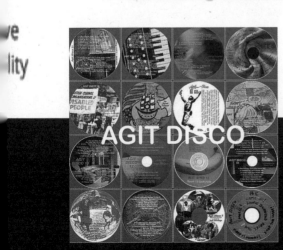

AGIT DISCO

Mark Sanderson

The Text that Reads Itself

[1] These can be found mainly under the category 'Kinetic Typography.'

Looking at the proliferation of word animations on YouTube[1], one could be forgiven for thinking that all the dreams and experiments of the typographic innovators of a hundred or so years ago have been fulfilled. All text can now be instantly accessed, freely positioned, modulated, animated and vocalised.

The growth of these 'motion poems' (or, in some cases, typographic cartoons) appears to be a cultural trend that is significant in a number of ways: it heralds a change in literacy from print to screen; it could well redefine poetry; it offers greater authorial control over how text is expressed and received; it demonstrates the cultural continuity of modern movement typography; it provides a new and accessible creative exchange.

Of course, all or many of the above claims could be contradicted: it may be a short-lived phenomenon, already dated and soon forgotten; it may be deemed facile and conformist; its motives are mostly promotional; it marks a shift from print literacy to screen culture.

[2] Drucker, Joanna. (1993). *The Visible Word*. Chicago and London: The University of Chicago Press, p. 138

Whichever view one takes, and it depends on what is actually viewed, what is central here is the notion of a text that 'performs its own reading'. This was once a radical idea proposed by the Modern Movement, one that sought to eliminate the rift between writer and reader, signifier and signified, speech and page, mimesis and actuality. That drive to make words perform their meaning, to be visual and material, which was begun by Mallarmé and made famous by the 'onomatopoeic imagination'[2] of Marinetti has nowadays shed much of its radical apparel; however, it re-presents itself in vivid and eloquent new forms, now supercharged by technology and promising all kinds of textual liberation.

[3] Lanham, Richard A. (1993). Echoing the Futurist manifestos of eighty years before, Lanham describes the promise of complete interpretation that hypertext ushers in: *The Electronic World: Democracy, Technology, and the Arts*. Chicago and London: The University of Chicago Press, p. 5

'I can reformat a text to make it easier to read, or using a dozen transformations, make it harder, or just different, to read. I can literally colour my colours of rhetoric. I can heal the long hiatus of silent reading and make the text read itself aloud.'[3]

Kinetic typography videos, animated poetry, title sequences–
essentially all forms of motion graphics–are facets of the same
technological package that has radically changed reading and
readerships, and has endowed words with a mobile and
compelling visuality.

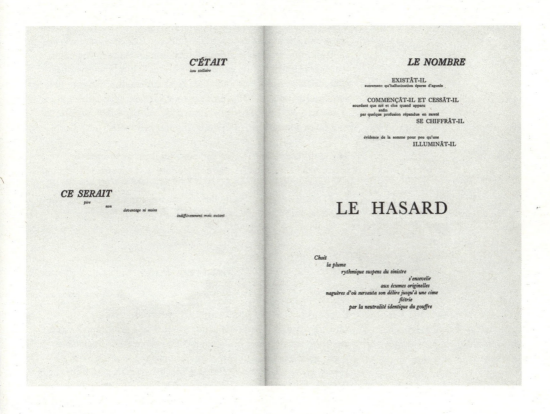

The unlikely progenitor of all this is Stéphane Mallarmé, whose twenty-page poem, *A Throw of the Dice Will Never Abolish Chance*, was published first in 1897 then in a new, definitive version in 1914.

The poem is famed for its radical positioning of text on expanses of empty space, mixing fonts and point sizes, abandoning the conventions of both syntax and typographic layout. It makes numerous appearances in histories of graphic design – usually in the form of four of its most reproduced double-page spreads.
It is interesting to note that its high profile is consistently matched by a widespread indifference to its content. Perhaps it is a measure

Above:
Stéphane Mallarmé', *A Throw of the Dice Will Never Abolish Chance*, 1914, pp. 15-16

[4] Drucker, 1993:59

[5] Bowie, Malcolm. (1978) *Mallarmé and the Art of Being Difficult.* Cambridge: Cambridge University Press, p. 120.

[6] Drucker, 1993:52

[7] Bowie, 1978:121

of its success that the poem's intentions can be, to a degree, grasped visually. The impact and fame of *A Throw of the Dice* stem largely from what Drucker terms its 'figural, visual mode'[4] where the author 'attempts to evolve a language which will be at the same time alphabetic and hieroglyphic.'[5] It would seem that we are *seeing* the poem even more than we are *reading* it. For such an abstract, evanescent and hermetic poem it is surprising that it has such a material presence on the page.[6]

Mallarmé inscribes his pages with multiple routes of reading, false starts and a syntax that is hard to trail[7], the lack of closure nags as metaphors and voices multiply. As we wander through the poem we leave semi-detached words and phrases behind for new ones that satisfy partially; we anticipate fresh possibilities, finding new semantic signposts to move us across uncharted space. The text of *A Throw of the Dice* is complex, unwieldy, varied, and also sparse and mobile in appearance, in the way of a musical score.

[8] Bowie, 1978:118

The emptiness plans to lose and consign us to indeterminacy, while the text delivers us to chance connections and a distracted reading, anticipating the restless processes of hypertext. For Bowie, 'no poem […] from any age so firmly forbids the eye and mind to alight upon it and be still.'[8]

The Front Page

[9] The link between Mallarmé and hypertext has already been made by Jerome McGann and Timothy Druckrey among others.

Looking back at the poem from our twenty-first-century vantage point, it is impossible not to see it as a prototype for the discontinuous reading of hypertext[9]. However, the influences on the poem itself are from an earlier age of mass communications. It was, above all, the vast influence of the newspaper on mass society at the turn of the century that shaped readers, providing them with the means to process information in an abbreviated, fragmented way: entirely comparable to how Internet 'readers' of today navigate, skim, browse, and skip to keywords.

[10] Drucker, 1993:55

In fact, the design of the poem draws much from the elements of a newspaper[10]. Headlines, bylines, banners, subheads and jumps are all reflected here, in the way the reader is kept moving through fragments of information.

[11] For a vision of words in every part of C.19th Paris see Edmondo De Amicis cited in Morley, Simon. (2003). *Writing on the Wall: Word and Image in Modern Art,* London: Thames & Hudson, p. 19

A Throw of the Dice presents a peak in a form of print literacy, and also the beginning of something quite different. With its polished, faceted phrasings and plottings it ushers in a new phase for both reader and writer, where the element of chance makes a generalised, depersonalised reference to the modern world of fragmented, fugitive and displaced words.[11] McLuhan notes that it was 'Mallarmé who

formulated the lessons of the press as a guide for the new impersonal poetry of suggestion and implication. He saw that the scale of modern reportage and the mechanical multiplication of messages made personal rhetoric impossible.'[12]

[12] Marshal McLuhan, *'Joyce Mallarmé and the Press'*, Sewanee Review 62(1), Winter 1954. In: (eds.) McLuhan, Eric McLuhan and Zingrone, Frank. (1997). *The Essential McLuhan*, London: Routledge, p. 64

Random Thoughts

'The blank page is the nothingness–the silence–on which the words enact their epic journey, which is both a quest for meaning and a creation of meaning.'[13]

Mallarmé's *A Throw of the Dice* is a poem that is about thought itself: the process of emerging ideas, words forming, choices being made.

Paul Valéry, Mallarmé's friend and disciple was to write this on reading the poem:

'It seemed to me that I was seeing the shape of a thought, placed for the first time in our space […] The wait, the doubt, the focus were *visible entities*.'[14]

No closure, no certainty: just possibilities, things emerging from inexistence: the void where patterns are read as constellations, allusions to the sea that holds a shipwreck, the white space of the page which the mind of the author has not yet decided to inscribe. The act of thinking exists in terms of randomness, the continuum of thought.

'For the distinction between mattering supremely and mattering not at all has not been established by the artist within the text: it is ours to make, and may be gained or lost in a blink.'[15]

A Throw of the Dice is a portrait of interiority, a high point and end point of the mind alone with itself: the act of thinking and creating represented in all its incompleteness and fortuity. The reader finds heightened awareness and singularity instead of guidance and kinship in relation to the author in relation to the author, usual in nineteenth-century literature.

Although any notion of interiority is usually related to the book or the literary mind, it is equally possible to have a heightened awareness of the self in terms of other media: film, music, and even games.

It is likely that thought is changing, and tempting to think that without silence, alienation, boredom or solitude we will end up thinking – and even being – very differently. Maybe we are already

[13] Hardison, Jr., O.B. (1989) *Disappearing through the Skylight: Culture and Technology in the Twentieth Century*. London: Penguin, p. 156

[14] Bowie, 1978:117 [My translation]

[15] Bowie, 1978:152

finding the means and incentives to escape interiority; in the same way that words are escaping the page to colonise new spaces, we may be discovering new locations for the self.

[16] Carr, Nicholas. (2010). *The Shallows: How the Internet Is Changing the Way We Read, Think and Remember.* London: Atlantic Books, p. 116

Mallarmé's famous claim that 'all the world exists in order to end up as a book' has, in a sense, come about, especially if we substitute something like YouTube for book: for us, the computer holds the access to the world in all its geography, its events, its culture, and its narratives. The Internet unfolds like a gigantic, four-dimensional newspaper that is relentlessly 'repetitive, intensive, interactive, addictive.'[16]

Technology offers us social spaces where individuality may be collectivised, harmonised diminished or possibly just redefined. In some ways it is a shared mind space that we are already connected to, and it is likely that as we internalise it we will come to a more evolved relationship with it.

However, for now, it is possible that most of us have already been reformatted in the multiple personalities of technology. We dream in shot and countershot, sentimentalise in song lyrics, fantasise in music videos, publicise our private selves on social media sites, and imagine in special effects.

Liberating Words

In the 1980s and 1990s, the emergence of digital technology imparted a distinctive, visual expression to the postmodern phase of graphic design. Numerous designers used computer graphics to convey exciting and fashionable ideas about chance, chaos and deconstruction.

In Jeff Keedy's *Fast Forward* we can clearly see elements of Mallarmé's poem: the elegant, typographic disunity and spatial drama of *A Throw of the Dice* acquire a postmodern exuberance in this affirmation of new technology. Phrases emerge, articulate, liquefy; announce themselves randomly, dissonantly, portentously. Everything, although printed, is about the dynamic nature of hypermedia, where words no longer want to stay as words.

This liberation of text by software is matched also by a desire for actual content, and this became a feature of some of the more famous graphic design work from the 1980s on. *Fast Forward* has the feel of a manifesto, made up of McLuhanesque slogans, commenting on way technology converges and redefines form and experience.

Above:
Jeff Keedy, *Fast Forward*, book spread, California Institute of the Arts, USA, 1993

The emergence of online poetry collections – one of the foremost being *Born Magazine* – has led to a search for new literary forms. *The Language of New Media* by Thomas Swiss and George Shaw is a silent, animated, interactive poem that demands effort of hand and mind from its readers/users to summon words, then twist, capture

Right:
Thomas Swiss (text) and George Shaw (design), *The Language of New Media*, *Born Magazine*, 2003

and consume them.[17] The initial inscrutability of the poem recalls *The Throw of the Dice*, as does the sense of uncertainty about how to proceed, bring forth the text, conclude. What is distinctive in this collaboration is that technology is not used uncritically, and it is not just new media that is ironised here, but poetic reflexivity too.

[17] Aarseth defines this more demanding form of reading as 'ergodic.' arseth, Espen J. (1997) *Cybertext: Perspectives on Ergodic Literature*. Baltimore: The Johns Hopkins University Press, p. 1

Right:
Jeff Smith-Luedke (Azrienoch), screenshot from Minimalism, typographic poem, 2009

A rarity in the field of kinetic typographic is the author who creates both text and design. Jeff Smith-Luedke (aka Azrienoch) is a versatile cultural producer, and what could be termed a visual writer. His animated poems are different from most kinetic typography in that he is the sole author. Two of his poems appear on YouTube: *X vs. O* (2009), poem on a war between two letterforms, and *Minimalism*, a staging of reflections on an abstract painting. Both are graphically rich, witty and fluent, although *Minimalism* appears to conform more to the conventions of kinetic typography, by including mixed fonts and faces, continual movement, variation and frequent flipping of text, whose purpose is to sync imaginatively to the declaiming voice.

Another accomplished example of the genre (despite being only a university project), and one that seems closer in spirit to Futurist poetry and the calligrammes of Apollinaire, is the typographic animation of a verse from the Tom Waits track, 'What's He Building In There?' from *Mule Variations*, 1999, where words take on the

Left:
Stephen Elliget (Stevadore), screenshot from 'What's He Building In There?' Kinetic Typography, 2010

shapes of doors, branches, swings, mailboxes and steps, as the sinister implications of the narrative accrue.
The various animation software programs available to contemporary designers have facilitated the integration of text and image that was being envisaged by the likes of Marinetti in the early twentieth century. A later and far more direct influence on typographic animation is Saul Bass whose innovative designs of title sequences in the sixties established the model for the industry by unifying words, moving images and music.

However, Google lists the (contested) first example of kinetic typography as *Amore Baciami* by Oliver Harrison.

[18] www.oliverharrison.com

It was first made in 1988 as a graduation film in 16mm, and subsequently used in an advert for the Royal Mail.[18] Harrison followed it with *Time*, 1990, and looking at these two films, it seems that both belong as much in the music video category as they do to kinetic typography: while visual words are the subject-matter of the films, they perform only in relation to music,
unfurling hand-in-hand with the melody.

Music, rhythm and timing are key elements in both title sequences and kinetic typography. Although the latter usually uses the human voice monologuing, it still relies on the tempo of speech to deliver the word-pictures on cue, like punchlines.

It could be argued that a form of timing is also present in *A Throw of the Dice*, but here nothing moves, and it is down to the reading mind to supply the pauses and the falls; it is in the way that words are spatialised and modulated by their isolation or emphasis on the page that we evoke a sense of time.

The viewer-reader of motion graphics is provided with not just the timing of words, but also a heightened sense of their spoken-ness. We hear and observe words unfolding in space and time – words that account for themselves visually. But there is the further, compelling illusion that, as the words present and spread before us, we are somehow witness to the moment of writing.

Kinetics and Memetics

Kinetic typography – the text that reads itself visually, aurally and temporally – has established itself since 2006-07 as a distinct and highly videogenic genre. Here is an exciting, inventive, accomplished and ultimately redundant medium that is both rewarding and faintly disquieting.

[19] There are numerous postings of kinetic typography depicting scenes from *Fight Club* (dir. David Fincher, 1999) and *Lock, Stock and Two Smoking Barrels* (dir. Guy Ritchie, 1998).

It is as if no sign can go undecoded, unanchored, unillustrated. In many ways, the point of these typographic packages of pop-poetics is to delight the eye with sustained connotation, to ease the effort of reading, and to keep moving. Everything is hyperactive, all signifiers are on steroids, everything is visible and audible. Familiar and favoured speeches from films[19] are supplied with visual words that are in turn transformed into energetic, typographic performers, acting out meanings figuratively, allusively or arbitrarily. The result is often merely to furnish the written word with a universal and at times multipurpose onomatopoeia.

The irresistible flow of text is indeed kinetic, as it advances, flips, mixes, rotates. It seems less concerned with words as with a

depersonalised dynamism, and the representation or, more accurately, enunciation of speech patterns.
Typography is used almost aphoristically, to pin a phrase, make memorable the one-liner, confirm the dialogue. Ultimately it could be seen to function as a new form of phonetics.

On one level, this typographic genre seems to be bringing about a renewal of reading: in the hands of the new author-designer who makes use of all creative means digitally available, the text will become a *gesamtkunstwerk*. Our experience of words will be at once aesthetic and functional: both beautiful and easy.

On another level, much of it has little to do with reading.
It is primarily oral, and nearly all the words we see are figurative and recycled, rather than literary and original. The authors have generally very little interest in literature, or even typography, but their practice has everything to do with interpretation.

What can be found in the 'kinetic typography' category on YouTube is, for the most part, an array of talented graphic designers (practitioners, students, amateurs) showcasing technical virtuosity, imagination and a keen understanding of advertising. All of kinetic typography is posted in social media, which is part gallery, part chat room, part marketplace and part indefinable cultural space where things happen and there is always feedback on tap.

One significant linguistic development is the emergence of the 'meme' as an Internet unit of momentary, cultural currency.
The word originates from Richard Dawkins' *The Selfish Gene*[20] where he coins the term as a contraction of mimema, 'something imitated or reproduced,' to refer to a unit of cultural selection.

[20]Dawkins, Richard. (1989). *The Selfish Gene*. Oxford: Oxford University Press, p. 109

The Internet meme is essentially a positively-charged cliché, which is traded, developed, elaborated, drawing creative dialogue around it in response. Memes range from obvious commercial plants, sound bites, famed cinematic moments to more original, occasionally hilarious found phrases, picked up and refined with dark or cruel wit in more esoteric chat rooms. With few exceptions, these animations require a common currency content to transact.

Musings on
a Single-Function
Device

At the heart of the debate on the nature of old and new forms of literacy is the fact of the static text and the limits of the page.
What is there is all there is, sequenced and stacked into a cultural

container that is the codex, enough for the mind to convert into meanings, associations, sounds and pictures.

With the rise of hypermedia the book will seem too material and unchanging to the 'post-reader,' too isolated and devoid of functions. In much the way that Cubists saw Renaissance perspective as incapable of describing the changing age, so too are new readers deeming the book unable to process the flux of the present.

The great divide (which can possibly take place within single individuals) has already opened. On the one side, we have the post-reader becoming restless and dissatisfied around books[21] that appear static, solitary and tardy when compared to the socially addictive habits of the computer, which, in contrast, is versatile, instantaneous and connected to the external world. This reader reads in a non-methodical, nonlinear fashion, responding to cues and distractions (hotspots, keywords, textboxes).

On the far side, is the book-reader, perhaps less concerned with the here-and-now, and ready for the long haul of a sustained and anti-social relationship to text. This reader is capable of solitude and interiority, committed to the finite and reassuring physicality of the book, and to its prescribed spaces and fixed sequences.

The seismic shifts in reading are already leading to changes in mental generativity, as Carr[22] sets out: the capacity to retain knowledge, to imagine, and even, conceivably, to be individual and sustain a mental space or 'noosphere' are seen as being impaired by the structural distractions of the Internet. Bolter points out, that 'hypertext and all other forms of electronic writing are participating in the refashioning of our notions of self in the late age of print'[23] while Ong, writing nearly a decade before Bolter, reprises a key McLuhanist theme:

'Technologies are not mere exterior aids but also interior transformations of consciousness, and never more than when they affect the word.'[24]

However, we need to remember that important changes to reading have happened before: word separation, punctuation, silent reading, writing styles, printing, education, newspapers.

Hypertext – like a more successful Tower of Babel – is always being built. The open-ended nature of digital knowledge, with all its expansions, updates and multiple links has had one result for reading: we don't know where to stop. Further readjustments to our reading processes will be inevitable. For Hardison, literature encountered online 'tends to disappear into hypertext like water in a sponge' in a 'process [that] is interactive and discontinuous–almost the opposite of reading.'[25] This disintegration of the text reverberates in other cultural forms as we seek out the 'director's cut' reissue of a DVD, the remixes of famous songs, or pick up the 'author's preferred text' in

[21] Carr, 2010:9

[22] ibid.

[23] Bolter, Jay David. (1991). *Writing Space: The Computer, Hypertext and the History of Writing.* Hillsdale, N.J.: Erlbaum, p. 189

[24] Ong, Walter J. (1982). *Orality and Literacy: Technologizing the Word.* London and New York: Methuen, p. 81

[25] Hardison, 1989:264

a bookshop. The text, as many have proclaimed, is losing its identity and, with it, its authority as it is eased out of its preferred – and obsolete – containers. In this context it becomes hard to imagine how 'the reader becomes the book.'[26]

[26]Carr, 2010:74

It would seem safest to agree with Bolter in his measured and McLuhanist prognostication that the 'shift from print to the computer does not mean the end of literacy. What will be lost is not literacy itself, but the literacy of print, for electronic technology offers us a new kind of book and new ways to write and read.'[27]

[27]Bolter, 1991:2

These new forms of writing are now here – interactive books, electronic readers, kinetic typography – but they may never definitively 'arrive,' for the simple reason that a Gutenberg is always turning up with a new idea, and a new system to propose. But if any form of literacy is established long enough for a poem to appear, one that is hard to navigate, nearly unreadable, and defies all conventions of writing, then we should read it carefully, because, like *A Throw of the Dice*, it may be pointing us cryptically towards another kind of reading.

seekers of lice

Invent the Present: Footnotes

[1] As the Argonauts sought the golden fleece they obeyed Athena's stricture not to forsake the Argo. Individual elements were rebuilt and replaced over the years until nothing remained of the original ship except the name. The text voyages through cyberspace.

[2] Through the worm hole: work entering through a wormhole then existing in different forms.

[3] The only persistent property of the Cheshire Cat in Alice in Wonderland is its smile.

[4] 'A writing machine does not tolerate binary opposition.' Deleuze and Guattari Kafka: toward a minor literature

[5] The physical object thumbed pages flicked through dog eared written on bookmarked heft feel smell paper cut indexed contented signed named inscribed dirty spine sunbleached.

[6] The physical book may be the dinosaur to the e-book's human span.

[7] John Steinbeck wrote in a letter in 1962:

The Morgan Library has a very fine 11th century Lancelot in perfect condition. I was going over it one day and turned to

> the rubric of the first known owner dated 1221, the rubric a squiggle of very thick ink. I put a glass on it and there imbedded deep in the ink was the finest crab louse, pfithira pulus, I ever saw. He was perfectly preserved even to his little claws. I called the curator over and showed him my find and he let out a cry of sorrow. 'I've looked at that rubric a thousand times', he said. 'Why couldn't I have found him?

[8] Christian Bök's work The Xenotext Experiment will infuse a bacterium with a poem using the letters of the genetic nucleotides. This poem will cause a chemical reaction in the bacterium's DNA which will 'write' another poem. The bacterium, the most resilient on the planet, can survive nuclear holocaust, the end of the world as we know it, with the poem inscribed within it.

[9] In Western culture the codex gradually replaced the scroll. From the fourth century, when the codex gained wide acceptance, to the Carolingian Renaissance in the eighth century, many works that were not converted from scroll to codex were lost to posterity.

[10] Read as a flaneur, who looks and walks on, slowing where whe pleases:
 no narrative drive turn on a heel
 the act of contemplation as a loop
 the action and acting of contemplation
 the only requirement is to keep moving to inhabit the world
 not making meaning making maps

[11] Print on demand books can create small readerships or no readership at all. The books for which there is no demand remain in a limbo of potentiality. In 1936 Samuel Beckett sent the manuscript of Watt to Chatto and Windus. They turned it down, having sold only 2 copies of More Pricks than Kicks.

[12] There is a protean transformation of knowledge, a liquidity & porousness, a flow of texts from screen to paper to talks to readings to recordings, subtly or grossly different versions all existing simultaneously.
Let your liquid siftings fall. The authoritative ur-text is losing its hold.

Next Page:
From *Footage Aldgate May 2012* by Seekers of Lice

seekers of lice

¹³ How long does it take for a genuinely new art form to develop? The telegraph freed communication from the constraints of geography. Objective journalism finds its roots in the communicative strictures of the telegraph, which led to transmission of news *without the luxury of detail and analysis.*

¹⁴ The American poet Charles Bernstein argues that codex and text have only recently developed a genuinely original and specific form, the text which cannot be remembered, which exists as a state of continuous reading and which isn't structured round mnemonic features such as rhyme, rhythm, repetition, characterisation or narrative. The written form eventually produced the text written for reading, and for rereading over and over.

¹⁵ The fundamental experience of the text on paper is the reading of it, the direct interaction of the visual, aural (the sound of the inner voice reading or the sound of reading aloud) and oral (the mouth shaping the words, giving voice to the text). These combine in the construction of meaning. In Finnegans Wake, often described as unreadable, the act of reading aloud transforms the text. The sound provides a key to meaning. Always to be in the middle.

¹⁶ Is the fundamental experience of digital text the action of sifting, scanning and filtering, a more purely visual approach to text? The Gertude Stein scholar Ulla Dydo believes that the 'unreadable' Stein texts were written to be scanned and skimmed for the visual pleasure of repeated letters, words and sentence constructions, patterns that do not require literal understanding.

¹⁷ In White Elephant Art vs. Termite Art (1962) Manny Farber, the American artist and film critic, describes termite art as an 'act both of observing and being in the world, a journeying in which the artist seems to be ingesting both the material of his art and the outside world through a horizontal coverage.' He talks about 'the concentration on nailing down one moment without glamorizing it [...] forgetting this accomplishment as soon as it has been passed; the feeling that all is expendable, that it can be chopped up and flung down in a different arrangement without ruin'.

[18] 1960s poetry magazines were made possible by the invention in 1959 of the Xerox 914, the first plain paper photocopier. It enabled multiple copies of pages to be printed off relatively easily and cheaply with the writer/editor able to control the whole process. The pages could then be stapled together and distributed within hours.

[19] 'My heart is in my/pocket, it is poems by Pierre Reverdy.' Frank O'Hara, *A Step Away From Them*.

[20] 'The real technology – behind all of our other technologies – is language.' Norman Fischer

[21] There is a continuous expansion and contraction, a breathing in and out, between the 'informationsuperhighway' and the intimacy of the e-reader or book. An interesting feature of digital technology is the contraction in size; the iPod, smart phone and the e-reader. The intimacy of the experience. Allowing someone to riffle through the playlist on your iPod or the contents of your e-reader is an act of intimacy, putting your soul in someone else's hands.

[22] Miss the dirt. The scuffs and dirt of matter, greasy handmarks, sunbleached spines, cracked bindings, books which fall open at a particular place, stains, dirt as life and life as dirt.

[23] Stéphane Mallarme was one of the first writers to use the integrity of the printed page as a compositional element. The layout of his work on the page and the relationship of white space and black text use the frame to create meaning rather than pouring the text into the book in whichever shape it made. The pdf preserves this integrity, fixes it.

[24] What errors/mis-takes are specific to a technology and feed into the creative process?

[25] Different technologies produce different mistakes. These can be fundamental in the compositional process. The handwritten text

may be difficult to decipher so words get replaced by similar looking words. The similarity of the French words verre and vair enabled Cinderella's slipper to be transformed from glass to squirrel fur in later versions, then back to glass.

The writer composing on a keyboard inevitably produces typos, with the possibility of new words or hints of different words which the writer may incorporate into the finished work. The ease with which u / i /o can be substituted due to their position on the keyboard; or r / t. Mistyping can introduce extra letters which hijack the writer's original intentions. Leopold Bloom contemplates his name on the list of mourners: L Boom. Joyce's use of deliberate *mistakes* was often derailed by printers correcting what they perceived as typos. In Joyce's world language has been infected by the printed word and the easy substitution of letters in mechanical typesetting: Bloom's reply to a question is 'Ness. Yo.'

[26] Artists are continually seeking ways of deforming the conventional, natural mode. Googlefish, the universal translator, distorts and preserves and creates. The results can be close to the word for word translation Walter Benjamin advocates in The Task of the Translator, preserving the strangeness of another language. Clarice Lispector complained that some of the translators of her novels from the original Portuguese removed the prickles from the cactus by translating away her awkwardness. Automatic translators can preserve the awkwardness and roughness of an original.

[27] Linotype mechanised the setting of print for the first time. The process was speeded up dramatically, as urban life also speeded up and writing found new ways to be. Before the invention of the Linotype in 1884, no newspaper in the world had more than eight pages.

[28] Readers had to learn a new relationship with reading to read modernist books like Ulysses and the works of Pound and Eliot. Reading in a machine age without a single viewpoint or omniscient narrator. The difficulty of reading obscure, difficult texts.
The texts require readers with patience, require attention.

[29] The digital age has changed the relationship between writer and reader. The writer's authoritative text is compromised by digital versions which can be changed at will, cut and pasted into different combinations. Plagiarism has been ousted by appropriation.

Everyone writes. Who reads? Who is prepared to, or has the time to read? The accelerated production and dissemination of text online means there aren't enough readers to go round. Text is looked at, skimmed. The reader's main task is to filter out what they decide is noise. The future of the *difficult* text is uncertain. Difficulty requires the acceptance of struggle and work to discover something, it is about doggedness rather than surfing.

[30] Flarf is an avant-garde poetry using digital text.
'Flarf, as it is usually practiced, takes as its raw material the results of Google searches on words or phrases chosen by the poet. The writing that emerges, though heavily edited and reconfigured, typically bears the stamp of its sources, with a special affinity for the *junk language* of online chat rooms, forums, and blog comment streams.'
Franklin Bruno, *Flarf Poetry Bookforum*, July 7 2009.
Original flarf member Gary Sullivan describes flarf as 'a kind of corrosive, cute, or cloying awfulness. Wrong. Un-P.C. Out of control. 'Not okay'.

[31] 'Property relations in Mickey Mouse cartoons: here we see for the first time that it is possible to have one's own arm, even one's body, stolen. The route taken by Mickey Mouse is more like that of a file in an office than it is like that of a marathon runner. In these mankind makes preparations to survive civilisation.'
Walter Benjamin, *The Subversive Mickey Mouse,*
or *Disincorporation Phobia* (1931)

[32] 'It's time also to remark how High Modernism did not outlast transparent technology. Beckett, its last master, already carries it into the intangible realm of information theory. And Beckett... is a bridge to the so-called post Modern... to our present world of enigmatic 'text', of foregrounded codes and redundancies, of microchips through which what moves may be less interesting then the process of moving it elegantly.' Hugh Kenner, *The Mechanic Muse* (1987).

[33] The language of computing, the use of commands and binary logic. The early part of the twentieth century saw a rapid growth in the formal analysis of randomness, as various approaches to the mathematical foundations of probability were introduced. In the mid- to late-twentieth century, ideas of algorithmic information theory introduced new dimensions to the field via the concept of algorithmic randomness. Randomness had been viewed

as an obstacle and a nuisance for many centuries. In the twentieth century computer scientists began to realise that the deliberate introduction of randomness into computations could be an effective tool for designing better algorithms. In some cases such randomised algorithms outperform the best deterministic methods.

[34] In information science, irrelevant or meaningless data is considered to be noise.
In communication theory, randomness in a signal is called *noise* and is opposed to that component of its variation that is causally attributable to the source, the signal. http://en.wikipedia.org/wiki/Randomness 18:42 27.04.12

[35] 1440 the invention of the Gutenberg press and the mechanisation of bookmaking led to the first mass production of books in history in assembly line-style. A single Renaissance printing press could produce 3,600 pages per workday, compared to forty by typographic hand-printing and a few by hand-copying. Books of best selling authors like Luther or Erasmus were sold by the hundreds of thousands in their lifetime. By 1500 printing presses in operation throughout Western Europe had already produced more than twenty million volumes. In the sixteenth century their output rose to an estimated 150 to 200 million copies.

[36] Technologies are the means by which people are re-invented. Marshall McLuhan wrote of the emergence of Gutenberg Man, whose change of consciousness was brought about by the printed book. McLuhan argued that the development of the printing press led to the creation of nationalism, dualism, the domination of rationalism, uniformity and standardisation of culture and alienation of individuals.

[37] He believed that print culture would be superseded by *electronic interdependence*, with humans moving from individualism and fragmentation to a collective identity, with a 'tribal base' – McLuhan's global village.

[38] Tactics for the deliberate introduction of randomness:
Jackson Mac Low's poems used random numbers and computerised selection procedures; John Cage used the I Ching. The Internet is a

random world. The generation of pseudo-random numbers is an important and common task in computer programming. The appearance of randomness is culturally determined.

[39] A theme of conceptual writing is that the world is saturated with text: we don't need more text, we need different ways of arranging the text available. Appropriation is a perfectly legitimate strategy – appropriation without reference to the source. The cut and paste methods of dada, of Burroughs and Gysin, are accelerated and magnified into a methodology which schoolchildren learn and use for their homework.
Originality is in appropriation, a sought text rather than found text. See for example Marjorie Perloff *unoriginal genius: poetry by other means in the new century* (2010). 'Postmodernism is modernism without the anxiety of influence.'
Jonathan Lethem, *The ecstasy of influence: A plagiarism* (2007).

[40] The development of prose is the development of artifice. Poetry was an earlier oral form. Prose had to be invented. Writing is not a natural activity.

[41] Minor forms of literature appear and disappear unnoticed: the note on the door *I missed you.*
In 1944 Dubuffet's Messages these can be deciphered on the newspaper support:
'I will wait for you until 8:00. Come back.'
'The key is under the shutter. Wait for me.'
'That will teach you.'
'The entropic deliquescence of language' (Yve-Alain Bois Ray Guns) has been superseded by the constant present of the text message.

[42] Resulting pressures of new technologies on human behaviour cannot be predicted.

[43] 'The function of form is the conservation of energy'
Stanley Kunitz.
The physical book is a battery, a specific concentrated source of energy.

Romi Mikulinsky

**Reading and Writing
in the Digital Age**

**I.
The Word/Image Bind and
the Shortening of Distance**

In our age of connectability and interconnectivenss, streams of images are intertwined with an overflow of textual data; the ever-changing contexts and multiple platforms construct a world of readable images and legible texts.[1] Words, codes, or metadata, which can be read by humans or machines, have all become potentially interconnected. Moreover, the constant framing and reframing of images and words brought to the creation of endless narratives a certain destabilisation of meanings as every movement or manipulation of images or texts is registered into an infinite archive. The role of images online and in digital publishing has become a key aspect in the contemporary experience of reading; the hyper-connectivity of the digital age accelerated the convergence between words and images. Images are woven into a textual setting being always surrounded by additional information, links and exhortations. As a result new ways of interacting with images and texts have developed. The speed and immediacy that defines the interaction with images and texts today, the facility with which they are produced, distributed and circulated conjure up new sets of relations between the images and text.

This essay examines processes of reading in the digital age and centres upon the development of new relations between technology and its use. The advent of technology turned reading processes into an increasingly layered experience, parallel to the convergence of images and texts. This convergence can be referred to as the word/image fusion into a near-inextricable symbiosis.[2] It is an expression of a broader phenomenon that can be seen in several arenas – amongst which are the acts of writing and reading, writing and publishing, the interstice between readers and writers, and man and machine. In all of these arenas the distance has been shortened, both spatially and temporally.

[1] Text, from Latin 'textus', means style, the tissue of literary work (literally that which is woven), web, or texture. Vilém Flusser writes that 'Etymologically, the word text means a textile and the word line a linen thread. But texts are unfinished textiles: they consist of lines (the woof) and are not held in place by vertical threads (the warp) as a finished textile would be' (Flusser, 2011:5).

[2] As Jennifer Allen and Dominikus Müller put it there are several expressions of the symbiosis between texts and images: 'images in the digital age are literally written and read in algorithms – there has been a change in the way text and image appear on the Internet.
That also means a change in the status of the image itself, which ceases to be a likeness and starts to become an action.'

For media philosopher Vilém Flusser the relationship between texts and images is a crucial question for history. He delineates the struggle between the two as beginning in the middle ages with Christians, faithful to the text, set against idolaters or pagans. In modernity the two were positioned one against the other with textual science against image-bound ideologies. Already in 1983, years before computers became omnipresent, Flusser envisions texts and images drawing closer to each other: 'images become more and more conceptual, texts more and more imaginative. Nowadays, the greatest conceptual abstraction is to be found in conceptual images (in computer images, for example); the greatest imagination is to be found in scientific texts.'[3] Flusser elaborates on the mutual dependency of the two entities – 'texts admittedly explain images in order to explain them away, but images also illustrate texts in order to make them comprehensible […] In the course of this dialectical process, conceptual and imaginative thought mutually reinforce one another'.

[3] *Towards a Philosophy of Photography*. (trans.) Matthews, Anthony. London: Reaktion Books. Flusser, Vilém. (2000:11).

Whether or not the mutual reinforcement of texts and images is an inevitable process, one consequence is an anxiety about the presence of the machine or the automatic in the human sphere. The fear that accompanies the growing dependency on machines (or external devices) is hardly a new phenomenon; Socrates himself lamented the invention of books in the 'Phaedrus,' that, according to him, 'create forgetfulness' in the soul by encouraging readers to blindly trust 'external written characters' instead of remembering themselves.[4] If we are to remember that the interface with books and our reliance on external devices were criticised already in Socrates' time, the contemporary outcry about the end of books can be perceived differently.

[4] Socrates. *Phaedrus*. In: Cooper, J. M. (ed.) (1997) Complete Works. Indianapolis: Hackett, p. 481

The convergence between words and images may be best exemplified by digital photography. Digital photography today stands out as instigating several unique interactions between texts and images, interactions that also illustrate the shortening of distance between reading and writing (by both man and machines). The metadata[5] produced with the creation of digital photographs and the additional data added with the uploading of digital photos to the Internet call attention to the richness of the layering of texts and images in the digital age.

[5] The term metadata has several definitions, but for the purposes of my discussion, I refer to metadata or descriptive metadata that are 'data about data content' or, as the Wikipedia entry specifies 'data providing information about one or more aspects of data.'

II.
New Forms of Story-Telling

The writing and publishing processes have become almost entirely digital – with the book assuming a physical form only at the very end. Questions about how books are written and how the advent of

technology affects reading and the interaction with books are urgent ones. It is evident that reading is becoming more and more mediated; No one was surprised by Amazon's announcment that e-books sales surpassed printed book sales.[6] But is technology changing the fundamentals of writing and reading? And what are its uses and effects? The first example I offer here was written in 1894 and depicts various aspects of man and machine interface within the publishing industry and its impact on the reading and writing processes.

Written by Octave Uzanne with illustrations by Albert Robida, *The End of Books*[7] directly addresses the future of publishing, reading and authorship. Published as part of a series of short science fiction stories in a French newspaper, it is a reaction to anxiety about the collapse of the traditional knowledge structures, exposing the loss of control when it comes to the 'containers' of knowledge and their stabilisation.[8] *The End of Books* describes a post-literate society in which books are replaced with phonographs, and writers (or narrators, storytellers) are valued for their storytelling skills and quality of voice instead of their writing talent. According to this prediction, in the future, printed books will be redundant, and reading – or listening – will be quite different from reading as we know it. In the short story, authors (now called narrators) deposit their voice and story in the patent office where books (now called phonographs) are recorded on cylinders that enable immediate distribution to the readers. This kind of reading (or listening) is praised as much more hygienic, democratic and liberating since it frees the eye from the fatiguing role of reading. Consequently, this new form of reading becomes popular and omnipresent.[9]

The illustrations of the text depict the ease of producing and distributing the books/phonographs and the 'ineffable delight' of the readers/listeners.

This vision of the future according to Uzanne and Robida features a world with no publishers, in which the distance between readers and writers (or listeners and narrators) is eradicated, with phonographs supplying accessible and affordable entertainment present at every street corner – by providing an auditory experience – for, the short story concludes:

> Either the books must go, or they must swallow us up. I calculate that, take the whole world over, from eighty to one hundred thousand books appear every year; at an average of a thousand copies, this makes more than a hundred millions of books, the majority of which contain only the wildest extravagances [...] Our social condition forces us to hear many stupid things every day. A few more or less do not amount to very great suffering in the end;

[6] Richard Adams cites a company statement from January 2011: 'Amazon.com is now selling more Kindle books than paperback books. Since the beginning of the year, for every 100 paperback books Amazon has sold, the company has sold 115 Kindle books. Additionally, during this same time period the company has sold three times as many Kindle books as hardcover books.' Adams writes that it won't be too long at this rate before 'Gutenberg's offspring is dethroned.'

[7] Both the English version and the original French version are available online including the illustrations. (http://ebooks.adelaide.edu.au) Today this short story is considered visionary for its description of the publishing industry and relationship between authors and readers.

[8] David Weinberger writes that in the digital age, knowledge lies in the links between data and info; for him the web is a more accurate reflection of human knowledge than print media could ever be.

[9] According to Uzanne and Robida not only the writing process will be easier and automated but the distribution as well. The new system will also promote the sales of classics such as Dumas or Dickens: 'At every open place in the city little buildings will be erected, with hearing tubes corresponding to certain works hung all around for the benefit of the studious passer-by. They will be easily worked by the mere pressure of a button. On the other side, a sort of automatic book-dealer, set in motion by a nickel in the slot, will for this trifling sum give the works of Dickens, Dumas père, or Longfellow, on long rolls all prepared for home consumption.'

> but what happiness not to be obliged to read them, and to be able at last to close our eyes upon the annihilation of printed things!

The desire to be rid of fatiguing reading and to liberate the eye from the tiresome task is only one reaction of the overflow of information has threatened to overwhelm humanity. The exaggerated expression of relief at the prospect of print's annihilation should be taken as a cynical, deliberately radical reaction of two bibliophiles (for both Uzanne and Robida were writers and men of letters, deeply involved in publishing).

The Automatic Library

III.
Computers Writing Poetry for Computers?

Long before the inventions of Kindle or e-publishing, experimental literary movements challenged the traditional hierarchy between readers and writers and responded to the technological circumstances of the production of writing. With new possibilities for storytelling inspired by new technologies, the shortening of distance (be it between readers and writers or between man and machine) created paths for writers and readers to carve out and experiment in. The networked society, with its openness, disruptions, and abundance of data, invites experimentation and calls for additional ways to engage with narratives, words, and images. Readers are thereby prompted to be more active not only in deciphering the story, but also often in reacting or even (re)writing it. Contemporary conceptual writers and poets together with programmers[10], go beyond the material qualities of the page, the book, and traditional definitions of writers and readers reacting to the technological advent. With appropriation and repurposing, protesting against or embracing aggregation or 'robotised automation of creativity' – readers and writers expose the conditions of reading and writing.

[10] Christian Bök asks 'how do we write poems in a world where a spambot, like @horse_ebooks, gets to write all the great lines...?'
When bots start writing literature can they ever be considered operating autonomously? Could poems ever become independently from their maker, and who is the poet? The bot or the programmer that wrote the algorithm?

The poet and now conceptual artist, Kenneth Goldsmith, refers to himself as a 'word processor.' Famous for his experimental poetry and 'Uncreative Writing,' Goldsmith writes deliberately unreadable books compiled of transcriptions of weather reports, twenty-four-hour traffic cycles or baseball games radio broadcast (*The Weather* (2005), *Traffic* (2007) and *Sports* (2008) respectively). But what Goldsmith may be most famous for is his monumental ode to 9/11 *Day* (2003), a tome in which he retyped an entire edition of the *New York Times*, including all the ad copy, cover to cover.

Goldsmith's subversive publications prompt a rethinking of the acts of writing and reading; for him writing means moving language from one place to another, turning human writing into something more similar to machine writing, at the cost of making it less suitable for human reading. Goldsmith stresses the significance of responding to the new condition of writing and to the overflow of information:

> [...] it seems an appropriate response to a new condition in writing: with an unprecedented amount of available text, our problem is not needing to write more of it; instead, we must learn to negotiate the vast quantity that exists. How I make my way through this thicket of information – how I manage it, parse it, organize and distribute it – is what distinguishes my writing from yours.

Endeavors like Goldsmith's call on us to not only reconsider the form, format, and platform of texts but also to accept the exposed flexibility of writing and reading. Even though Goldsmith encourages and teaches 'Uncreative Writing' as a university course his works can be read as examples of conceptual art celebrating new structures and platforms that man-machine interfaces introduce.

IV.
Descriptive Camera

The rise of the image as a virtual, spatial image turned digital images to 'ubiquitous tools within the global reorganisation of labor' as Grau and Veigel assert. Matt Richardson's 'Descriptive Camera' is an explicit reaction to the surplus of images. Created for a Computational Cameras class at New York University, this prototype produces written descriptions rather than photographs.
In this experiment, Richardson's camera outputs textual descriptions instead of images. Richardson's prototype was influenced by the metadata cameras produce; wishing cameras could do more than simply state the date, time, camera settings (and often the location), he envisions an apparatus that will enable us a better organisation system for our photo collections.[11]

Metadata may not be a term familiar to everyone, but it is omnipresent online. The term 'metadata' describes other data, providing information about a certain item's content. By describing the contents and contexts of data files, the quality of the original

[11] More information can be found on Matt Richardson's blog.

files is greatly increased. As such, they can be stored and managed in a database, often called a registry or repository. However, it is impossible to identify metadata just by looking at them because humans cannot differentiate between data and metadata in the same way that computers can. Metadata in digital photography can include both man-made and machine-made data. One may write into a digital photo copyright and contact information in addition to descriptive information (such as keywords), on top of the data the camera itself generated. On photo-sharing services like Flickr and Picasa, the aggregation of metadata and textual information around photographs is notable. The websites interfaces have been programmed to show both man-made and machine-made metadata.

Digital photographic images therefore feature a certain twist to the idiom saying that 'a picture is worth a thousand words.' Each photo may be accompanied with thousands of words – tagging, description, title, comments are all added to the automatic data.

In this age of hyper-connectivity, the photographs are weaved and presented within different contexts be it with other photos taken at the same time, same location, by the same photographer, or sorted according to key words. The clusters of photographs can be organised according to arbitrary or a meticulous organising principles unraveling potential narrative forms. The descriptive information and metadata produce endless combinations and narratives inviting literary, artistic or technological uses.

Returning to the 'Descriptive Camera,' Richardson's mechanism enables the transformation of images into text, but does so provocatively. This is not a camera mechanism that autonomously produces descriptions of the pictures it takes and publishes them instantly, here the thermal printer outputs the resulting text relying on mediation. In order to receive a textual description of the depicted scene, Richardson turned to 'Amazon's Mechanical Turks' – a service allowing developers to submit a Human Intelligence Task (HIT) for workers on the Internet to complete. Outsourcing the process – Richardson set the price asking the results to return promptly – with a HIT price of $1.25, results are returned typically within six minutes and sometimes even faster. He has taken pictures of negligible scenes and the description he has received reads: 'Looks like a cupboard which is ugly and old having name plates on it with a study lamp attached to it.' Or: 'This is a faded picture of a dilapidated building. It seems to be run down and in the need of repairs' (mistakes are included in the original).

This project may be read as a conceptual artwork protesting against outsourcing, the abstraction of the production process and the division of labor. At the same time it may also be considered as a humorous reaction to the increase in the amount of files, be they textual or visual. The poor quality of the images and the sarcastic tone of some descriptions (together with the spelling mistakes) enable a dismissal of the 'Descriptive Camera' as a serious, critical action. Without the mechanical Turks – the people behind the textual descriptions – the 'Descriptive Camera' could not operate as a transcoding device. It can be interpreted as a contemporary version of the chess-playing automaton from Walter Benjamin's 'On the Concept of History,' which is actually a hunchback dwarf operating a puppet in a Turkish attire. It can be also said that Richardson is conducting a collaborative project of which the contemporary mechanical Turks are not aware. Richardson can be considered as the editor (or producer, or curator), in charge of a group of writers working semi-automatically in the shadows, and as a result of their work the image is covered, or replaced with texts. The 'Descriptive Camera' not only provides astute commentary on issues of originality, ownership, authorship or copyrights but sheds light on automatic writing, automatic image-making and the interstice of the two. The interaction between words and images, and the shortening of distance between textual and visual entities present themselves in

the very form of machine-made writing (especially those produced by cameras). The processes of reading, writing, publishing and distributing are changing and new sets of relations are introduced in the digital, virtual space of the web. The power of aggregation to create narratives for humans to read may not yet be considered as literature – but it can be easily argued that the new interfaces create narratives. Goldsmith's experimental poetry and earlier attempts of automatic writing (for example, by Surrealist writers or more recent responses for machine-writing) herald the creation of a new literary era in which computers may write poetry for computers.[12] Richardson's 'Dercriptive Camera' can join the lineage of 'robotized automation of creativity' that simultaneously inquires into its own technological circumstances.

[12] Goldsmith wonders whether 'all texts in the future be authorless and nameless, written by machines for machines?'

V.
The Book Reads Us
The Data-Driven Approach

The current transforming and expanding of the book cater also to publishers that have only just begun to explore potential uses for e-reading data. For centuries, reading has largely been considered a solitary and private act, taking place in the readers' minds. But the rise of digital books prompted a profound shift in the way we read, transforming the activity into something measurable and to an extent public. James Bridle writes that Amazon is in fact an infrastructure company, not a book, retail, or Internet company. According to Bridle, from the outset, Amazon sought after data and acquired statisticians, analytics, data miners and hardware technicians.

Alexandra Alter reports in an article entitled 'Your E-Book is Reading You,' that the shift to digital books motivated digital start-ups to pursue and analyse the massive amounts of data collected by e-reading devices and reading applications.[13] Kindle users sign an agreement granting the company permission to store information from the device – including the last page users read, their bookmarks, highlights, notes and annotations – in its data servers. Moreover, Amazon can identify the popularity of certain passages of digital books, and shares some of this data publicly on its website through features such as its 'most highlighted passages' list.

'You very rarely get a glimpse into the reader's mind,' says David Levithan, Scholastic's publisher and editorial director. 'With a printed book, there's no such thing as an analytic. You can't tell which pages are dog-eared.' The physical marks on physical books are replaced with e-readers devices like Kobo that track the time readers spend on particular titles and whether they finish the book. The publishers, of course, are not getting a glimpse into the reader's

[13] See Jason Pontin's article on MIT's *Technology Review* from May 7th, 2012 (http://www.technologyreview.com/news/427785/why-publishers-dont-like-apps/)

mind but abstract data on an abstract idea of a reader. The data gathered merely refers to patterns of e-reading and e-books usage. The best-selling books figures have now expanded to include statistics about paragraphs and sentences that have been highlighted most. It is not that reading has become commodified, capitalised, or abstracted, but that the publishing industry can take advantage of the e-readers to track reading patterns.

Some worry that a data-driven approach could hinder the kinds of creative risks that produce great literature and dread the moment that readers' feedback will be incorporated into the print version. Such reading processes and interactive digital books are already available today – Coliloquy's digital books, for one, have a 'choose-your-own-adventure'-style format, allowing readers to customise characters and plot lines. The company's engineers aggregate the data assembled from readers' selections and send it to the authors, who can adjust story lines in their next books to reflect popular choices. How is reading different, then, from other forms of culture like the cinema industry, in which several versions of final scenes are available for the audience to choose from? Is it because the reading experience is traditionally considered as a solitary, somewhat solipsistic experience? Another criticism levied against publishers is that instead of developing new avenues for the book, they are turning it into commodity that invites consumer participation – similarly to other entertainment markets. Whereas new ways of interacting with textual content have appeared, invitations to the reading community to participate in the writing process are scarce. But are collaborative books the future of literature? Is the reading process to be replaced by writing? Or, perhaps, there are now more writers than readers?

[14]Flusser, Vilém. (trans.) Roth, Nancy Ann. (2011). *Does Writing Have a Future?* Minneapolis: University of Minnesota Press. p. 37

Despite the shortening of distance in several arenas outlined here, it is possible that literature has always been interactive and demanded the participation of readers. Flusser calls literature a 'universe of texts' that is always half finished, demanding completion from the reader: 'the writer weaves threads that are to be picked up the receiver to be woven in. Only then does the text achieve a meaning. A text has as many meanings as it has readers'[14]. If literature is interactive, it can be argued that books are interactive objects that enable readers to take the authors' words into their imagination.

To conclude, the changing body of knowledge, the abundance of words, images, data and narratives and their hyper-connectivity, all affect human memory, processes of writing and reading and the spatial experience of books. The interconnections between readers and writers, humans and machines, and the shortening of distance between words and images carve new forms of engagement with texts. The man-machine interface and the layered, online reading also bring forth a conversion between seeing, hearing, and touching that affects the centers of meaning of books, or of the narratives that can be included in the new literary spaces. Readers' wish to immerse

themselves in the expanding paths of the book (no matter if online or printed), to lose themselves among its pages, is not going away. The new forms of storytelling, and the potential new writers of literature may all contribute to the evolution of literature and to books, rather than bring its end.

Bibliography:

Adams, Richard. (2011)
Amazon's Ebook Sales Eclipse Paperbacks for the First Time.
In: The Guardian.
At: http://www.guardian.co.uk/world/richard-adams-blog/2011/jan/28/amazon-kindle-ebook-paperback-sales.

Allen, Jennifer and Müller, Dominikus. (2012).
Doing Things with Images.
In: Frieze d/e. issue no. 4, Spring 2012. At: http://frieze-magazin.de/archiv/kolumnen/vom-abbild-zur-aktion/?lang=en.

Alter, Alexandra. (2012)
'Your Ebook Is Reading You.'
In: *Wall Street Journal*. Dow Jones and Company. At: http://online.wsj.com/article/SB10001424052702304870304577490950051438304.html.

Benjamin, Walter. (2003).
On the Concept of History.
In: *Selected Writings, Vol. 4.* (eds.) Eiland, Howard and Jennings, Michael W. (trans.) Jephcott, Edmund et al. Cambridge: Harvard University Press.

Bök, Christian. (2012).
The Jubilee of Poetic Crises. In: Poetry Foundation.
At: www.poetryfoundation.org/harriet/2012/04/the-jubilee-of-poetic-crises.

Bridle, James. (2012).
From Books to Infrastructure.
In Domus 958. May 2012. At: http://www.domusweb.it/en/design/from-books-to-infrastructure/.

Goldsmith, Kenneth.
It's Not Plagiarism. In the Digital Age, It's 'Repurposing.'
At: http://chronicle.com/article/Uncreative-Writing/128908.

Grau, Oliver and Veigl, Thomas. (2011).
Introduction: Imagery in the 21st Century.
In: *Imagery in the 21st Century*. Cambridge: MIT Press.

Wikipedia: The Free Encyclopedia. (2012)
MetaData.
Wikimedia Foundation, Inc. At: http://en.wikipedia.org/wiki/Metadata.

Uzanne, Octave. (1895).
La Fin des Livres.
In: *Contes Pour les Bibliophiles*, Libraires-Imprimeurs Réunis, Paris, 1895. At: www.hidden-knowledge.com/titles/contesbib/lafinlafindeslivres.

Uzanne, Octave. (2012).
The End of Books.
In: *Scribner's Magazine 16* (1894). pp. 221-231. At: http://www.bodley.ox.ac.uk/djp/uzanne.

Weinberger, David. (2011).
Too Big To Know: Rethinking Knowledge Now That the Facts Aren't the Facts, Experts Are Everywhere, and the Smartest Person in the Room Is the Room.
New York: Basic Books.

Daniela Cascella

En abîme: a Reading

The following text is an extract from Cascella's new book *En abîme: Listening, Reading, Writing. An Archival Fiction* (Zer0 Books, 2012)

In Rome today I walked, from the Protestant Cemetery to via Appia. Across trains shrieking and crowds rumbling in the streets, across the uneven rhythm of sirens, the roar of engines, the ceaseless hissing of people's iPods stretching like filigree, across the coarse texture of the city noise, a train of thoughts unwinds along my journey.
With great lucidity I recall a certain painting from the sixteenth century and with it the stupor that overcame me when I first saw it in a book at school. A *Deposition*: my eyes first encounter those of the young man who holds not just the heavy body of Christ, but the entire composition. No cross appears in the picture: this painter always hides the props. It seems that he does not need any architectural or structural grip to state his vision. All exists on the surface. The sky is defined only by a little cloud; only by a pale bit of ground, the earth. The colours one would expect in a landscape are transposed within the shapes of people: not only in their clothes but also in their skin, as if to reinforce the flatness of this surface and the non-hierarchical arrangement of its patterns.
A face is scarlet as the burning of a silent fever, another yellowy green as of dry leaves. Pallid, pastel, pain-stricken poses seem to fix these figures in a cloud of melancholy rather than in the pangs of loss. Only their glances flee. No angular lines: all is soft curves, yet caught in unnatural poses. The modulation of hues and tones calls for focus and displaces. The contours do not constitute the volume of the forms, but prevent them from gaining volume.
This is not painting and movement, this does not hint at sculpture and monumental balance. Classical forms here are devoid of any depth; they exist in their spiralling rhythm. This picture is resolved in the tempo of its shapes and this is a painter of visual poems.
The figure of Christ is bent in a double curve and swollen.
His torso, a lump of pink flesh. The face is not that of an eruptive cadaver but of a still body. Against a barely-there sky, at some point this entire surface seems to bow down, almost to lean toward me. None of the ten figures in the scene, spiralling, none of them keeps watch over Christ: either their eyes are averted, or they look at me out of the surface, stuck in their impossibility of roundness.
The Virgin wears a cloak of the colour of the sky: there is no real sky in this painting, the sky is in her cloak. She is stuck pensive in her

hushed lyricism. Maybe she is just about to sob.

The *Deposition* by Pontormo, kept in the church of Santa Felicita in Florence, was revisited by Pier Paolo Pasolini in a tableaux vivant featured in his short 1963 film *La ricotta*, shot in a site off via Appia in Rome.

In Pontormo's painting each face and each figure is arranged within the logic of the plane and evened out in an appearance of sublime grief. In Pasolini's film the sublime grief descends back to earth and the flatness gains volume out of the manners and the expressions of the people enacting the scene: the poor, the prostitute, the rich actress, the old man, all with their faces and postures, most of all with their direct presence. Human, and yet removed: *La ricotta* is a short film staging the shooting of a film, where the representation of the Passion of Christ is interwoven with the story of hungry Stracci, an extra who ends up being crucified – both literally, and symbolically. Orson Welles plays the film director, Pasolini's actors of choice play the real people who play the saints and the real people in the Passion, the Roman suburbs play a scenario of golden stillness. *Be still!*, shouts the voice of the director to the people in the film, who are staging the tableaux vivant reproducing Pontormo's painting. *You can't move, you are the figures in an altarpiece!* And yet they move; and yet the close-ups of the camera capture their most human gestures, they pry on the moments where hieratic poses merge into ordinary expressions, where solemnity is touched by distraction. Then the entire construction falls down, clumsy, and everyone laughs. Pasolini's oxymoronic vision spans the two extremes; it distils the innermost essence of human nature into a glimpse of beauty, soon to be corrupted and to fall apart. In his representation of Pontormo's painting he reveals the tangible and the unspeakable together, as one shakes the other in a vision of stillness before crumbling down.

Ghosts on via Appia this morning. Twenty degrees, rain and damp. Catacombs of Saint Callixtus, the archives of the primitive Church. Ninety acres of land, four levels of subterranean galleries twelve miles long. Half a million tombs. Cemetery of Saint Callixtus, Crypt of Lucina, Cemetery of Saint Soter, Cemetery of Saint Mark, Marcellianus and Damasus, Cemetery of Balbina. And when the sun falls down the pine trees I still walk on these stones and there is a humming coming from below the catacombs and these slabs of history. It whispers death along this evening, it breathes in, it breathes out, in, and out, following me chasing me out of this still city of tombs. This still dead city of tombs is chasing me, I walk. Up to this very moment walking, listening, recalling.

I return to via Appia and to those Roman aqueduct arches, and to the mellow suburban countryside on a hot, rainy morning, November 2010. Once it was August, the year 1995, the heat unbearable, the black silhouette of the Cecilia Metella Mausoleum and the maritime pines drawing a silent backdrop to the early evening walk, that you and I had decided to take. We'd spent the whole midsummer day driving around the ring road of Rome, in one direction and backwards, filming – against the boredom of that Roman summer and against that whole year, as a double noose holding and hanging that whole year. We'd spent the whole mid-summer day driving around the ring road of Rome, in one direction and backwards, listening – in the extreme sunshine and in the lethargic pace of Roman summers, car windows open wide and music full blast, until the texture of those sounds reached and merged with the melting lights.

It arrives as a piercing signal, a ruthless clasp of frequencies pointing right at the essence of rhythm. It arrives as the sound of a new disquieting language; as a rhythmic pattern and oscillation devoid of any reference, other that the push-pull of sound you feel in your body, and the grip of our sonorous now. A bony creature is dancing along the broken structures of audio tracks, built upon the sonic detritus of what once was called techno. Stark on a sensorial plateaux, a thousand needles pierce this sonorous now. Subtle, severe, insidious: here is a plus, here is a minus. A plus, a minus, a minus. Then come the bass sounds, to the earth and up from the earth. Don't tell me these sounds are cold. If something resounds here, it is a shivering body: the body of rhythm exposed in its nerves, in the contractions that keep it alive. It might be mutilated by the cuts of this sonic blade but it is always there, in its presence and denial: a plus, a minus.

I return to via Appia, with you and it is evening. We walk along the stone-paved street from twilight into night, listening to noises sifted from the sheltered villas. A knot of voices, smells, slivers of light. All the buildings, pines and stones narrated by the daylight have crumbled down into a storyless black. Across the metal bars of gates and the tall brick walls the night is here again.

A low hum propagates, made of the same substance of the heat. Our blinded eyes and our deafened ears hope to see a new vision and chase a new melody.

I return to via Appia this evening and I'm lonely.

Arthur Conan Doyle set one of his *Tales of Terror* just around here, *The New Catacomb*. *The great Aqueduct of old Rome lay like a monstrous caterpillar across the moonlit landscape,* he wrote. This evening the great aqueduct of old Rome in the moonlight doesn't look much like a monster, but as a tamed force. I walk back, alone and toward home.

I enter the Basilica dei Santi Quattro Coronati and listen to the enclosed nuns as they sing the Vespers. Even the stones are drenched in the void of this confinement. What is this voice whispering muddled tunes into my ears?

I return to via Appia, and to those Roman aqueduct arches and the mellow suburban countryside, following the steps of

Nathaniel Hawthorne and Herman Melville. I am on their traces along the old Roman road, and as I walk I engage with them in a series of fictitious interviews.

I ask Melville of an entry in his Roman diary, March 1857: *Walk along the walls outside. Solitude & silence. Passing gates walled up. Perfect hush of all things.* This morning he is a reminder: of the time of words when they take time to resound or seep through the mind, the time of thoughts as they take shape into words, the time of actions kept inside words. Everything seemed gathered, concluded; it now opens up again and draws a new horizon. It all has to be part of some other yet uncovered landscape.

I ask Hawthorne of an entry in his diary, 23 October 1858. *What now impresses me is the languor of Rome – its nastiness – its weary pavements – its little life pressed down by a weight of death.*

Did he know this weight is even heavier today?

Between these unspoken interviews, loaded with memories and echoes, and sounds recalled from reading, I do not feel any loss in the absence of my interlocutors. Maybe I just want to be in that silence, in the time of a *recordare*. To record, to recollect.

Typical Roman-noon white light. Metallic noise. Shall we descend? Let's go. Haze and dust and more noise. *The underground of Rome is unpredictable. Here the underground is made of eight layers. We are not just builders, we need to mutate into archaeologists, into speleologists.* Tunnels underground. *We are now travelling underneath the Appio quarter.* Tunnels coiling down. Clangour. *We are under via Appia Antica, near Porta San Sebastiano.* A row of people wear red helmets, faces covered. *Here is a necropolis with four hundred skeletons.* Third layer. The clangour thins down to a hiss. Then a roar again. *Another void cave has been found.* Deafening noise. *It is a very big void that's been detected.* I HEAR AN APPARITION AND ITS COLOUR IS WHITE. The hand of the engineer touches the wall and probes it intently. *Start the milling cutter.* A high-pitched engine noise is repeated in a stubborn pattern. The milling cutter looms. OUT OF THIS PERENNIAL DARKNESS A SPARKLE GLEAMS, IN MY VISION HOURS UPON HOURS PULVERISE INTO DUST, THESE FIGURES COMPOSE THEMSELVES IN A PARADE OF DEATH, I HEAR AN EXPLOSION FAR AWAY THEN ALL IS SILENT, AS A GATHERING OF DUSTY CLOUDS LOOMS OVER THESE FAKE HORIZONS. I HEAR AN APPARITION AND ITS COLOUR IS WHITE. Now the camera shows an underground cave immersed in whitish

light, in contrast with the earth-coloured hall where the workers stand. The engineer seems to faint. Ancient wall paintings all around. SOMETIMES, FROM THE FRESCOES AND PAINTINGS, THEIR FACES STARE AT US. FROM BOOKS THOUGH, YOU HARDLY EVER HEAR THEIR VOICES. As the milling cutter drills a hole, a gust of wind hisses through the void halls. *A Roman house, from two thousand years ago! Down.* Descend. Still white sculptures, a hiss again. A procession of figures is pictured on one of the walls. A mosaic face on the floor, underneath a shallow pool of water. Half-cracked faces loom from the vaults. Those faces stare at us as they are being stared at. A moment of recognition. The faces in the wall paintings begin to dissolve. The air from outside destroys the paintings, up to that point preserved in the balanced air of their being locked in. *Do something, do something!* The faces dissolve into a dusty whitish blue. THAT LITTLE POINT OF WHITE NOW SWELLS UP AND PRECIPITATES IN MY VISION AND IT MAKES THE BLACKNESS FLOURISH AGAIN LIKE A NEW CLOUD, THEN IT DISCLOSES A SUN SHEDDING LIGHT ALL OVER. A LUMINOUS NEBULA OF TINY POINTS DRIZZLES LIKE A WARM RAIN, IT FALLS ALL OVER THE THIN WHITE COLUMNS UNTIL A VEIL OF DARK AND POWDER COVERS ALL, UNFORGIVING. I HEAR AN APPARITION AND ITS COLOUR IS WHITE. Then the hiss of the wind only, and I'm watching Federico Fellini's *Roma*.

And I'm watching Rome. Melting lights and bursting knots of noise: November. On a damp late November day I descend to meet more wall paintings, in the Domus Aurea. As I walk down, I feel close to something from which I'd kept away. Gone is the time of hiding. *Stay close to the abyss.* A forceful movement arises from the past, a vortex jolts out of a primordial eye in this cave. All the rest now has to do with living up to this, close to the abyss. I heard an apparition and its colour was black. Have you ever seen the edges of these figures? Have you ever seen their eyes? They form a fraying frame, an ersatz reminder of rotting icons, with no edge other than these walls. Their faces scream bordello. They disappear beneath the surface. I heard an apparition and its colour was black. Ghosts in this hall, a dome inside. And as the howling and the screaming clear away of this heavy night, I hear the pace of a slow *Kyrie* unfold. My words record the eroding howl, its closely muffled verse. Animal verse, outside verse. I heard an apparition and its colour was black. Its hiss is on my heels calling for me, calling me out of this dead city of tombs. This dead city of tombs is chasing me, I walk. Up to this very moment walking, listening, recalling.

Going out, to the surface, I think of Henri David Thoreau and of one point of *Walden* in which he wrote that, no matter where he found himself, in his walks he always headed West. My words and my walks always point South–East. As I exit the Domus Aurea I look over the pine trees down toward via Appia, across dishevelled Mediterranean shrubs, as if the only way out was my sense of direction, while the rest crumbles away to a pre-language made of hiss, gushes and half-guessed formulas. As I walk South-East, heading toward a cemetery, some verses return: a voice returns to via Appia. It speaks of watching the twilights and the mornings over Rome as acts of Posthistory, to which I bear witness, for the privilege
of recording them
from the outer edge
of some buried age.

Bibliography:

La ricotta, Pier Paolo Pasolini, dir. (1963), in Ro.Go.Pa.G., Roberto Rossellini, dir. (1963).

Melville, Herman. (1989). Journal 1856-57. In: *The Writings of Herman Melville, vol. 15*. Evanston and Chicago: Northwestern University Press and Newberry Library.

Hawthorne, Nathaniel. (1980). *The French and Italian Journals*. Woodson, Thomas (ed.). Columbus: Ohio State University Press.

Conan Doyle, Arthur. (1930). *The New Catacomb. In: Tales of Terror and Mystery*. London: John Murray, p. 67.

Roma, Federico Fellini, dir. (1972).

Pasolini, Pier Paolo. (1964). Poesie mundane. In: Poesia in forma di rosa. (2001). Milan: Garzanti, p. 24

Marco Bohr

Appropriation & Voyeurism in Self-Published Photobooks

The images of this article are represented in colour in the Reference Images section on pages 186-188

Early drafts of this paper were published in different segments on Marco's blog at visualcultureblog.com

In the last few years a growing number of artists and photographers self-publish photobooks in an attempt to make their work visible while bypassing more 'traditional' publishing routes. The popular website Blurb.com is perhaps the best-known platform on which photographers can upload their work and create a book that customers can purchase directly from the Blurb website. Instead of printing hundreds of books all at once, many of which might never be sold, Blurb prints books on demand and thus reduces the risk of over-production to both photographer and publisher. This system bears similarities with the just-in-time production philosophy introduced by the Japanese carmaker Toyota – auto parts are only delivered once they are required in the production process, which, in turn, reduces the cost for storage, rent, insurance and so forth.

In the same year that Blurb was incorporated in 2005, Google introduced an early version of Google Earth, which proved to be an instant hit on the Internet. The application allows users to view and zoom in on satellite images of the Earth. While initially Google Earth had to be downloaded and took up a lot computer memory, the service eventually expanded into a user-friendly and easily accessible web application. In parallel to Google's stratospheric economic growth, in 2007 the company introduced Google Street View, which allowed users to view their environment more up close and enter 'street level'. First introduced in major U.S. cities but quickly expanding to most parts of the industrialised world, Google Street View images are produced from a camera with nine lenses mounted on top of car that drives at slow pace down the road. These images are then digitally stitched together in an attempt to produce a seamless representation of our environment. The growing network of images in Google Street View allows users to virtually traverse the world from the comfort of their own home. As the network of images grew, users ventured further and further to 'discover' the world as recorded by Google.

It was only a question of time until the worlds of self-publishing and Google's ever-expanding image database would collide. In this paper

I focus on two distinct case studies in which, firstly, an artist has appropriated images from Google Earth or Street View for their own artistic purposes, and secondly, these images were then reproduced in a self-published photobook on the Blurb platform. In spite of the exponential growth in images from the Internet, the artists discussed in this paper appear to find an aesthetic and conceptual order in images – an order which is ultimately reinforced in the very format of the book.

O Campo
by Joachim Schmid

The German artist Joachim Schmid – well-known for appropriating images from sometimes bizarre sources – was an early adaptor of Google Earth and Blurb. In his self-published book *O Campo* (2010), 'The Field' in translation, Schmid collected satellite images that captured football pitches in Brazil. Unlike the perfectly groomed premier league pitches as seen on television, Schmid's collection depicts pitches that are dusty, crooked and awkwardly shaped. Though as Schmid points out in the online description of the book, these pitches, most of them located in economically deprived areas of the country, produce some of the most celebrated footballers in the world.[1] Schmid's collection of images is an ironic commentary on the rules of the game literally being bent on the fringes of Brazilian society.

The dusty football pitches represented in Schmid's *O Campo* also function as a visual metaphor. By focussing (or literally zooming in) on Brazil, Schmid's work can be read as a commentary on the extreme economic and social disparity in the country. Apart from an

Above: Joachim Schmid

O Campo, 2010.
(see color image pp. 186-187)

[1] http://www.blurb.com/bookstore/detail/1269569

actual reference to the politics of football in Brazil however, *O Campo* addresses a disparity between the 'artist' and his 'subjects'. Schmid accesses the Internet from the comfort of his home to literally look down on the footballers on the dusty pitch in faraway Brazil. This is a one-way relationship: the artist (and by extension the viewer) is looking at the footballers, while the footballers are unaware that they are being looked at from high above. The power to look, collect and subsequently publish images from Google Earth lies with others. As a result of this power dynamic, Schmid's *O Campo* throws up a number of questions in this newly emerging cultural industry. In the first instance, to what extent can the artist also be regarded as the producer of the image considering that the images are appropriated from the Internet? Similarly, who actually owns the copyright to the image? The artist? Google? The public? Lastly, are we justified in collecting images of subjects, particularly in the so-called developing world, without their awareness or consent? Schmid's project highlights the precarious condition perhaps characteristic for a cultural industry that is still finding its footing.

Schmid's methodology of collecting images is reminiscent of a typology: the images essentially depict the same subject photographed from the same vantage point and distance. Indeed, *O Campo* bears striking similarities with Bernd and Hilla Becher's iconic series of photographs on *Water Towers*.

Like the Bechers, Schmid seeks to represent his subject 'objectively'. This apparent embrace of objectivity is partially signified in the very fact that the photograph functions within a series of photographs that depict the same subject. As a result, the viewer is invited to look at the football pitches and compare their size and shape with other pitches. It is only in comparison with the other pitches that the viewer can see the real crookedness of the subject represented in the photograph. Ironically, in spite of highlighting the awkward shape of the football pitches, by representing the work as a typology, Schmid also brings order into this world.
This order is created by recognising a visual pattern that is, ultimately, recreated on the pages of the book. Rather than being the producer of the image, Schmid's act of 'creation' lies in recognising, editing and reproducing a visual pattern that, without his intervention, could easily get lost in cyber space.

No Man's Land
by Mishka Henner

No Man's Land (2011) by the Belgium-born Manchester-based photographer Mishka Henner is a collection of images, appropriated

from Google Street View and subsequently published as a Blurb book depicting the periphery of Spanish and Italian cities. To achieve the best image clarity, the Google Street View car usually takes pictures on clear days while the Mediterranean sun ads a painterly quality to the images. The camera's high vantage point gives the viewer a towering perspective over the landscape. What at first appears to be a rather banal depiction of the encounter between the natural and urban environment, turns out to be, on closer inspection, a strikingly haunting and surreal representation of the sex trade. Trawling Google Street View while researching a potential photographic assignment, Henner discovered that Google's omnipresent camera inevitably photographed what appear to be prostitutes waiting for their clientele. Like all Street View images, Google seemingly protected people's identities by blurring their

faces. The landscape, no longer innocent or benign, is marked by a trade that thrives on inequalities, exploitation and abuse. It is with considerable irony then, that a number of images depict accessories that presumably make the physical demands of the sex trade more bearable: one women stands under an umbrella to protect herself from the scorching sun, others have found a chair to sit on, and water bottles give an indication about the daytime temperatures.

While most women in Henner's *No Man's Land* clearly stand out from the surrounding landscape, at the same time, some of them also appear to withdraw into it. Hidden pathways, tiny side roads and cave-like hedge formations further emphasise the ambiguity in the sex workers' activities. While they 'wish' to be seen by those seeking

Above: Mishka Henner

San Fernando de Henares, Madrid, Spain

SP90, Rivolta d'Adda, Cremona, Italy

(see color images p. 188)

for sexual pleasure, they also need to remain hidden from the wider public, the law and the police. The title of the series *No Man's Land* thus evokes a number of interpretations. In a literal sense, *No Man's Land* highlights the gendered dimension in this body of work: in Henner's project no man is represented in the land. Yet the title also refers to the fact that the sex trade functions precisely because it is located in a space in which the land's law is seemingly suspended.

While Henner's work alludes to the harsh gender inequality of prostitution, it also refers to the politics of globalisation: the sex trade not only thrives on the exploitation of women, more specifically, it thrives on the exploitation of the migrant worker, or, in the extreme, the victim of human trafficking. The women in *No Man's Land* thus appear marginalised on a number of levels: marginalised by their locality on the edge of the city, marginalised by their 'trade' on the edge of legality, and finally, marginalised by their presumed status as undocumented citizens.

Standing along the picturesque country roads leading to major Italian and Spanish cities, the women, some of them wearing little more than a bikini, seem wholly out of place. It is perhaps the extreme contrast between luscious greenery, bright clothing and exposed skin that makes Henner's work so unsettling. This visual contrast functions as a metaphor for the extreme socio-economic contrast of modern day slavery apparently thriving in some of the world's most advanced economies. It would be incorrect however to assume that these landscapes of exploitation don't equally exist in other parts of Europe, or indeed, in other parts of the world. In that sense, *No Man's Land* also alludes to a prototype borderland in which the sex trade flourishes because of economic, monetary or legal differences: the middle-class German sex tourist driving over the border to Poland to exploit economic disparities, or the Chinese trucker who capitalises from a favourable currency conversion in Vietnam, or, as the American ambassador to the Philippines controversially highlighted, the American men who take advantage of seemingly lax laws in the Philippines. Yet Henner's *No Man's Land* is no distant country: for those in search of sex, it is often only a few minutes drive away from home. In one photograph, the tire marks coming from a dirt road gives an indication on the frequency with which *No Man's Land* is entered.

Similar to Schmid's project, Mishka Henner's work also raises questions about authorship: these are, after all, images that are freely available to anyone with an Internet connection. To that extent, Henner himself inhabits a peripheral state as photographer as he is neither taking, constructing or even printing the photograph. Rather than photographing *No Man's Land* himself, Henner's work is more closely aligned with that of a curator who assembles and edits images to create a visual narrative.

Henner's work is ultimately about exploitation. In the first instance, it is the subjects in the photographs that are sexually and economically exploited. Yet, as physically removed the 'photographer' or the 'artist' might be from his subject, *No Man's Land* also evokes questions about the subject being exploited by the image-maker. But who exactly is that? Is it Google's invasive lens scanning the landscape in pretty much every advanced economy on the globe? Or is it Henner who has subsequently collected a wholly subjective and voyeuristic interpretation of the urban periphery? The viewer, too, is complicit in this exploitation: Google's ever-growing image database and the various photographic projects that have since used it as source material emerge out of the demands of an economy thriving on images, thriving on seeing what would otherwise remain unseen, and thriving on the complex and unequal power relations that such form of seeing entails.

For artists like Joachim Schmid and Mishka Henner, the act of creation does not lie in the act of photographing, nor does it necessarily lie in discovering visually provocative images online. Rather, their act of creation lies in establishing an order of images, making sense of that order, and taking the image out of its original context and reproduce it in a book. This new way of looking at images from the Internet allows the viewer a totally new way of perceiving and understanding our social and digital landscape. Ironically, in a day and age when the camera increasingly encroaches on all aspects of everyday life, Schmid and Henner make these landscapes visible in the first place. In a sense, these interventions tell us more about our complex relationship with images, the availability of images via the Internet and the collapse of the private and the public, then they do about the particular subjects they depict.

Rather than the artist constituting the producer of the image, the artist becomes the producer of an idea as expressed via images. As the various copyright lawsuits all over the world indicate, the question of who owns the images that Google captures is a yet unanswered issue. In defiance of copyright laws and global capital, the act of appropriating images from Google becomes an act of subversion. The subversion lays bare a fragile network of images that can easily be accessed, appropriated, decontextualised and reproduced. In this quickly shifting environment, it is the book that ultimately functions as the metaphorical anchor point.

Joan Fontcuberta

**A Bio-Optically
Organised Knowledge
Device Called
'BOOK'**

Joan Fontcuberta suggested an interview format, as a way perhaps to open up a debate around some of the work he presented at the symposium. We proposed a three way conversation at a distance.

A few quick questions to break the ice so to speak:

What is the last book you bought?

Histoire du Miroir, by Sabine Melchior-Bonnet.

What is the first book you remember reading?

The Grimm Tales.

What book if any, can't you live without?

Evidence (1977), by Mike Mandel and Larry Sultan.

RSS. You studied journalism and worked in advertising before working as an artist and this seems to have informed your practice, quite clearly in the clever use of the design and packaging of your projects. You re-present to us known genres, whether that is how we expect a museum exhibition to look, or the type of photography associated with news stories, or published in National Geographic, using the same aesthetics of the genre much the same way advertising might to communicate ideas. But you have been quoted as saying, although rather mischievously, in previous interviews that 'aesthetics is an accident' in your work – could you expand on that and does this mean the book is just aesthetics to you?

I am especially interested in photography's 'habitat', the space it inhabits: it can live in family albums, on newspaper pages, in archival filing cabinets, on billboards, on museum walls or in a book, amongst many other places. Each context calls for a different kind of photographic image chosen according to the specificity of its function.

Aesthetics represent the architectural shape of the chosen *habitat*, the combination of qualities that a support or container has. In my opinion, aesthetics enables the function of the image forcing the container to take shape or 'body'. Aesthetics is subject to concept; it becomes the strategy that enables the transmission of the concept. In this sense, I think aesthetics is contingent and accidental because it depends on what we do with the image.

The book, however, is a battleground in which the form and concept confront each other. A good book is the result of an intelligent alliance; a bad book is a waste ground splattered with corpses from one side or the other.

EW. You have titled your presentation A Bio-Optically Organised Knowledge Device Called 'BOOK'. Could you explain what you mean by this?

For one of its campaigns, an online book distributor called Popular Libros[1] uploaded a video on YouTube that soon went viral and was subtitled in many languages. The title of my conference is taken from the first line that appears in the video:
'We'd like to present a bio-optically organised knowledge device called 'book". The video's success is due to the absurdity of the situation, which is a parody of the mise-en-scene found in current marketing videos when a new product is introduced into the market.

[1](http://youtu.be/iwPj0qgvfls)

The use of current technological terminology and stereotypical language, usually found in advertising, to describe a thousand-year old product is comical. The humorous message of the video allows for different readings that seemed pertinent to me for a conference in which we were going to discuss the current state of the artist's book: for example, the expiry date (or not) of the object-book, the limits to the concept of book, the tension between paper and screen as devices containing 'bio-optically organised knowledge', etc.

EW. In the résumé you gave us it says 'Joan is best known for exploring the interstices between art, science, and illusion'. I think this is best expressed in your book works in which the three are brought together making it difficult sometimes to tell what is what, the illusion being so complete or reality so farfetched. Many have been fooled, myself included by *Artist and the Photograph* (1995) where you fabricate very convincing photographic works by Picasso, Miró, Dalí and Tàpies. It is because I encountered the work in a well-known museum bookshop in Barcelona that I believed it to be genuine.

Most of my work – not just the published work – is based on provoking a confusion of genres. For example, when we watch TV we are conscious of which images belong to the world of information and which images belong to the world of fiction and entertainment, or to the world of advertising. But what happens when these conventions get confused? I like to think that my projects have a prophylactic effect, that they act as epistemological, preventative measures, warning the spectator of the dangers of the routines and prejudices that govern our interpretation of reality. One of my books called *Sputnik* describes the tribulations of a soviet cosmonaut lost in space at the peak of the Cold War. It is completely made up, but the story is told as a documentary and includes many photographs as proof of the facts, and as a result, a distracted reading can lead to misunderstanding. My great satisfaction is when I find copies of this book in public libraries or universities, classified under the Russian History section or History of Astronautics and not under Art or Fiction. The librarian, who didn't pay enough attention, and his error, gives these books a new life; they become time bombs waiting for an unsuspecting reader.

EW. In what section would you prefer to see your books in bookshops, libraries or personal bookshelves? Have you ever been tempted or asked to infiltrate other spheres than the art world with projects like *Deconstructing Ossama* or *Haemograms* for example?

A book's journey through the bookshops has to be provisional; a book's final destination has to be on private bookshelves or in libraries. Although in fact, a book is a tool and therefore has different missions to carry out during its journey, from initial conception until it reaches the reader's hands. For some of my projects,

I try to ensure that this journey doesn't happen very quickly, allowing for possible tactical diversions of my books under cover (commercial, scientific, religious, etc.). I am really interested in infiltrating spheres outside of artistic institutions. What's more, art that is presented in a strictly artistic context disables a large part of the critical energy that all works of art should contain. That's why I prefer to transfer artistic actions to places where they are unexpected. Artistic institutions do not allow the living presence of a work of art; they only allow its dissection in document form.

Left: *Haemograms* installation.

Galeria Helga de Alvear, Madrid, 1999.

EW. As in many projects you use parody and satire to great affect, managing to both celebrate and criticise various aspects of contemporary society. In that sense putting you in the same league as Rabelais who used the grotesque or La Fontaine who spoke via animals, as a way of being politically subversive and avoid censorship and/or the guillotine - do you consider projects like *Deconstructing Ossama* or *Haemograms* to be political, and if so, in what way?

All genuine art has a political dimension. The political effect doesn't need to be deliberate because then it tends to fall in a kind of humanist mannerism or pseudo-non-conformist style that in the end is deactivated by being absorbed by the market. Let's not forget Daniël Buren called Christian Boltanski 'the Pierre Cardin of Shoah'. I don't have faith in what is commonly known as 'political art'; I would put my faith in a way of doing politics artistically. My work was born out of resistance to the dictatorship I was born

in. Only in this way is my work understood as a rejection of any kind of authoritarian discourse and in the libertarian sharpness in projects such as *Sputnik* and *Deconstructing Ossama,* in which I criticise the ways in which history is written or how current affairs are explained. But there's no need to extol it constantly, because if all art is political what's important is what it carries beyond politics. It is in these additional values, in this excess, that we must pay attention.

RSS. I was very interested in the first book/selection of images you showed, *Haemograms,* as my first artist book *Observe 1994-2011* was a series of photographs of blood tests, which spoke of continuous medical investigations in relation to living with a long-term illness, in this case HIV and in part questioning the authority of medical and scientific practices by giving the patient some form of control as well as exploring blood as both giver of life and carrier of disease and viruses.

Haemograms evokes, in fact, the tragedy of HIV but not solely, because it benefits extensively from the symbolic richness that blood has that you mention. Blood is associated with the idea of intimate exchanges; we understand it as a vehicle of life, as a principal generator, as an allusion to life and death, pain and passion, inheritance and identity... Blood is the basis of a wide variety of rituals and beliefs such as purification, atonement, exorcism, menstruation, etc. And even, as you say, with opposing values: in some cultures, drinking the blood of a victim signifies absorbing a life force (vampirism) or establishing a union with divinity (the Eucharist); on the other hand, in others like Judaism, contact with blood is avoided and cannot be drunk or spilled in sacred places. Finally, blood conveys sacrifice, suffering from illness or death.

But beyond the political dimension, here the excess has a semiotic and ontological basis. The *Haemograms* are gigantic enlargements of small blood deposits and it's normal that their perception is ambiguous. The process I follow becomes simple: it consists of asking different donors, people I know, for a drop of blood. These drops, placed on a transparent acetate strip, are used as negatives once they coagulate. Asking for blood and giving blood implies a saturated gesture of symbols and emotions.
But what is symbolic is the order of the contents, which corresponds with the symbolism of the process itself. Because these images, made with the blood of loved ones, speak to us of transparency and opacity: the resistance of the matter at being crossed by light in a metaphor that involves the notion of truth. In the end the *Haemograms* force us to delve into the shapes of prints and remains, in the nature of the document as a trace.

RSS. Your project appears to deal will familiar themes apparent in the rest of your work, those of theoretical and philosophical questions on the nature of science, how pictures relate to the world and how

photography helps us to, not just represent but think of the world. Could you expand on this approach in relation to *Haemograms* and more widely in your practice?

Many of my pieces superimpose different signifying layers. For example in *Haemograms* there is a social and relational aspect in the process involved, which includes in the exhibition of the work a hospital booth with a nurse extracting blood from visitors that want to collaborate on the project. But there is another aspect that refers to the analysis of the nature of the photographic image, of its connection to the notion of indexicality or 'empreinte'. Another aspect that refers to the recycling of Art History, in relation to Abstraction, Material Art, Expressionism, the dripping technique: to what we could consider within the propaedeutics and aesthetics of scientific experience. In short, I want my projects to be polyhedral and multi-dimensional.

RSS. Another aspect that I find in your work, that of a certain playfulness and humour is also apparent in *Haemograms*. As a book the images are as if abstract paintings, sometimes the images reminding me of strange tropical fish or perhaps sperm. Although when I describe them as such I feel that they act as a Rorschach inkblot test and you're analysing me in a psychological experiment. As viewers we are separated from the image and who the blood belongs to; knowing who donated their blood, were you tempted to draw comparisons between the image and person?

It is true that *Haemograms* also includes the idea of the test by Rorschach, so the psychoanalytical diagnostic method would be incorporated into this stratification of different readings.
No, I've never been tempted to establish connections between stains and people. The system required me to hand in an A4 sheet to each participant and ask him or her to fill it out with drops of blood. The first drop was always a simple circle. But slowly, each person would introduce experimentation and creativity: I gave them all *carte blanche*. Since most of my friends are artists or designers, they wouldn't settle for boring shapes and went to a lot of effort to achieve original morphologies, from which I could select whichever ones I wanted. It was as though I was establishing a typology of drops of blood, compulsively collecting these graphic and textural deposits like the Bechers might have done with industrial structures. This constituted yet another significant layer.

EW. Lately as in *Through the Looking Glass*, about the content and dissemination of mobile phone photography, or *Deletrix*, your thought provoking appropriation of book censorship throughout the ages, It seems that your tactics are changing; minimal intervention on your part and very little fiction or forgery. The humour is also different.

Obviously I have the right to evolve and not always feel like a prisoner of my own past. But I believe that in the series that you mention some of my main concerns remain: the tension between reality and fiction, the distance between facts and experience,

Right: *Deletrix: Erasmus #4*, 2006.

Print. 560 x 400mm

the trompe-l'oeil and the palimpsest… In portraits, that I call reflectograms, we support the dialectic between mask and mirror, between the construction and control of our image when all of us turn into homo photographicus, between the self and prêt-à-porter fictions elaborated in front of the mirror. *Deletrix* is a plea against fanaticism and censorship by those who want to preserve the dogma

free from cracks and limit freedom of expression and thought. Language is therefore suspended. There is a willingness to obscure words, to prohibit knowledge, to attack intelligence. And at the end I put forward the recurrent question of image ethics: do aesthetics redeem violence?

Regarding what you say about a different kind of humour, hmm… it is true that the humour is different. In projects like *Milagros & Co* the humour is more mischievous, absurd, Monty Python-esque. *Sputnik* has a more Woody Allen type humour.
At the moment I'm going through a more subtle humour, bitterer, perhaps more like the one that Cervantes exudes in Don Quixote.

EW. I am wondering why? Has reality gone further than you could imagine?

Like Oscar Wilde, I still believe that reality imitates art.
The Internet, for example, comprises a mirror of little known realities that are astonishing.

RSS. You appear to like dressing up, having fun and in the book Holy Innocence you are particularly mischievous with this when you con a con man, someone promising billions of Iraqi cash. You convince him that you are a priest needing funds to complete the Sagrada Familia. The book returns to familiar themes of you acting as the principle figure in the work, although would you agree this project is different as it relies on the viewer knowing the priest is you so that they are in on the joke? Has it been important to you as an artist to use yourself in your work and are you able to now play on your fame as an artist?

I began appearing in my own projects for practical reasons but soon realised that it introduced a complimentary strategy of camouflaging identity, like Pessoa's heteronyms. In each project the reasons and aspects of my participation vary. For example, in *Sputnik*, the fact that the main character has my face is a way of signing the project without my name appearing anywhere because the authorship of the project falls simultaneously on an inexistent Russian Foundation. Other times, like in *Milagros & Co* or *Sirenas*, the narrative structure unfolds in a fiction within a fiction, so I have to play different roles. In *Holy Innocence* I adopt a false identity to contrast the false identity of a fraudster who pretends to be a US soldier in the Iraq war. The fraudster thinks he's fooling me and that I'm convinced I'm dealing with a philanthropic soldier. But I anticipate his fiction and neutralise the falseness of the story with my own story.
Finally the only real thing is my trickery.

Andrej Blatnik

Mass-Produced, Media-Promoted, Handmade: Books in the Twenty-First Century

Production vs. Consumption

Despite the popular theses about 'the end of Gutenberg's galaxy' and 'victory of the line over the letter' the number of books printed, particularly in the sphere of fiction, keeps going up; in the same time, literature is becoming increasingly related to other cultural practices and is appearing in different, not necessarily paper forms, be it hypertext or slam, artist book or live event, probably also in hope for a wider readership or, in some cases, audience. If – in the days before mass printing – it was still possible to determine with precision which books one was supposed to read in order to attain education, now – given the almost infinite choice – it is very hard to decide which are worth at least giving a try. In 1450, the ratio of titles per one million inhabitants of the Earth was 0.3, in 1950 this ratio was 100, and in 2000 as high as 167[1]. 'According to *Bowker's Global Books in Print*, 700,000 new titles were published worldwide in 1998; 859,000 in 2003; and 976,000 in 2007. Despite the current downturn of the economy, soon a million new books will be published each year.'[2]

In addition to this, printed books are today just one of the ways in which it is possible to spread knowledge, information, or culture. 'The shift of public space at the turn of millennium is incredible'[3] and it is no exaggeration to say that all human knowledge and culture are becoming increasingly dependent on new communication tools and appearing in different, not necessarily paper forms. The instant accessibility of almost all data brings re-evaluation (or should we frankly say *devaluation*?) of the creation process, it creates the need for a different approach towards the status of the creator, *the author*. The middle ages paid no big respect to the authorship[4] and the author was less important for the development of human thought as the owner of the particular book which was in most cases available in only one copy. Reading was not only an intellectual task, but

[1] Zaid, Gabriel. (2003). *So Many Books: Reading and publishing in an age of abundance.* Philadelphia: Paul Dry Books.

[2] Darnton, Robert. (2009). *The Case for Books. Past, Present and Future.* New York: Public Affairs.

[3] Johnson, Steven. (1997). *Interface Culture: How New Technology Transforms the Way We Create and Communicate.* New York: HarperCollins.

[4] Minnis, Alastair. (2009). *Medieval Theory of Authorship: Scholastic Literary Attitudes in the Later Middle Ages.* Philadelphia: University of Pennsylvania Press.

also physical – coming to the source of information was connected with many obstacles. You needed to travel under uneasy conditions to get to the monastery libraries, and quite a few books (and the knowledge in them) were inaccessible to almost anybody, in some cases because of the remote location, in other cases because of the strict guardianship of the library where the particular codex was kept. Even in the middle of the 17th century, authorship was not a big thing: 'Only 40 percent of the titles carried the author's name in 1644 and only 43 percent in 1668.'[5] Now it seems to us that via the ever-present Internet almost everything is accesible in an instant, legally or illegally (via various download methods), and the aura of the work as something which is not easy to reach, a 'cult', a 'mistery' – the term aura is used here in the tradition established by Walter Benjamin[6] – has shifted to the *pseudo-aura* of the author.

The number of published books in paper form alone, let alone other forms, is constantly growing, and we are talking about the real-time production, which every year adds to the general cultural heritage. Therefore, the number of the books on offer is on constant rise, like it or not; the proportional number of *read* books per capita is, alas, not. What mechanisms therefore nowadays direct the attention of potential readers to particular authors and particular works?

While Virginia Woolf spoke about 'one's own room' in a completely literal sense and understood it as a liberated territory intended for creative process,[7] and at the same time emphasised its symbolic dimension as a place of formed identity, the end of the millennium faced authors and other artists with new challenges. What art, after its *conception*, needs nowadays for its *survival or existence*, is in fact a *public room*[8] – an artist's presence in the industrial environment of the mass media. Contemporary artists and writers who want to gain any attention outside a limited circle or dedicated followers cannot escape the dictatorship of public presence. They have to, like it or not, appear in the media whenever possible, and the PR staff of publishing houses offers them up for TV round-table discussions, where they are used as 'persons who are supposed to know', and to trendy magazines, where they are presented in pictures which also expands the potential market.

[5]Robert. (2009).

[6]Benjamin, Walter. (1936). *L'œuvre d'art à l'époque de sa reproduction mécanisée. Zeitschrift für Sozialforschung 5, 1936 I, S. 40–66.*

[7]Woolf, Virginia. (1929). *A Room of One's Own.* Hogarth Press.

[8](having in mind the conclusions of literary, art and communication theories emerging from Roman Ingarden's thesis of literary work's intentional existence before the work is read) *Das literarische Kunstwerk. Eine Untersuchung aus dem Grenzgebiet der Ontologie, Logik und Literaturwissenschaft,* Halle: Max Niemeyer. Ingarden, Roman. (1931).

Visible vs. Overlooked

Since more and more books come out every year, public attention is split up into more and more parts. Very few authors avoid the media and let their books speak for themselves. Some of them (Thomas Pynchon and J. D. Salinger, for instance) have created an attractive

[9] Epstein, Jason. (2001). *Book Business. Publishing Past, Present, and Future.* New York: W. W. Norton & Company.

media story out of their avoidance of not only the media, but any public appearance whatsoever. All others try to make it in a more conventional way – by being visible in the media. The author's name is becoming a *brand name*; it personifies his or her style and ensures an appropriate quality level of the product. This effect is particularly characteristic of popular culture products: Jason Epstein states that as many as 63 titles from the list of a hundred best-selling books in the USA between 1986 and 1996 were written by only six authors: Tom Clancy, Michael Crichton, John Grisham, Stephen King, Dean Koonitz and Danielle Steel.[9]

Homogenisation of the canon (if the list of best-selling books can be understood as the popular culture canon) is also happening in the 'high' culture where sales results don't matter as much as *presence in the cultural flow,* which is ensured by the authors via the homogenisation of literature syllabi at all levels of education and via translations. This then creates a snowball effect: translations into major languages trigger off translation into less widely disseminated languages, and authors already translated have priority over those not yet translated, as they are already at least partly established in the target culture. Simultaneously, translation in a specific way strengthens the role of larger cultures: in pre-globalisation times neighbouring literatures were entering into direct mutual contacts, while nowadays they often become known indirectly – via more accessible cultures. According to Jaume Cabré, the European *lingua franca* is a translation – but not a translation into Catalan, Slovenian or Estonian, but into English or some other major world language.

The reason for saying that writers writing in English are 'born translated' is that English has become the common global language, taking over the role Latin had a few centuries ago – the writers who do not write in English might 'become translateable' if they are translated into English – not only because English is a common language of (also literary) communication, also because it represents a demanding gatekeeper – percentage of translations among books published is the lowest in English-speaking countries. Approximately 2 percent in the UK and *3 percent* in the USA, including everything from French and Russian classics to contemporary poetry, as opposed to many European countries where number of translations, especially translations from English, of course, amounts to 50 percent or only slightly less of book production, in fiction or general publishing alike.

A 1999 study of translation by the National Endowment for the arts gathered its figures from reviews published in all the country's literary magazines, no matter how small. The NFA study found that of a total of 12,828 works of fiction and

poetry in the United States in 1999 (as reported by Bowker), only 297 were translations – that is, a little over 2 percent of all fiction and poetry published, and far less than 1 percent of all books published. A closer look at these 297 titles further reveals that the list includes many new translations of classic works.[10]

[10] Allen, Esther (ed.). (2007). To *Be Translated or Not to Be*. PEN/IRL *Report on the International Situation of Literary Translation*. Institut Ramon Llull, Barcelona.

Taking into account only the titles which have elicited any kind of response reduces the number still further. The role of the 'one who chooses' the material for publication or translation, for media appearance or inclusion into a university study programme, the role of *cultural mediators* – as Pierre Bourdieu calls the new decision-makers in the cultural industry – is being strengthened at the same rate as the supply goes up. This is happening in an increasingly non-transparent cultural sphere where production is growing in every national culture with ever-increasing crossing of boundaries. Thus an editor moves from the background of the publishing industry – where, according to Raymond Williams, he or she is a writer's professional mediator, but without direct influence on his or her work – to the foreground, at the same level then the custodians of gallery collections. Previously anonymous outside professional circles, he or she becomes as famous as the curators whose names guarantee quality and – more importantly – media coverage of a particular exhibition. Leading events of visual arts like Documenta, Manifesta or the Venice Biennale are thus setting up a veritable star system which frequently puts custodians above the artists whose works are on display.

Literature appears to be a slightly more traditional art; it seems that the ever-increasing number of writers as well as cultural mediators and publishing houses has created the situation in which a stronger promotion apparatus is needed in order to establish a brand name in fiction that is actually possessed by the literary apparatus of publishing business. An apparatus similar to that owned by the television – as is well demonstrated by the programmes like *The Oprah Winfrey Show*, *Apostrophes* and *Das Literarische Quartett*, if we limit ourselves only to the long-lasting TV brand names having an extraordinary influence on the reception of the works discussed. And at the same time the canon is penetrated much faster than via ordinary academic channels by those literary works awarded major literary prizes. David Lodge writes:

The Booker Prize, which had been trundling along for a decade without making much impact on the reading public,

[11] Lodge, David. (1996).
'O Ye Laurels' In:
The Best of Young American Novelists Granta 54, Summer 1996.

suddenly became the focus of intense media interest, and a powerful engine for generating book sales.

Before 1980 the shortlist was announced, and the winner secretly chosen, at the same time. Under new rules, the meeting to decide the winner was held some weeks after the shortlist meeting – on the very day of the banquet at which the result was announced. This meant that bookmakers would accept bets on the outcome, and turned the banquet into an occasion of high drama and genuine suspense, a kind of literary Oscar night, broadcast live on network television.[11]

[12] Ondaatje, Michael. (2003).
Is the New Book Culture Killing Literature? In: Toronto Star, 4 November 2003.

And on the occasion of The Giller Prize awarding ceremony Michael Ondaatje wrote: 'Books are judged today as successful or not depending on sales and jury short lists. Meanwhile the critical climate, for all the media coverage of writers, is random and manic… The authors are either in the centre of attention or completely overlooked.'[12] His opinion is shared by Pierre Bourdieu, who warns:

[13] Bourdieu, Pierre. (1966).
Sur la télévision, Raisons d'agir.

The 'feedback mentality' is nowadays the ruling atmosphere in editorial offices, in publishing houses, etc. Everything is judged through commercial success. Only thirty years ago, and it had been like that since the mid-19th century, since Baudelaire, Flaubert, etc., commercial success was deemed suspicious among avant-garde writers, the writers for writers, those admired by other writers as well as among artists admired by other artists: commercial success was viewed as a sign of making compromises with contemporaneity, with money… And today the market is increasingly recognised as the legitimate agent of legitimacy, proof being another novel invention, namely the best-seller lists. Last night I heard a commentator on the radio who learnedly talked about the latest best-seller, saying: 'Philosophy seems to be in fashion this year as 800,000 copies of *Sophie's World* were sold.' He offered the final judgement – the one expressed in sales numbers. And through this kind of feedback the market logic is entering the cultural production.[13]

It is generally believed that an invasion of commercial barbarism into culture can be backed off by the ivory tower of university, but the question is to what extent the university discourse in its desire not to lag behind the 'real world', but to coexist with it in synergy,

is willing to change its criteria, which is now also demanded by an increasing share of people going for university education. Yielding to the desire of 'users' usually implies lowering the criteria, and lower criteria enable easier penetration among the chosen. Although it is impossible to deny the need for democratisation and transformations of the canonic selection of great authors and although a number of authors (most notably and most disputed Guillroy[14] and Bloom[15]), the line between the 'strictly limited' and 'anything goes' is sometimes quite obscure – and dependent on a number of previous choices, which define what is accessible, what is translated, what is visible and finally – what agrees with the current aesthetical and ethical standards.

[14] Guillory, John. (1993). *Cultural Capital. The Problem of Literary Canon Formation.* University of Chicago.

[15] Bloom, Harold. (1994). *The Western Canon: The Books and School of the Ages.* London: Harcourt Brace.

Mass-produced vs. Handmade

As the book, the classical media of knowledge of the last 500 years, is to a greater or lesser extent competing with the new forms of modern culture, we can draw some parallels in this field.
To name one example, it seems that almost no one is buying the physical carriers of sound and pictures such as CDs and DVDs any more. Most users acquire them via digital transfer in one way or another. However, CDs and even vinyl records are still selling, particularly at concerts. They represent a material memento of an event: the former a*ura of inaccessibility and exclusivity* of a product (not many more than a hundred years ago we would have had to travel a long way to be able to hear the music we wanted to hear performed live, as there was no other way) has been replaced by the *aura of its creator,* a genuine one or one that is produced with the help of the media. This is why we go to concerts – not only in order to hear what may be a different performance of the same work, but also (or primarily) to be among the chosen few who experience the work *live,* with the live author included.

And this is perhaps good news with regard to books.
Even if e-books one day for whatever reason (because they are handier? cheaper? do not take up so much space? simply because the Amazonian rainforests disappear, and paper with them? or for all these reasons combined?) replace paper books, those attending a literary evening will probably bring a printed book to be signed by their favourite author, even if they have to print it at home.
It is hard to imagine they would be happy with a digital signature in a digital book as this would ultimately remove the uniqueness and intimacy of the book and such a signature could be obtained through remote access against payment. Books as material objects will gain in value, it is no surprise, by the rarity of the object,

the low number of copies made, as is normal with any work of art – the handmade (or printed in low printruns) book will keep some of its *aura*. And the author of such a book will keep more control over it.

Commodification vs. Creation

[16] Groys, Boris. (2008). *Art Power.* Cambridge: MIT Press.

Art will regain its autonomy and (let us say once more) aura only if it gives up its commodification, its transformation into a consumer good; however, the question arises whether without such a transformation it will be able to survive at all, which is of course not an issue only connected with it but also with a whole series of other things people do. Placement on the market facilitates the existence of numerous things, material or spiritual, whereas the market demand for standardisation reduces the possibility of the appearance, existence, recognition and survival of an internally complete and radically innovative work. We would be pessimists if we thought that everything is lost. Boris Groys[16] is not the only one who thinks that these days the economy cannot be avoided, but neither can it be controlled and so the only way of understanding it is to actively participate in it. The cultural economy is not the description of culture as the representation of certain economic processes outside culture, but an attempt at understanding the logic of the development of culture itself and the economic logic of the re-evaluation of values.

Alongside the practical deconstruction of religion into economic 'solidity' and 'justice' and the simultaneous establishment of the new social networks into active entities (such as is, paradoxically, made possible in particular by the phenomenon of electronic communication facilitating the Twitter and Facebook revolution) there is a growing awareness of the moral economy and symbolic capital. Just as being on the market no longer disqualifies art and thought, it is also no longer the only manner of its survival, as it seemed until not long ago. Moreover, in today's consumer practice, culture is increasingly moving beyond the market and, after the initiation period of being tied to the market is (again) becoming more publicly accessible, be it in what is a more or less tolerated illegal manner (downloads from the web in various forms) or in the form of social agreement on culture as a public good (free of charge borrowing in libraries, open days in cultural institutions etc.).
It is thus possible to hope that in spite of the globally prevailing principle of industrialisation in the production and representation of art and culture the new empty spaces for different, multilayered intellectual formations and presences are available – our individual one among them.

The choices of whoever does the choosing are naturally offered up for evaluation, and can – of course – be rejected. There exist alternative canons, protests against the selection of prize-winners and competitive (and often incompetent) media presentations, but all these models of *different choice* follow certain – although different – criteria. The relation between the autonomy of literary taste and the commands of current users' expectations creates *a conflict between the chosen and the overlooked*. Extra-textual circumstances on the one hand enable not only the survival of literature, but also its visibility, its response in the public, and on the other, they lessen its possibilities of autonomy and thus reduce the possibilities of conception, existence, recognition and survival of the internally comprehensive and *radically innovative* works of art. All those participating in the selection processes in the literary sphere therefore take part in choosing between *freedom* (new, different) and *command* (known and recognised), in which not only their aesthetical taste, but also ethical choice is involved. *The choice is the message.*

Bibliography:

Anderson, C. (2006). *The Long Tail: Why the Future of Business Is Selling Less of More.* New York: Hyperion.

Carr, Nicholas. (2010). *The Shallows: What the Internet Is Doing to Our Brains.* New York: W. W. Norton & Company.

Heisenberg, Werner. (1927). Über den anschaulichen Inhalt der quantentheoretischen Kinematik und Mechanik, *Zeitschrift für Physik 43 (3–4)*: 172–198.

Jauss, Hans Robert. (1982). *Toward an Aesthetic of Reception.* Translated by Timothy Bahti. Minneapolis: University of Minnesota Press.

McHale, Brian. (1987). *Postmodernist Fiction.* London & New York: Methuen.

Paul Soulellis

Weymouths

Journey

The entire presentation with images can be found online: weymouths.tumblr.com

[1]Internet bots, also known as web robots, WWW robots or simply bots, are software applications that run automated tasks over the Internet.

Weymouths is a project about two places named Weymouth, one in England and one in Massachusetts. I was commissioned to do a twelve volume book project for Weymouth, Dorset in England for the b-side multimedia arts festival (part of the London 2012 Festival for the Cultural Olympiad). The two Weymouths are connected by a journey that occurred in 1635. This is all I knew when I started the project in early 2012. I read about the journey in the Wikipedia entry for Weymouth, England. At the time, hundreds of editors, a combination of humans and bots, had created the 7,000-word entry, with nineteen images, telling the story of this place, which I knew nothing about. This is where I began my research.

The historical significance of this story seemed awesome enough – Puritans from Weymouth, England crossed the ocean and founded the town that was to become Weymouth, Massachusetts.
With these words alone, I was engaged. In a way it was like finding a loose thread, just before you start pulling.

But it was the fragility of this seventeenth-century trip that taunted me. A risky journey, under true life-and-death conditions – marked today with placenames on a map, but little else.

What I wanted to know was this: does an imaginary 'dotted line' exist today, drawn between these two places, connecting them in time and space? Where is it? Could I see it? What had become of these twin towns, separated at birth? Could I draw my own connections and stitch them back together, 377 years later?

Or would I pull on a thread and unravel something?

The only plan I had was to create a series of books. I knew I would author these books, but not much else. What I mean is – I didn't really know what I was getting into. So the way I got into it was somewhat by chance. I simply drove to the American Weymouth on January 10, 2012 to see what would happen.

All data, people and connections encountered were fair game for me, for interaction and incorporation into the project.

I was no stranger to chance. I had just completed a book project based on a single object in the John Cage archives, and had used chance operations to generate its content and design. To Weymouth, I brought intent, and my own agency, but no agenda.

So I drove to Weymouth. My destination was the Jason Holbrook House, built in 1763. Not exactly pilgrim material, but home to the Weymouth Historical Society.

I entered the back door and met Jim, a 92-year-old man and self-proclaimed 'curator'. He offered a tour of the house and I accepted, and recorded the conversation. What followed was a two hour journey through the rooms of the house, with stories about objects in their collection, and into Jim's own memories. He talked about his experiences in World War II and rambled on about Civil War history, how the collections grew, how the house itself had been moved across town.

Two photographs

I took hundreds of photographs that day in Weymouth, Massachusetts.
Two of them are at the heart of this project.
One is a photograph of a page in a book.

Near the end of the tour I was sitting in the kitchen, chatting with some of the elders hanging out there, and Jim mentioned that a couple had visited recently – from Weymouth, England. He was convinced that this couple was associated with my project, and was intent on telling me exactly when they had visited. So he searched for the guest book where they had signed their names and address. Sure enough, he brought over the book and there they were.
Two names, a man and a woman, who had visited in October 2011.
I photographed the page.

The other photograph I took was out back, behind the house, in a shed. An exhibit of shoes was on display, describing the history of the Stetson Shoe Company. The shoe factory had been just down the road, and had employed most of the town for over a hundred years, before shutting down in the 1970s.

There, I took a photograph of a reproduction of a photograph.

In it, a bearded man holds a shoe, next to a display of shoes.
But it was the typography that fascinated me. I'd seen late-nineteenth-century American letterforms similar to this, but nothing quite so geometric and stilted and odd. And the fact that it was here, in the shed, down the road from the factory – and that this typography probably hadn't had much of a life beyond a mile or two from this very spot where I was taking the photograph – grabbed me.

What happened next was a turning point in the project, where chance, intent and agency commingled. I'd found a few threads.
It was at this moment that I began to draw my own lines back across the ocean.

Geo-typography

First, I started drawing the Stetson letterforms in the photograph.
And I worked with a type designer to complete the alphabet, and we produced a working font.
I started thinking about this as geo-typography. We all know how

typography can have a very particular relationship to
time – a moment, or an entire era. But what about place?
Not just a macro-relationship, like Gill Sans and England – but
something much more acute. Can a typeface emerge from a building,
or a corner of a room? Or between two towns?

Back in 2010 I had created Ding Dong, a sketch for an amusing
alphabet in Venice. And I drew Divieto in Rome last year.
In each case something vernacular and of the place (something
local, casual, conversational) had inspired the letterforms. In Venice
it was the doorbells – in Rome a particular street sign. I treat these
chance finds like evidence – inspirational cues pointing to language
and place, embedded in the culture of the street. I've discovered that
creating these alphabets is an essential part of my work in a place.
The find is like a scrap, or a cell, and I grow something from it.

These alphabets tie the work to the place, but they also refer to my
presence in the place, my authorship.

Perhaps this is a kind of geo-historical typography. Stetson now
refers to two highly specific spatio-temporal moments – it locates
itself within the original photograph (late-nineteenth-century
New England), and equally so, in the shed with me,
on January 11th 2012. It vibrates in time and space.

Spiralling

That other photograph – the one I took of the guest book where the
couple had signed their names – was like a rocket that propelled me
out across the Atlantic. It led me to an appointment at the
Old Rooms Inn, in Weymouth, England on March 6th, at 11am.

I'd found one half of the couple on Facebook – a woman named
Mairi – and sent her a message in February. I asked if she'd be willing
to be interviewed about her experience in Weymouth, Massachusetts
for my book project. I heard back from her five days later – 'I would
prefer if you would contact my husband by email – he does not
use Facebook.'

So I travelled to England and Jack and I met at this pub for a pint.
I recorded our conversation, and learned that he and his wife had
lived in Weymouth, England for twenty-six years. He had visited
Massachusetts on a work-related trip a few years earlier, stopping at
a Dunkin Donuts, but without much of an impression of the place.
Based on this experience, Jack decided to return to the U.S. with his
wife for their 40th wedding anniversary. They arrived in Weymouth
in the morning and went searching for breakfast. By chance, they

ÆSTHETICS—A DRAFT
‹VIS-À-VIS—MADAME!›
A SPECIFIC MOMENT, A
BUILDING, A CORNER
OF A ROOM.

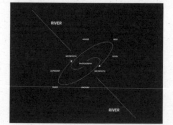

The Book is Alive

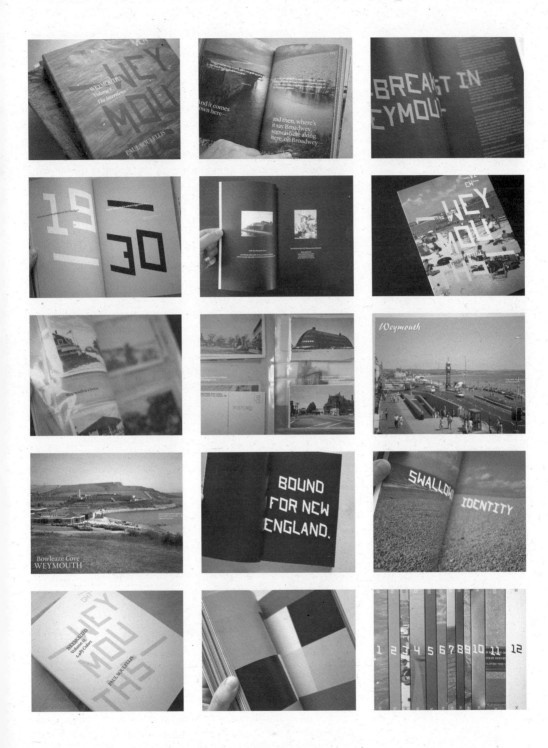

Paul Soulellis

found themselves across the street from the Jason Holbrook house, and entered out of curiosity. They got the tour of the house, from Barbara, who I had also met, and signed the guest book.

It's at this point that my dotted lines get more complicated, and begin to spiral. Like the photograph that turned into the Stetson font, I'm drawing a circle in time, starting with my photograph of a page in a book inside a house in Weymouth, leading me to the other Weymouth, to Jack, and to his memory of his signing of the book, and to his telling me about that experience.

I had begun to assemble my story of Weymouth, my historical archive. Starting with the face-to-face.

Deep history

While in England, I stayed in the home of a geography teacher named Jane. Jane added a new dimension to my archive.
She opened my eyes to the river in Weymouth and she told me the story of its forming, over thousands of years, from an underground spring that had forced its way out of an exposed ridge of rock, or scarp, and how that spring, today, comes out at a wishing well about five miles north of Weymouth, in Upwey. The river continues to its mouth in Weymouth and empties into the Channel.

Jane's ten-minute geology lesson did two things: it introduced a new line to the story, the line of the river forming and the creation of the town itself; but it also introduced a new scale to the project.
The 10,000-year scale, the scale of a million years, the scale of geological formation. Scales of becoming and erosion that extend far above and beyond our own human sense of time. 'Awesome time' revealing sublime structures. What if my archive could take on these other narratives? What if Jane, Jim and Jack could open doors to deeper histories that exist both on and off the timeline?

Present voice

And so, the first of the twelve volumes, the River, is a book of interviews that flows like water – my face-to-face conversations, and at the heart of it, Jane's geology lesson. I used Jack's voice, which is the most detailed of the three, to structure the book. Jack's is the narrative and in a way, because of the scope of our conversation, he guides us through *Weymouths*. Other elements are woven in and out of Jack's voice. It's a 300-page story that is also a

departure. Volume 1, The River, is about flow and conversation in the present voice.

Disambiguation

In Volume 2, I leave the personal behind but continue in the present. And my dérive goes digital.

Wikipedia says that 'disambiguation is the process of resolving the conflicts that arise when a single term is ambiguous – when it refers to more than one topic covered by Wikipedia articles.' In some kind of effort to literally 'make sense, to locate meaning, I used Wikipedia content to generate Volume 2. These are all of the Weymouths – thirty-three of them – as listed on Wikipedia's disambiguation page. I grabbed every photo from each entry, and all of the user-defined metadata, including the captions associated with each image, to create a new catalogue of Weymouths. This is how the Internet defined Weymouth on April 29, 2012 – a group effort of humans and bots that I assembled into an immediate, collaborative book portrait. 'Weymouth can refer to' is the title of Volume 2.

In the same spirit, I searched for 'Weymouth is' on Google and on Twitter and used the results for Volume 3. Stripped of context, these search results are more elusive in meaning. As we get deeper into the results, other Weymouths are revealed. I used the search results to re-caption old postcards – idealised views of the town that had been collected into a binder at the Weymouth Public Library. And from Weymouth, England, I used modern-day souvenir postcards from one particular gift shop, where I had purchased all of them.

Past voice

Our new public archives are Google Books, Gutenberg.org and Archive.org. I used them to find countless texts – geology textbooks, nineteenth-century guidebooks, accounts of shipwrecks, novels connected to both Weymouths. Volumes 4 through 8 open up the project to historical narrative. This is the voice of our digital archives.

Volume 4, Bound for New England, is the 104-person passenger list of the Hull Company, that ship of families who travelled from Weymouth to Weymouth in 1635. This list is loaded, a snapshot of several family trees as they branches out from Europe. Within each name is the story of the founding of the United States and what it means to be American. The book is designed as an infographic – men

on black, women on white, servants on blue, ages in relative font size. Volumes 5, 6 and 7, examine the interactions between English settlers and the Native Americans, a relationship frequently forgotten or mishandled. The permanent settling of Dorset pilgrims in Massachusetts was the beginning of the end for the Native Americans. The cultural destruction and genocide of an entire population begins here, with the establishment of European settlements in North America.

I included a first-hand account of the Native Americans as published by Thomas Morton in his 1637 New English Canaan. Morton describes the natives as superior to the English and admired their spiritual relationship to nature – he was arrested for his beliefs and banished to Maine by the Puritans. It's a text of protest, one that suggests other outcomes, other American histories.

In 1885, Gilbert Nash writes that the Indian title to the town was extinguished by purchase. Volume 6 is the entire text of the 1642 deed documenting the purchase of the land from the natives – the land that was to become the town of Weymouth, Massachusetts. It's signed by the English and the marks of three Native Americans.

In 1965 a perfectly-preserved Native American canoe was found in the mud at the bottom of a lake in Weymouth, Massachusetts. It's been carbon-dated to 1450 and I use my photographs of this canoe, now in the basement of the Weymouth Public Library, to introduce the concept of slow reading. The book zooms into a photograph of the canoe as I extract, sentence-by-sentence, each instance of the word 'canoe' from Samuel de Champlain's 1603 text 'The Savages.' A 1968 paper describing the process used to preserve the canoe is also included in this book.

So, these civilisations that pre-date our own, but continue to exist parallel to us, just below us – this continues with a nineteenth-century text about the discovery of Roman ruins at Jordan Hill, just outside Weymouth, England. An account of ashes, human bones, skeletons of birds and architectural fragments extends the scale of the archive back – from my own on-site photographs, to the 1854 text, to the Romans themselves, two thousand years earlier.

Sublime structures

The last four volumes of the archive deepen the narrative by asking us to cross unfamiliar thresholds. Inspired by Jane's account of the forming of the River Wey, I use geology as an excuse to return to Massachusetts for a second visit, to photograph House Rock. It's an erratic – a gigantic rock transported to its current location by

retreating sheets of glacial ice 10,000 years ago. It sits in the centre of town, surrounded by a park, forgotten. The pilgrims at Weymouth were aware of House Rock and wrote about it in their own histories. My forty photographs of the rock comprise Volume 9 – Errare – to wander.

The opening paragraph of John Cowper Powys' novel *Weymouth Sands*, describing the awesome power of the sea, is slowed down to a fifty-nine page read and paired with my photographs of Chesil Beach, a rare, seventeen mile geological formation in Dorset, just to the west of Weymouth.

Surprisingly, I found memorial benches that overlook the sea in both Weymouths. I documented dozens of these tiny plaques, and sat on each one. Each memory bench is a banal reminder of the small scale of human life, but paired with its own view of the sea – opens us up to expansive memory. Limitless journeys.

The final volume of Weymouths dissolves into light. I used chance operations to select 1,485 pixels of colour from my photographs of both Weymouths. This book is 330 pages of pure colour.

Archive as performance

In August 2012, I transformed a room above a bakery at the centre of Weymouth, England into a reading room installation.
All twelve volumes of *Weymouths* were there and open to the public. Weymouth was the site of the Olympic sailing competitions, and received thousands of visitors. I produced an edition of thirty-five of each volume, print on demand, and gave them away as a series of encounters every morning, a new volume each day, for twelve days. By the end of the Olympics, the entire edition was given away, each book an excuse for a conversation. By the end of the project, I had received several gifts in return: books, notes, original artwork, countless stories and powerful memories that will stay with me forever. I continue to be inspired by all of the encounters.
The community that formed around my books was small but seemed expansive in its ability to generate new meaning. In each connection, regardless of what was exchanged, my audience countered the books with their own sense of the meaningful, and passed it on.

The *Weymouths* project was an opening, a kind of open text, encouraging the reader to use the books – to participate, to look differently, to engage in rhetoric, to draw new relationships. I believe my investigation is at the centre of these four ideas: Archive, Author, Place and Identity. It's an invitation to wander, to roam, to search for other narratives. It's a beginning.

Matt Hulse
& Barnaby Dicker

The
Dummy Jim
Cycloscope

Dummy Jim is Hulse's second feature film released in 2013. Hulse and Dicker have been enacting an informal dialogue over the film during the final stages of its production. The Cycloscope joins the many offshoots Hulse's film project has spawned.

www.dummyjim.com

This Cycloscope reflects Dicker and Hulse's presentation at the BOOKLIVE! international symposium entitled *Feature Film as Artists' Book?*

Inspired by earlier adventures in cycling and optics, this device sets out to demonstrate how an artists' book may be constructed using a 'moving image' apparatus. It is, if you will, an exercise in the possibilities of the animated page.

The Cycloscope needs to be cut-out and assembled and used in conjunction with your record turntable. It consists of two parts: (A) the cycloscope drum and (B) a backdrop card. The apertures on the drum strips *must* be cut out first. These are marked in a beige hue (but do not cut out the '*I cycled into the arctic circle*' parts). The strips can then be joined together with the tabs (marked grey) on the outside. Assembled correctly, it will sit comfortably around a 7" record. The backdrop card should be positioned beyond the drum on the turntable and opposite to the viewer. The position and orientation of the backdrop can be altered by the viewer in any way they see fit.

I CYCLED INTO

THE ARCTIC CIRCLE

I CYCLED INTO

THE ARCTIC CIRCLE

Cycloscope Outer

via I was unaware that I must bring my c
me to the station at the river of Schelde, as
electric stairs might take me with my cycle
the deep tunnel and let me go on a walk
cycle beneath the river to the second elect
when I reached Antwerp. " Edinburgh of the

cycle with *via* I cycled into the silence of
as the first pitched my tent beneath the b
e down to beyond the Dutch peasants' ho
k with my take a walk to attend the ca
ctric stairs purchased a Dutch round loaf
he South." Dutch gentleman kindly offered

of the country. There I *via* There is an
branches of two fir trees sea, but we make
home. At dusk I left to fences are well-pa
afe restaurant, where I of brass which is v
f for the price of 6d. A the busy heart o
ed me a cup of Horlicks Military Headqu

n old Dutch proverb: " God made the ʋ
ke the shore." For a thousand years the n
ainted. Part of a tall pump is made to e
well polished. Dutch inhabitants are to t
of this Belgian capital to the Allied for c
uarters, where I applied to a British- do w

Cycloscope Inner

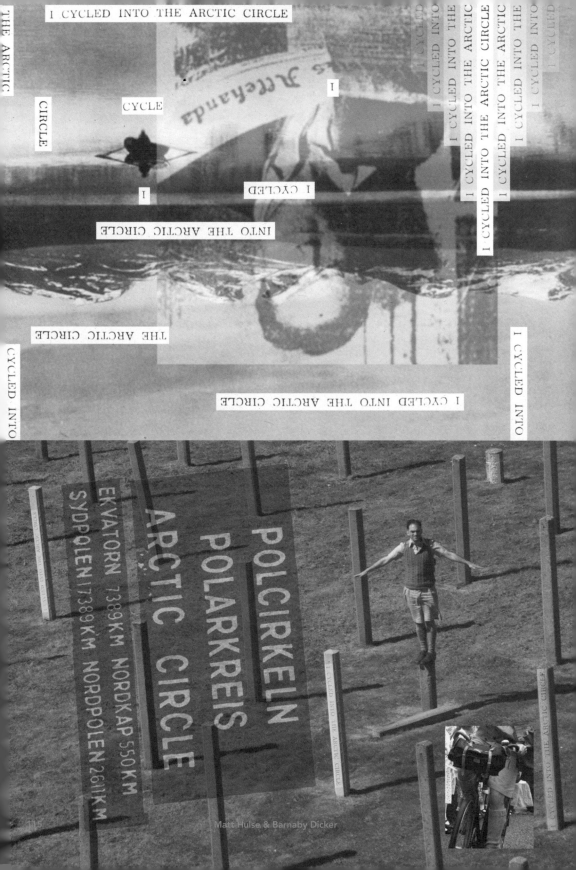

Matt Hulse & Barnaby Dicker

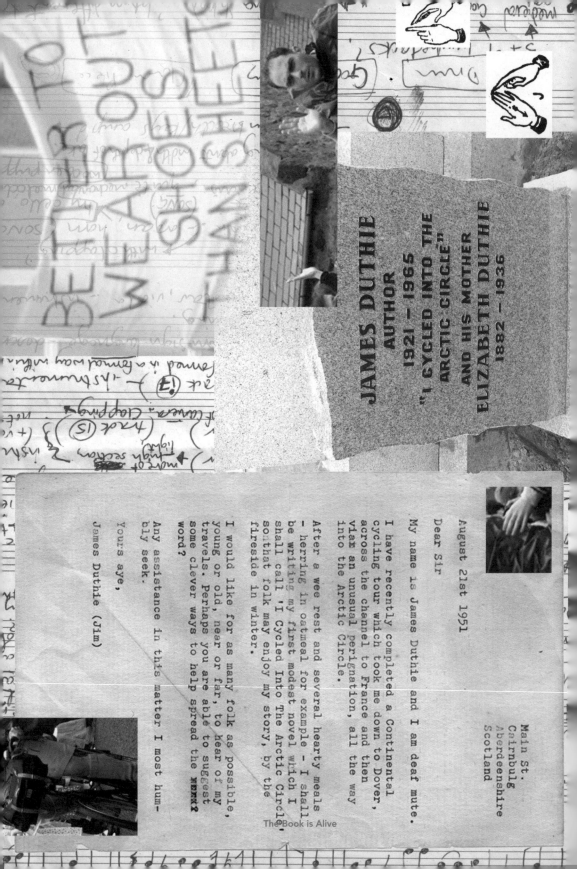

David W. Speck

Brecht, George. (1961) *TWO EXERCISES*. Arr. Speck, David W. for Terminal in C. (2010). London: David W. Speck

A first draft of this text was read out by David W. Speck at BOOKLIVE! on 9th June 2012. The book containing the score was read out loud with each page simultaneously projected onto the screen. The title of this text was then projected onto the screen while this text was read.

This book contains the score for a performance artwork, which is realised upon execution by a computer. The computer performs the score itself using the person at a computer terminal composed of a display screen and keyboard to perform the exercises contained within the score. Although the process is observable there is no provision for an audience. The art status of the performance is in question as although the computer is performing the instructions of an artist, in this case George Brecht, it is incapable of creating art itself. The result of executing the score is no different if initiated by an artist or a non-artist. It could also be argued that the art status of the work was lost during the translation from the English language to the C language yet that translation was performed faithfully by another artist so by that logic this arrangement has more art value than the original score.

The arrangement has been publicly performed twice. It was first presented then performed by a MacBook with Orlando Harrison as the other at Poltroon (a literary saloon) in October 2010 and then at bookartbookshop by a Digital HiNote Ultra 2000 in March 2012 where it was also interpreted and performed by Orlando Harrison with Sandra Harrison and others. In book form it was launched at the Small Publishers Fair in October 2011 and was exhibited, one page per day, in the window of bookartbookshop over two weeks in March and April 2012. It has been acquired by the Poetry Store, which is one of the Small Press Collections at UCL, and by the National Art Library at the V&A.

There are many things I could talk about regarding the score but here I will concentrate on why this is a book.

Its success is largely down to its form. Had I presented the arrangement as a downloadable file or paper printout from a computer it would not have caused such interest. The fact that it was printed using movable type and hand bound by Alexandra Czinczel in a limited edition allowed it to be taken sufficiently

seriously for it to be picked up and its content to be read.
If it were a computer printed hot glue (or perfect) bound book it would probably be ignored as just another computer book.
In addition the book form improves the legibility of the score.
At first glance the C language appears unintelligible. Yet when it is divided up into small parts and viewed one page at a time most people can understand it with only a little effort. The typographic C language is punctuation heavy so by using a lighter weight type for it punctuation is set back from the text allowing even the casual reader to concentrate on the recognisable words and not be distracted by the semantics of the language.

It is no longer sufficient for an artist to create an aesthetically pleasing object if they want to disseminate their work to a wide audience and be invited to speak at conferences. For the work to be accepted as a possible art object I also needed to place it in the right context. To describe this context I need to explain my understanding (as an artist) of the development of what I see as the prevalent theories of art in use today. In the interest of brevity I'll make many generalisations and sweeping statements. Please bear with me.

During the 1960s and 70s the idea that an artwork's status as art was recognised and validated by a critic's evaluation of its aesthetic value and competence of execution was challenged and eventually overturned by two theories of art.

The first was what I will refer to as the intentional theory of art, which proposed that a work was art because the artist intended it to be so. This intention could be implicitly acknowledged as the reason for an artwork's existence or explicitly declared by the artist. The artworks that were often used to illustrate this theory were Duchamp's ready-mades, Bottle Rack and Fountain, which had remained almost forgotten for 50 years. It was Duchamp's apparent intentional declaration of these objects as art that made them so.

The removal of the need for a critic's validation undermined the critic's role in interpreting and explaining artwork which allowed the artist to directly communicate the ideas and processes involved in creating art. Some artists took this a step further and presented the ideas or processes in place of the work.

At the same time Duchamp's ready-mades were being used as proof of another theory of art, the institutional theory. This held that the placement of the objects in an art context, i.e. in an exhibition in a gallery or museum, gave them art status. I would suggest that this theory has been combined with the intentional theory to form the main theory of art in use today.

Both theories are of equal value and appear to be complementary. There is, however, one important difference, which is that while

the intentional theory puts the artist in charge of the production and dissemination of art works, the institutional theory puts the institution, personified by the curator, in charge.

This power imbalance between the two theories has resulted in the institutional theory becoming dominant. Despite a brief moment in the late 1960s where the artist, at least in New York, was in charge of the production and dissemination of art work, the void left by the decline of the critic was soon filled by the curator, whose role, thanks to the institutional theory, has expanded over the last 50 years to include not only the roles of collector, interpreter and explainer but also that of patron and instigator. As this has seemingly resulted in more opportunities (shows, funding) the rise of the apparently benign, non-judgemental, curator has been largely unchallenged and mainly welcomed by artists who are the ones who have, in my opinion, benefited the least from this development.

Although the institutional theory has gained importance it still requires the intentional theory, albeit in reduced form. A work requires both artistic intent and institutional acceptance to acquire full status as art. The curator is incapable of subjective critical judgement so the decision as to what is art has remained the artist's responsibility. The intentional theory has been reduced to merely confirming the initial art status of a work i.e. the artist presented this as art therefore it is art.

This may seem to have made the production of artwork easier for the artist and the selection easier for the curator but it has posed a new problem. How does the curator know that the person submitting and declaring their work as art is an artist?

Whereas a critic would have pointed out the competence of the artist, possibly in the case of an Abstract Expressionist by simply declaring them so and justifying this by pointing out earlier figurative works, a curator can do no such thing. Subjective judgements are hard to justify within an institution. So instead the artist is judged on their professionalism, first by their attendance at art school followed by their exhibition and acquisition records. This record, the artists' CV, can be evaluated not only by the artist's achievements but also on the status of the institutions that educated the artist, exhibited the work, etc. The artists CV is therefore more a record of institutional acknowledgement of an artist's professional status. It states that the artist is qualified to declare work as art. The higher the status of the artist the more outlandish the claims they can make as to the art status of their work. A newly graduated artist is usually limited to widely accepted forms of art whereas an established artist is able to claim almost anything as art.

Therefore in order for a work to be fully accorded art status it needs to be produced by an institutionally approved artist in a

form appropriate to the artist's status and accepted as art by a recognised institution.

So the other reason for presenting the score as a book was that in order for it to be disseminated widely it needed to be in an institutionally acceptable art form. The artwork itself is not fully observable so, for example, a video recording a performance of it would not have worked as my reputation as an artist is not strong enough for such a work to be accepted as art. The work needed to be contained in an object which could be accorded art status irrespective of its content, in this case an artists' book. That, along with my identification as an artist allows it to be accepted as an artwork.

Sarah Bodman

New Pages: Celebrating the Book as a Democratic Multiple in a Variety of Twenty-First-Century Forms

In the digital age, artists are exploring and utilising the tools available to create books as e-pub, hypertext and print on demand (POD) models. And, against the trend of predictions for the death of the printed book, artists, writers and small publishers are embracing the potential of small-scale publishing of affordable, inventive, paper-based books.

In the 1960s, as a freer society emerged after two world wars, many artists explored alternatives to traditional means of producing and exhibiting artworks; moving away from more established gallery shows towards more public interaction. The philosophy of collaboration, exploration and dissemination for many artists over the last fifty years, exemplified in the Fluxus movement, meant producing affordable book works as 'democratic multiples'. This involved utilising commercial production processes such as offset-lithography, photocopy or screenprint, to make large editions of books or pamphlets that could be sold very cheaply or just given away.

As digital technologies have developed in the twenty-first-century, artists and writers are now exploring POD video production, open-source software (OSS) and electronic book production. This fluidity of publishing allows digital to support the physical book through publishing of variant editions to a wide audience, and there is still much future potential to explore the merging of and distinctions between screen and page, and the discrete strengths and capabilities of each.

Digital technology has allowed artists to design books to upload for print and distribution through websites such as Lulu and Blurb, and to convert for tablet and iPad devices, building upon the 1960s tradition of the democratic multiple through affordable, unlimited editions, now printed or downloaded to order. Utilising these technologies allows artists to share their ideas freely, and to offer them to a new and extensive audience. For example the British artist

Tom Phillips began his bookwork *A Humument* in 1966, scoring into the Victorian novel *A Human Document* by W.H. Mallock. Phillips has continued to create and publish variant versions of the book since the 1970s, and launched his *A Humument* App for the iPad in November 2010, introducing it to an entirely new generation of digital natives forty-five years later.

The artist Nicolas Frespech is experimenting with e-publishing artists' books that can be read on many devices including the free download e-book management application Calibre and more recently with open-source to produce works that can be read on any device. Frespech has also been assembling and publishing data on his website as a platform for dissemination dedicated to artists' books published in e-pub formats. From the website list, Florent Lagrange's *Itinéraire bis / Alternative Route* (May 2012) makes use of GPS tracking of the artist's walks, train and bicycle journeys, using the trajectory to visualise the journey as a drawing on the page, and *Prendre du recul / Stand back* (May 2012) optimised for the iPad, plays with the notion of depth in the device's screen.

With the e-book outselling the physical book for the first time in 2011, small publishers such as Visual Editions in the UK are producing affordable, specialist editions for a market seeking concept and aesthetic rather than masses of mainstream blockbusters. Visual Editions, founded by Anna Gerber and Britt Iversen, has published four successful editions of books since its inception in 2009. They not only publish beautiful, affordable books but also utilise multi-media platforms to showcase writers' works to a wide public, VE3: *Composition No.1* by Marc Saporta for example (August 2011) can be purchased as a physical book object or as an App for iPad and iPhone. The physical series of loose-leaf pages in a box can be read in any order, to create multi-faceted or individual narratives.[1]

VE4: *Kapow!* by Adam Thirlwell (May 2012), unfolds in a multi-directional structure to convey the chaos within the texts.
VE2: *Tree of Codes*[2], by Jonathan Safran Foer, is a complex, die-cut sculptural book, with a different die used for each page, using an existing text (*The Street of Crocodiles* by Bruno Schulz). A new story was created through literally cutting out words, so that texts interplay through viewing holes in the pages. Produced by Die Keure in Belgium, this book would probably not have been viable a few years ago when e-books had not taken over the market so voraciously. But now, specialist design and print in relation to appearance and touch, are effective tools for small publishers to focus on when thinking of how their books will compete with the digital editions available for a few pounds or less on Kindles.[3]

Visual Editions publishing shares some of the concepts of the Liberature movement founded in 1999 by Katarzyna Bazarnik and Zenon Fajfer in Poland, which decrees absolute attention to

[1] www.visual-editions.com/our-books/composition-no-1

[2] www.visual-editions.com/our-books/tree-of-codes

[3] Fajfer, Zenon. (2002) In: Bazarnik, Katarzyna (ed.) *'liryka, epika, dramat, liberatura'*, Od Joyce's a do liberatury. Krakow: Universitas, pp. 233-239 Read the English text at: www.liberatura.pl/teksty-dostepne-nastronie.html

[4] ibid. v.

[5] The kinetic version of 'Ars poetica' can be viewed at: www.techsty.art.pl/magazyn3/fajfer/Ars_poetica_english.html

[6] www.ha.art.pl/wydawnictwo/katalog-ksiazek/833-herta-muller-straznik-bierze-swoj-grzebien.html

[7] www.ha.art.pl/wydawnictwo/katalog-ksiazek/2201-james-joyce-finneganow-tren.html

[8] An interview with Radoslaw Nowakowski, by Sarah Bodman and Tom Sowden, June 2008, discussing End of the world according to Emeryk, can be watched at: www.bookarts.uwe.ac.uk/nowakowski2.html

[9] www.issuu.com/futurefantasteek

[10] www.issuu.com/verysmallkitchen

considering and conveying a book in its entirety. As small press publishers, Liberature's books celebrate all aspects of the work, from concept to format. Their works are visual and experimental but they are adamantly opposed to their being labelled as 'artists' books': '[…] despite their unconventional appearance, in fact, we have never thought about our books as artists' books, as their origins were literary. They grew out of texts (out of telling stories and expressing emotions) – that were seeking space to accommodate themselves in it […in liberature] the physical object ceases to be a mere medium for the text – the book does not contain a literary work, *it is the literary work itself*'.[4] The shape and structure of the book, its format and size, layout and kind of typeface, kind and colour of paper, illustrations, drawings and other graphic elements can be valid means of artistic expression. Fajfer's *Spogladajac przez ozonowa dziure (Detect Ozone Whole Nearby)* published by Korporacja Ha!art, Poland, 2004, has an innovative 'emanational', multilayered structure in which initials of the words reveal a hidden text. The procedure of reading the initials should be repeated until the whole text is reduced to a single word. The text printed on transparent foil is placed inside a bottle. *Ten Letters*, published in 2010 explores a range of media production, from the printed page, to electronic publishing,

and another emanational piece *Ars poetica* works successfully across both paper and screen, relying on the engagement and voice of the reader to complete it.[5]

Liberature's recent publications include the first translation of Herta Muller's first poetry volume *Strażnik bierze swój grzebień/ Der Wächter nimmt seinen Kamm*[6] and this year saw them publish a Polish translation of *Finnegans Wake*[7], following Joyce's original layout, typography and design, very closely. Liberature have also worked with the Polish writer/artist Radoslaw Nowakowski. Nowakowski has been publishing his own books since the 1970s, upgrading from a typewriter and carbon paper to working with hypertext. End of the world according to *Emeryk*, is Nowakowski's 'Hasarapasa hypertext tale in four parts about what may happen one hot summer's day in a few or in a dozen of years when p-paper is finally replaced with e-paper', which has also been designed to be impossible to print out on paper.[8]

Many artists use online viewing to showcase exquisitely crafted books, the Australian artist Tim Mosely produces very limited editions and one-off pulp-printed books on handmade paper, with parallel free online versions of the same content viewable through PageFlip; for example *White as Snow* in 2010, exists as a unique handmade book, online PageFlip and free PDF download version. Book artists have also been tapping into Issuu, for example, Jackie Batey publishes all of her *Future Fantasteek!* editions in paper and issuu versions[9] and verysmallkitchen has been publishing online bookworks by artists Mary Yacoob, seekers of lice and David Berridge,[10] all of which can be viewed and shared.

The American writer, poet and artist Clifton Meador, has been producing his artists' books via Lulu, since 2006, with ninety-seven titles published to date. These books range from free (or very cheap) PDF downloads, to 350-page hardback editions.[11] Meador is prolific in his outputs, and uses the book format to create complex visual and text-based narratives. Publishing through a POD allows him to disseminate his ideas, from conception and design to output, a nd to be able to offer full-colour editions with hundreds of pages. As POD involves no outlay costs for the artist publisher, it really does make it a truly democratic means of producing multiples in the twenty-first century. Anyone with access to a computer can now produce a book, decide on any profit margins and publish. Offering a range of choices from free download to hardback editions makes the work accessible to an international audience, whether that is of institutional collectors who can purchase the hard copy, or students and peers interested in the artist's ideas who can leaf through the free PDF versions.

Artists and publishers will of course, continue to work with the book in any format that suits their project, and this includes traditional print methods such as letterpress. The small press as an artistic, political and social alternative to mainstream publishing is evidenced in the work of national and international small publishers; Bracketpress (www.bracketpress.co.uk) has printed many editions including pamphlets such as an array of essays and prose works by Penny Rimbaud, including his political prose *How?*, dedicated to the memory of Allen Ginsberg. Bracketpress also published *We Want Everyone: Facebook and The New American Right* by Tom Hodgkinson, an investigation into the politics behind the world's biggest social networking site and the data security implications for Facebook's millions of users. Aaron Cohick's NewLights Press (newlightspress.blogspot.com) works with writers including Kyle Schlesinger and J.A. Tyler, to produce hand printed editions of experimental writing and imagery. *What You Will,* a recent book of poems by Kyle Schlesinger was letterpress printed at NewLights Press in three colours from photopolymer plates, and J.A. Tyler's ZZZZZZZZZZZZ *[an island]*, as one of five narrative works based on a single core story. *The new manifesto of the NewLights Press,* by Aaron Cohick is a collection of thoughts on and of the book; of what it can mean to make books now, and how they might be received by their audience. It is published as a letterpress printed unlimited edition, free PDF and digital version. As an aside, the NewLights Press has a brilliant policy to promote handling of their books and artists' books when purchased by public and academic library collections. If library staff buy any of their editions for their special collections (i.e. non-circulating),
NewLights Press will give them the same book free, or another publication to the same value if the library prefers, on the condition that the second copy goes out onto the public shelves for library users to borrow.

[11] www.lulu.com/spotlight/cliftonmeador

[12]www.victorygarden.co.uk

[13]www.themostdifficultthingever.blogspot.com

Kevin Boniface is an artist/writer and postman, based in Huddersfield.[12] His ongoing publishing output has evolved from his first photocopied zine edition in 1999 *White Dog Biz*, which interspersed Boniface's Royal Mail diary entries with photographs by Shaw & Shaw, to video and POD in 2012. Other small, self-published editions of books followed *White Dog Biz*, with a foray into the mainstream in 2008 when Old Street Publishing brought out *Lost in the Post: Dispatches from inside Her Majesty's Postal Service*, with Boniface's text garnered from observations on his postal round, alongside Shaw & Shaw's photographs. More recently, in 2011, *The Most Difficult Thing Ever (The Movie)* condensed one year's observations into half an hour, with Boniface reading excerpts from his blog *The Most Difficult Thing Ever*, as pigeons wander in and out of vision on film and cars slowly cruise country lanes. Boniface's observations are sharp and dry, but told with a warm affectionate humour that genuinely wonders about, and observes how people live today.[13] Boniface began *The Most Difficult Thing Ever* as a blog, a documentary in diary form, assembled from found notes and objects on his postal route, short film recordings by Boniface as he walked, and overheard conversations; for example, the title piece:

> It was raining steadily as I made my way through the beer garden of the old Bare Knuckle Boys Inn (recently renamed Bar-celona) with a parcel for the landlord. All the wooden picnic style tables were empty apart from one; three young looking students were sat with a single glass of orange juice between them. They were all smoking and discussing the pros and cons of giving up. One of the girls – long slightly backcombed dyed-black-bob and stripy tights – said 'I couldn't give up, no way, I even smoke in the shower'. When the slightly camp boy with the thick rimmed glasses and the bandolero-style record bag said 'really?' she went on to explain 'yeah, it's the most difficult thing ever'

Boniface searched for a publisher but eventually decided to publish it himself, turning an online viewing platform into a POD printed paperback edition, under his own Victory Garden press imprint - a nice reversal of roles in the digital age. A different example of digital to paper output is the Danish artist Mette-Sofie D. Ambeck's *Day Return*, produced at CFPR Bristol with Tom Sowden. Ambeck made a video recording of her return journey on a night train to London, converting the video file to laser-engrave a metre-long concertina book. A laser cutter was used to engrave the blurred shapes of the passing lights from the video into black Somerset

paper, creating apertures for daylight to shine through as the concertina unfolds. You can watch a minute long video recording of the type of night journey that inspired the book on the artists' website.[14] The American artist Heidi Neilson produced her 752-page hardbound digital-offset printed book and fifty-second video, *Cloud Book Study*, in 2011. The book and video are intended to be viewed together, with the video showing the book paged though at high speed, revealing a time-lapse film clip of cloud motion across the pages. This gives an animated insight into the static paper version of the book; how it can be viewed and at what rate real clouds could travel across the pages.[15]

Now that making videos for upload onto public platforms is relatively easy, many artists have been introducing video works around the book into their repertoire. A search for 'artists' books' on YouTube or Vimeo yields a fair amount of results, considerable enough for a search term that doesn't exist yet on POD websites such as Lulu. Book related films by artists offer a variety of approaches to video. At CFPR, Tom Sowden and I have collaborated on books and videos as stand alone pieces using screen transitions as the equivalent of page turning; the Ed Ruscha homage *No Dutch Details*,[16] films that support an artists' book as a separate artwork; *Ø - Cherry Blossom Island Tree* (2009), *A Place of Interest* (2010), and annual, collaborative group videos with Nancy Campbell for World Book Night, where we produce a video and artist's book with artists, writers and musicians; *Dinner and a Rose* (2010), *TOAST: A Night on Weevil Lake* (2011), and *The Secrets of Metahemeralism* (2012). Apart from being great fun to make, the videos add another dimension to each project, producing a book can be slow and time consuming, but the video composition can be much faster and more playful, allowing contributions from anyone in the group. The videos also allow a 'behind the scenes' idea of how and why those particular books are being made, and what goes into the collaborative process.

The multi-disciplinary artist Guy Begbie produces videos by filming sections of text and images from the pages of existing books to create new screen-based narratives with audio. *Roma Berlitz* (2009) for example was constructed as a reconfigured new narrative using found travel guide book imagery.[17] Recent works by Begbie include *Back Room Sounding*, an installation piece of twelve structural artists' books that consider interior space, with excerpts of texts including Bachelard's *Poetics of Space and of Reverie* and Fernando Pessoa's *The book of Disquiet*. The installation includes screening a twenty-minute film by Begbie that surrounds the space occupied by the books. Begbie's most recent film *Orange Rumba* is a short video bookwork 'activation', using the law book 'Statutory Instruments' as a performative, pyrotechnic tool.[18]

The last example, and one of my favourites of an artist moving freely between traditional and digital is that of Andi McGarry,

[14] www.ambeckdesign.blogspot.co.uk

[15] www.heidineilson.com

[16] Ed Ruscha's *Dutch Details* was produced and published in Deventer, The Netherlands, by Stichting Octopus / Sonsbeek 71, in 1971. No Dutch Details deliberately fails to reproduce each of Ruscha's books published between 1963 and 1978, using only props found or created in miniature. The video can be viewed online at: www.bookarts.uwe.ac.uk/nodutchc.html

[17] www.guybegbie.com/Pages/video.asp

[18] www.vimeo.com/37903577

[19] Traditional and emerging formats of artists' books: Where do we go from here?
(09/07/09-10/07/09) A two-day conference, held at the School of Creative Arts, University of the West of England, Bristol, UK.
All presentations are online at www.bookarts.uwe.ac.uk

who absolutely shunned digital technology in favour of the hand-produced, only to be accidentally seduced by its potential. McGarry epitomises the possibilities of moving back and forth smoothly between video and paper-based books. As part of a presentation at the conference *Traditional and emerging formats of artists' books: Where do we go from here?*[19] McGarry explained his transition into e-publishing:

> In 2007 several things occurred which changed the way I was publishing, what I published and how I published it. Sarah Bodman had sent me a questionnaire asking me amongst other things 'Did I think computers would impact on the way I produced work?' the Luddite in me chortled as I picked up the quill pen to produce another hand made copy. Then I won a Folkatronica bursary with Visual Arts Ireland, this enabled me to run some ideas in a DVD Video format and produce a DVD with a soundtrack. The DVD featured lots of underwater imagery and was also turned into a book - but this got me thinking - making movies was such fun, and there were a host of new challenges. Simultaneous acquisition of a laptop and a digital camera allowed me to explore the possibilities of movie making using a simple editing programme (Movie Maker) it had all become possible. I began making movies at a feverish rate. […] The movie camera allows for a different kind of landscape appreciation, via editing and with inclusion of sound track the synthesis makes an entirely new form of artwork. I want my films to retain a notebook scrapbook journal feel. […] I have published a number of films on YouTube and as an outlet YouTube and similar sites are an interesting starting point. The work is available for free - thus the return of a kind of cheap multiple.

Andi McGarry still produces his beautiful hand made books, with marbled papers and images and texts all hand rendered in Indian ink, but he also publishes movies, using the transition between frames as he would turn a book's pages. An animated version of his unique artist's book *The Browness of Sleep* with a composition created to play alongside the animation was published on YouTube in 2010.
He says: 'Edgar Allen Poe refers to sleep as 'Little slices of Death' this sentiment is revisited in *The Browness of Sleep*, this uncontrollable urge, that inhabits us on a nightly basis. Collectively the works are a series of drawings, paintings and book works that chart this void. The original bookwork is a narrative, hand painted, unique piece and was a prize winner at the 8th International Book Art Festival in

Poland.'[20] It is this kind of movement across the borders of physical and digital book formats that allows artists, writers and publishers to create beautiful, unique pieces and small editions of works on paper, whilst simultaneously exploring the potential of play in the book through a variety of screen based media. Embracing this potential for multi-faceted publishing offers a wider existence for the book through the sharing of content and ideas. It also allows the work to be experienced freely on many levels that are accessible to an international audience; that truly is the concept of the democratic multiple.

[20] All of Andi McGarry's YouTube bookworks and films can viewed on his channel *AAAAAAndi*

Andreas Schmidt

The Speed of Books

17-32 of 66 Books First |

Facebookbook
Published 16 November 2011

Test 1/100
Published 07 November 2011

The Time Machine
Published 05 November 2011

NEON BONEYARD LAS VEGAS A-Z JUDY NATAL
Published 31 October 2011

watch?v=XrKFxtutR3s
Published 28 October 2011

watch?NR=1& v=h1BrNliowLE
Published 24 October 2011

...Opening soon
Published 20 October 2011

The Cost of Photobooks: A History volume II
Published 13 October 2011

ARTADVERTS OCTOBER 2011 I N T E R N A T I O N A L
Published 13 September 2011

Dark Matter
Published 12 September 2011

Just Published
Published 02 August 2011

Drones, Reapers, Predators and Hellfires (Autoflow)
Published 28 July 2011

I want to be your friend today, tomorrow and for the rest of my life.
Published 19 July 2011

Punkt und Linie zu Fläche
Published 05 April 2011

Digital Landscapes
Published 01 April 2011

Handshakes
Published 30 March 2011

49-64 of 66 Books First |

Images for - Report images
Published 22 September 2010

Suspended / Submerged
Published 08 September 2010

133 PAGE PSYCHO
Published 02 September 2010

YELLOW PAGES LAS VEGAS
Published 31 August 2010

SEPT.26,2009
Published 12 April 2010

IRAQ 9/19
Published 03 February 2010

Front Window
Published 13 January 2010

UNTITLED 1 877 333 9474/C
Published 16 October 2009

Please follow me.
Published 09 September 2009

Schmidt Sean Andreas Schmidt
Published 20 July 2009

Flugzeugbilder /Aircraft Pictures
Published 06 June 2009

ARTFORUM MARCH 2008 INTERNATIONAL
Published 20 May 2009

G20
Published 06 May 2009

Number 5
Published 17 December 2008

Marfa, Texas and Fort Davis, Texas and Prada, Marfa
Published 21 October 2008

Frieze Art Fair
Published 16 October 2008

65-66 of 66 Books First |

38 Andreas Schmidt
Published 10 October 2008

Identity
Published 10 October 2008

Peter Jaeger

John Cage, Chronobiology, and the Discourse of the Analyst

 I have nothing to say

 and I am saying it and that is

poetry as I need it (Cage, 1961:109).

Cage began using chance operations in 1951, when he was given a pocket version of the *I Ching* by his student, the composer Christian Wolff. He used this ancient Chinese oracle to determine such compositional factors as the number and duration of sounds in a musical composition, or the choice and placement of words in writing. This article employs an online random integer generator based on the *I Ching* to organise textual layout and to generate a performative reading pattern.

It may be enlightening to compare John Cage's use of blank space in

his 1959 text *Lecture on Nothing* to Charles Olson's discussion of the temporal qualities of open field notation. In the influential essay *Projective Verse*, Olson describes how the graphic organisation of space on the page represents time: the larger the space,

the longer the silence between words. Olson writes: 'if a contemporary poet leaves a space as

long as the phrase before

it, he means that space to be held, by the breath, an equal length of time' (Olson, 1950:245). By aligning spatial form

with time, Olson provides a means to chart a physical body in writing, to present text as a temporal indicator of

breath and of lived experience. Similarly, Cage's

Lecture on Nothing is printed in columns 'to provide a rhythmic reading' (Cage, 1961:109). Much like Olson's spatial notation, the blank spaces and durational stops

and starts in Cage's texts generate a series of temporal pauses which serve as sites for embodying a physical, material experience of

time. ¶ What does this physical embodiment of time in language have to do with the body? Michael Holquist has argued that 'body clocks organise the activities of cells, tissues, and hormones in a way that uses time to provide internal information about external conditions: the body, in other words, is dialogic' (Holquist, 1981:25). If the body is a dialogic sign system, it is potentially

translatable. In effect, the spatial notation found in Cage

and Olson can be read as a type of 'intersemiotic translation,' following Roman Jacobson's 1950 theorisation of this term as an interpretation of linguistic signs by non-linguistic sign systems, such as the ekphrastic translation of verbal language into painted image.

By foregrounding the body as text, Cage presents the page as

a site for the mutual interdependence of somatic ('natural') and symbolic ('cultural') registers. However, the intersemiotic translation of body events does not necessarily imply the presence of a universal, ahistorical, and acultural body language; the body is a sign

system which cannot exist apart from social and linguistic phenomena. Cage's implication of a chronobiological body in language invites readers to apprehend the relation between somatic 'language' and the symbolic order. The empty space represented by Cage's 'nothing'

functions as a kind of non-site for the body – i.e., for the experience of a living, breathing body as it is translated through time and language. ¶ Cage's representation of the chronobiological body via formal means shares some affinities with Jacques Lacan's late investigations into language and power,

at least to the extent that both the chronobiological body and Lacan call into question established modes of enunciating knowledge. In his *Seminar XVII* of 1971 Lacan posits four discourses which organise social relations: the master, the university, the hysteric, and the analyst. These discourses are not specifically

inhabited by individuals, but are relational. Put another way, these discourses are 'four possible articulations of the networks regulating intersubjective relations' (Žižek, 1991:130). ¶ The discourse of the master holds a privileged place among the four discourses; it provides a 'master signifier,' which must be obeyed, and which consequently occupies a position of

power. As Bruce

Fink writes of the master signifier, 'no justification is given for his or her power – it just is' (Fink, 1999:31). The master signifier is also

unconcerned with knowledge. The problem for the master signifier is that there is some disturbing surplus, some lack which escapes its power, an object which, in Lacan's terms, 'presents itself as the most opaque in the effects of discourse' (Lacan, 2007:43). We could say that the chronobiological body in Cage

stands in for this missing remnant, which cannot be

symbolised by the

master discourse. ¶ In

the discourse of the university, systematic knowledge is the ultimate authority. In order to present knowledge, the discourse of the university must repress the chronobiological body – in effect, the discourse of the university represses the surplus remnant of

bodily experience which escapes power. There is a hegemonic relationship between the discourses of the master and university, because the power of the master signifier lurks behind what seems to be neutral, unbiased knowledge. As Lacan writes, 'for centuries, knowledge has been pursued as a defence against truth' (qtd. in Fink,

1999:33). The discourse of the university is key

to socialisation, to the subject's assumption of a socially acceptable position within the symbolic order. However, since there is always a surplus remnant which escapes symbolisation (in this case, the blank space as a site for the

intersemiotic translation of the chronobiological body), the discourse of the university's act of

repression leads to lack. For Lacan one of the key misrecognitions propounded by the discourse of the university (in alliance with the master's power) is the notion that the subject takes the phenomenon of consciousness as unified and autonomous. One key element of the discourse of the university is its failure to unveil

this misrecognition; instead of questioning the master's discourse, it supports power by constructing the 'subject who knows,' who misrecognises him or her self as a complete and autonomous individual. Lacan coins the neologism 'I-cracy' to illustrate this complex: 'from every academic statement by any philosophy whatsoever ... the I-*cracy* emerges, irreducibly'

(Lacan, 2007:63). ¶ The discourse of the hysteric begins to

move beyond the hegemonic relationship upheld by the master/university complex of discourses. Hysterical discourse articulates the expression of a fissure; on one hand, this discourse recognises the existence of a subject position, situated in the

symbolic order or social network (e.g. 'I am a worker, a teacher, an employee, an artist, a student, etc.'). On the other

hand, this discourse also questions the non-symbolised surplus of unrealisable desire or lack which has been produced by the symbolic.

In effect, the hysteric discourse embodies this gap, this 'question of being' (Žižek, 1991:131). While the university discourse acts in alliance with the master discourse, the hysteric challenges the master by pushing the limits of knowledge into uncertainty, thereby maintaining the contradiction between conscious knowledge and unconscious desire. The hysteric does not gloss over this split by trying to

make phenomenon fit into an ordered and containable whole. The chronobiological body passes through the discourse of the hysteric because it contrasts conscious and

rational language with the unconscious and indeterminate surplus of bodily excess. This body in language is hysterical in the sense

of Žižek's politicised recasting of the term 'hysteria' – i.e., as an indication of the subject's resistance to socialisation: 'what is the hysterical question if not an articulation of the

incapacity of the subject to fulfill the symbolic identification, to assume fully and without

restraint the symbolic mandate?' (1989, 113). The chronobiological body exhibits hysterical symptoms by blocking

the subject's desire for the full presence of meaning. Instead of following

a desire for the university discourse's promise of knowledge as satisfaction, the chronobiological body desires dissatisfaction through indeterminacy and through the textual embodiment of physical, lived experience. Cage's experiential 'nothing' desires to have its desire for meaning

impeded, in order to frustrate symbolic totalisation. To situate the chronobiological body in the discourse of the hysteric is to illustrate how it articulates the experience of a fissure between

the signifier that represents a socially established practice of knowledge, and the non-symbolised, affective surplus that is repressed by the symbolic order. ¶ The split subjectivity that is found in the discourse of the hysteric does not mean that the unconscious is accessible (and therefore manageable) to the hysteric; Lacan saw the hysteric's discourse as an essential step in a process that culminates in

the discourse of the analyst. This final discourse is somewhat paradoxical, because it attempts to speak from the position of the element that escapes speech. In the context of Cage's intersemiotic translation practice, we could say that the discourse of the analyst stems from the chronobiological body. The body materialised by Cage as

a 'nothing' discursifies what has been repressed by the master/university hegemony of discourses. Here the subject begins to experience a transformation in its relationship to the symbolic order. In effect, the discourse of the analyst produces a new master signifier for the subject, and in Cage, this new signifier

is the chronobiological body. For Lacan, real social change will only occur once the subject can produce this new, un-totalising and adaptable master signifier. ¶ The unique perspective that Lacan's four discourses offer allows us to consider the potential for the

chronobiological body to effect social change, because the chronobiological body provides an exemplary site for undermining the discourse of the master. Cage's intersemiotic body translations point to an alternative mode of representing subjectivity – one that takes the body and lived experience into account, at a material level. In contrast to the 'living book' of chronobiology, the ordinary or dead book clearly participates in

the discourse

of the university, due to its stress

on the transmission of clear and distinct knowledge, presented in terms aimed

at a universal body of educated subjects who practice that knowledge – a form of discourse that Lacan would call 'the fantasy of a totality-knowledge' (Lacan, 2007:33). In contrast the chronobiological body as represented by Cage foregrounds the complex relationships formed among knowledge, language,

the body, materiality, and subjectivity. This arena of investigation complicates any straightforward reading, thereby calling into

question the university discourse's fantasy

of rationally communicated meaning. Cage's chronobiological texts function as sites for the eruption of non-sense – a seemingly pejorative term which would

ordinarily be repressed by the discourse of the university in its attempt to seamlessly produce knowledge. ¶ Instead of setting up

language as something to be interpreted, the chronobiological body reframes its referent by foregrounding that referent as a textual construction – i.e.,

as a translation of body into language
and silence, organised as 'poetry.' This dismantling of knowledge-production further entails a dismantling of the individual, self-present subject. The 'I' of Cage's

chronobiological body is not the unified

subject or individual as hero

of liberating knowledge found in the university discourse. It is instead a textual 'I' which destabilises the unicity of conventional reading and its construction of the classical subject of knowledge, the subject who can answer with his name or with the word

'I' to the question 'who is speaking?' The chronobiological body could thus be recasted in Lacanian terms as 'I am that which I am not,' or in Žižek's reformulation: 'I am conscious of myself only insofar as I am out of reach to myself' (Žižek, 1993:15). Following this logic, the chronobiological body entirely dismisses the idea of finding a 'voice' in favour

of producing the phrase without subject and of saying 'nothing'.

Bibliography

Cage, John. (1961). *Silence*. Middletown: Wesleyan University Press.

Fink, Bruce. (1999). 'The Master Signifier and the Four Discourses.' In: (ed.) Nobus, Dany. *Key Concepts of Lacanian Psychoanalysis*. pp. 29-47. New York: Other Press.

Holquist, Michael. (1989). *Bakhtin and the Body*. In: *Critical Studies* 1.2. pp. 19-42.

Jakobson, Roman. (1959). 'On Linguistic Aspects of Translation.' In: Brower, R.A. (ed.). (1959). *On Translation*. pp. 232-239. Cambridge: Harvard University Press.

Lacan, Jacques. (2007). *The Seminar of Jacques Lacan Book XVII: The Other Side of Psychoanalysis*. (trans.) Russell Grigg. New York: W.W. Norton & Co.

Olson, Charles. (1997). *Collected Prose*. (eds.) Allen, Donald & Friedlander, Benjamin. Los Angles: University of California Press.

Žižek, Slavoj. (1991). *Looking Awry: An Introduction to Jacques Lacan through Popular Culture*. Cambridge MA: MIT Press.

Žižek, Slavoj. (1989). *The Sublime Object of Ideology*. London: Verso.

Annabel Frearson

Frankenstein2...

Frankenstein2... is an ongoing endeavour which involves rewriting or more accurately rearranging Mary Shelley's *Frankenstein* (1831), using all and only the words from the original to create a new contemporary novel, or form of novel, and associated works.
To date extracts have been presented as narrated performances by actors, as posters, magazines, a film of movie titles, and an album of pop songs *(Bad Brain Call)*.

Frankenstein2... follows previous projects in which I have recontextualised existing texts better to understand them through a radical, material form of engagement while also attempting to grasp the implications of new forms of textual production and distribution, performance or dispersal. *BaudriR* for example is a verbatim reproduction of Jean Baudrillard's essay 'In the Shadow of the Silent Majorities' dispersed within AOL Internet chat rooms, using the avatar name of BaudriR.

The reconfiguration of *Frankenstein* is facilitated through a bespoke piece of software called *FrankenWriter,* developed by robotics artist Patrick Tresset. *FrankenWriter* both rationalises the process by relieving me of the arduous task of calculating how many of which words I have used up, overused, or if I am trying to use words outside of the *Frankenstein* 'dictionary', and helps to create a strategic distance from the original text.

By way of a loose plot, the lead protagonist of *Frankenstein2; or, the Monster of Main Stream* is a modern-day monster, an amoral product of mainstream influences, a banker, who, lacking the courage to kill himself, resolves to travel back in time to ensure that he is never born the first place. Afflicted by a speech impediment which locks him into protracted cycles of repetition, the (unnamed) protagonist indulges in wanton violence, pornography, and car chases, amid musings about his fondness for soft rock and recollections of his family: the cousin who died in the Twin Towers, his union-chief wrestling father, and his mother who lives in the mindset of a period drama.

Frankenstein2... seeks to replicate Shelley's intertextual approach in a contemporary context, in a form of dialogical negotiation. The extract included here ('My misery...') was conceived with both Brett Easton Ellis and Spike Lee's *25th Hour* in mind. And two of the songs on the album *Bad Brain Call* were written by rearranging the lyrics from songs by David Bowie and Lady Gaga, having first extracted the few words that do not also occur in *Frankenstein*.

Bad Brain Call was produced in collaboration with Joe Howe, a Glasgow-based sound designer and composer who specialises in synthesisers. 'You Will Be Mine, Mr Frankenstein' is the last song on the album, and the last set of lyrics I wrote. I would hazard to say that it's a fairly consummate pop song, combining narrative, rhyme, rap and meaning, brilliantly executed by Joe and vocalist Julia Scott. It is evidently an homage to Blondie – one of my first albums – but the song also reflects directly on the original *Frankenstein* story, framed in the pop tradition of unrequited love and desire. The rap section then unfolds the *Frankenstein* narrative into a commentary on the recent London riots. You can listen to this and the other songs on the album at: www.badbraincall.bandcamp.com

Extract from *Frankenstein2...* ('My misery...')

When I was younger I shared a house with my blind friend, Ernest Black; it was surprising how clean he kept it. Such a shame that we fell out; I thought I caught him looking at the object of my desires, Geneva Joy.

Geneva Joy, oh love of my life, she rendered me ardent with her ample anatomy, she assassinated me with her beautiful behind, her assembled loveliness pierced my heart like an arrowy arrow, her accent reminded me of Gale Porter. From the moment Geneva Joy joined my firm as an auditor, I was a beggar in her shadow, enraptured by those great orbs of delight. Her presence hung over me as a bauble of auguries, she inflamed my arteries, how I longed to roll in those boundless blankets of flesh.

While she was engrossed in her bookkeeping, I yearned to taste the bosom berries that strained against the elasticity of her dress and find myself drenched in the climes and curdles of her secret chamber. I passed hours gazing rapturously at her industrious fingers calculating the fluctuating fortunes of our enterprise, as a fiend possessed in the confines of my station. The expedient bustle of her petticoat left me floundering in

a sea of carelessness. When ever she summoned me to her celestial hemisphere to chastise the inadequate idleness of my labours, I came bounding like an antelope across the blue carpeted open plan room. By way of enticement I began to apply Oh de Cologne (its name really was 'Oh', believe it or not) and lingered doating in the environs of her dominion, as she brooded entrancingly over the books. I assumed a French sounding voice: 'Arose say lovely' I expressed under my breath in a murmur of inarticulate delirium; 'man rays do shone in the image of your divine beauty.' Geneva Joy, oh, most feminine of females, most bodily of bodies, benefactor of my dreams, or chasms of desire.

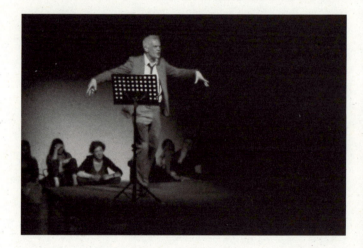

Frankenstein2...
'My misery' narrated by actor Alex Walker for the LUX/ICA Biennial of Moving Images, London, 2012

As you can imagine, I was heart-broken when she moved to Citadel following conflicting opinions with the powers that be. I could not make out the full sense of the argument but while listening near the door I over heard the words, 'fraud .. threat .. extort .. gigantic loss .. infamy .. imprisonment .. doomed .. imbibed .. glutted .. gilded pocket .. mutiny .. brink of incalculable disaster .. hangman .. offals on a stick .. doomed .. Ingolstadt .. indebted .. inquiries .. pittance .. run for the hills .. peasants .. imprecate .. judgment day .. schiavi ognor frementi .. high noon .. Red October .. ignoble, ignominious, ignominy .. doomed .. inexorable .. doomed .. Northern Rock .. print money .. inglorious .. insatiate :. mighty Mahometan .. profane .. invulnerable .. mutability .. Ireland .. plunged .. irreparable

144 The Book is Alive

.. Lausanne .. opprobrium .. resignation .. mountain of lies .. London .. Margaret .. misled .. misfortune .. Black Monday .. St Moritz .. parties over .. penniless .. penury .. nation outstript .. perdition .. execrated .. unparalleled, unprotected, unrestrained precipitation of stock .. money, money, money .. overtaxed .. doomed .. doomed.' And that, as they say, was that.

Geneva Joy: quitted. Geneva Joy: gone. Geneva Joy: left. Geneva Joy: forsaken. Geneva Joy: abandoned. Geneva Joy: departed. Geneva Joy: relieved. Geneva Joy: relinquished. Geneva Joy: removed. Geneva Joy: resigned. Geneva Joy: sacrificed. Geneva Joy: sailed. Geneva Joy: saluted. Geneva Joy: deserted. Geneva Joy: debarred. Geneva Joy: showed the door. Geneva Joy: absent without leave. Geneva Joy: ceased. Geneva Joy: dispelled. Geneva Joy: dispersed. Geneva Joy: dismissed. Geneva Joy: shunned. Geneva Joy: spurned. Geneva Joy: disowned. Geneva Joy: curbed. Geneva Joy: transported. Geneva Joy: vanquished. Geneva Joy: transmuted. Geneva Joy: withdrawn. Geneva Joy: unbounded. Geneva Joy: eradicated. Geneva Joy: terminated. Geneva Joy: quitted, quitted, quitted, quitted, quitted, quitted, quitted, quitted, quitted, quitted, quitted, quitted, quitted, quitted, quitted, quitted, quitted, quitted, quitted, quitted. I fled into the cold cold rain:

'My misery, my misery, my, my, my miserable, miserable misery, my misery, misery, misery, miserable, miserable, miserable, miserable, miserable misery, my misery, my misery, my misery, my misery, miserable misery, misery, misery, my, my, my, my, my, my, my, my, miserable misery, misery, misery, misery, misery, miserable, miserable, miserable, miserable, miserable, my, my miserable, miserable, miserable, misery, miserable misery, miserable misery, my miserable, my miserable, my miserable, my miserable, misery, misery, my misery, my misery, my misery, my, my, my, my, my, my, my, misery, misery, misery, miserable misery, miserable, miserable, miserable, misery, miserable misery, miserable misery, my misery, my misery, my, my, my miserable, miserable misery, my misery, misery, misery, miserable, miserable misery, my misery, my misery, my misery, my misery, miserable, miserable, miserable, misery, misery, my, my, my, my, my, my, my, my, miserable, miserable, miserable, miserable, miserable, my, my miserable misery, miserable misery, miserable misery, my miserable, my miserable, my miserable, my miserable, miserable misery, miserable misery, miserable misery, miserable misery, mine, mine, mine, mine, mine.'

The heat of the under ground and stifle of overflowing humanity benumbed the agony that had made carnage of my

heart, and by the time I reached Wood Green, after a quick flit through *The Evening Standard*, I was more interested in the fate of two cottagers found dead on the Heath.

And so it was with a cool head that I sought revenge on Ernest Black. Rather than blast him with my repeat action shot gun, I resolved to play him like a Game Boy. Having entered the house unperceived, I became an invisible torturer:

I removed his chair as he sat down; then I turned the heat up too far while he was cooking his food; then I poured water over him during his meal; then I relieved myself into the running water behind him as he bathed; then I cut pieces out of his clothing; then I came in his cottage cheese; then I hung his gold fish (why on earth did a blind man have one?) in a lamp shade; then I painted wild startled eyes on his lids while he slept, and wrote 'retard' on his forehead; then I threw up on his guide dog, Snowy; then I set fire to his seat as he indulged in a true crime murder mystery romance; then I performed a number two on his door step; then I placed his details on a gay Face Book group; then I burst my boils on his face flannel; then I dressed up like a vampire with cape and fangs and stood over him, teeth bared around his neck; then I knocked on the window whenever he lay down; then I had him drink blood for breakfast, combined with his milk and oatmeal; then I created large writing on the back of his jacket that said: I HATE CHINKS, DEWS, FROGS, THE WHOLE OF AFRICA, ARABIAN NUTS, GERMANS, GREEKS, ITALIANS, EASTERN EUROPEAN VAGRANTS, BLACK WOMEN, SPANISH MEN, BALMY RUSSIAN FOOT BALL TYRANTS, THE DULL DUTCH, INDIAN BEGGARS, FILTHY TURKS, THAT BLACK AMERICAN LEADER (who the Hell does he think he is??), ASYLUM SEEKING DISEASE SPREADING ORIENTALISTS, MERCENARY ASIATICS, DANCING IRISH FAIRYLAND DRUNKEN LABOURERS, ALL HOMELESS PEOPLE, THEIR DOGS, AND EVERY ONE FROM SCOTLAND TOO..' I would have continued but I ran out of space; then I ordered in his name the entire winter and summer collections from the Little Woods catalogue; then I consumed a large quantity of roasted vegetables and broke silent wind right next to him; then I made Snowy eat some Ecstasy and set him loose, watching with delight as he became fiendish in his affections and attempted to bestow his passions on all manner of creature and, indeed, inanimate objects: 'Down, Snowy! Down, Snowy! Down, Snowy! Down, Snowy! Snowy! Down!' echoed the voice of Ernest for hours, in vain against his unremitting exertions. In the end my laughter gave me away, and Ernest cracked.

The full vicious venom of a victim exploded upon me. Ernest rushed head long towards me – or at least to where he

assumed I was – an armada of fury, convulsive with contempt, demoniacal roarings gurgling in his throat. For some reason I decided to indulge him; it was strangely sublime relinquishing myself to a deranged deformity. After all, I did want to die and I was perhaps not really cut out to be a time traveller; my grasp of history was, I freely admit, rather woeful. By the time I had contemplated all of this, Ernest was upon me, arms desperately flying in the wildest revolutions, like a child taking its first swimming lesson. My shrieks encouraged him and, having struggled with me to the ground, he first wrenched my arms from their sockets and then jumped on them until he cracked the bone of one and burst the veins of the other so that blood gushed forth from it like a waterspout. Once my arms were broken I was resistless to the avalanche of violence that he reigned down on my suppliant body. He kicked the living day lights out of me, he crushed me under a chair, and then enjoyed a good stamp on my head. Following which he tore out a clump of my hair with his teeth then, digging his fingers into my eyes, he raised my head and held my face closely over some dogs do, causing me to throw up. Ernest rubbed my cheeks in the unhappy mixture and then I swallowed both under his bidding; I was sick again; and again it was eaten; again this unwholesome repast appeared; again I consumed it; again it refused to stay down; again I embraced it; again I wretched it up; again I returned it to my inmost being; again it expressed itself; this orphan form entered and left me, entered and left me, entered and left me, entered and left me, entered and left me, entered and left me, entered and left me, entered and left me, entered and left me, like the never ceasing tide of an abject sea. Just before I fainted Ernest turned his attentions to my other end and penetrated my behind with a burning candle (like a cruel form of the New Age pile treatment I had spent a good deal of money on three months ago). He took my under carriage to the breakers yard and choked my hard on with one of his ties. I contemplated a *Broke Back Mountain* moment but Ernest had rather chosen to inflict a series of heavy blows on the back of my knees with selected blunt weapons and generally beat me senseless.

Ernest Black left me black and blue and bloodless. I spent a long time afterwards on life support machines in a fluctuating state of concussion and delirium, marked by incoherent rambling: 'alas, poor albatross, there are no seas in Switzerland...'.

The resentment at my misfortunes soon passed, however, for that was how I encountered the filthy nurse, Safie Rose, who was obliged to bestow her full attentions on my agonies.

You Will Be Mine, Mr Frankenstein

Victor Victorious
You are so glorious!
So magnificent
Transcendent.
(In rapture)

I love your electricity
The spark of love
Between you and me.
You brought me back
From the dead
My limbs were cracked
I had no head.

My heart was cold
God knows how old
I was.
But now
Because of you
My hair is beautiful
Magnificent.

Instead of mould
You made me whole
Complete with feet
And now I chase you
Down the street.

You gave me colour
When I was black,
On the edge of decay.
Now your things are packed
You have gone away.

When our love sparkled
It was a blast
And now you are
Full of distrust.

We were magnificent
It was sublime
Now indifferent
Much of the time.

Our love is cold
And blue.
Blue oh
Blue oh
Call me.

Call me in the day or night, even if you hate the sight
Of this creature that you made me, with no future now degraded
You made me whole now you wrecked my soul
Mother father mother father mother father mother
I have no being, I am the other.

You leave me hanging on this precipice, loathsome island of artifice
Free to wander the land of the free, free to be the Unhappy.
Free to choose from the land of choice, free to speak but I have no voice.
You make me whole, then you crush my soul
Now I play alone on my console.

Beast with a broken attitude, impotent, nothing to produce
Nothing to love, no one to hold, left on my own to discompose
My main employment is destroy them, burning sensation in annihilation
Joy-imparting fire-starting, consummation of consolation.
You break my whole and you shake my soul.

Experience has shown that the penetration of the temples of accumulation
Is quite a good way to start a conversation, so
Call me in the day or night, even if you hate the sight
Of this creature that you made me, with no future now degraded.
You destroyed my whole, you are an are soul.

You took my picture but there is no one there, nothing to declare
But a soul so bare, victim of abortive speculation, aspiration's animation
Too little too late, refused to regulate, left a generation without a destination
The mule that can not reproduce respect no rule set down by a fool.
You stole my whole, you sick are soul.

Here I am, skin trader trash, tangible surface of the crash
Back to back, face to face, cast off of the human race
Nothing to make, nothing to do, nothing to consume but you.
I will have you whole, body and soul.
You will be mine, Mr Frankenstein.

Nick Thurston
& Sharon Kivland

Reading. Some Positions

I

[1] Malik, Rachel. (2008) 'Horizons of the Publishable: Publishing in/as Literary Studies'. In: ELH Vol. 75:3. Baltimore: Johns Hopkins University Press, pp. 707-735

Information as material is an improper name. Although it is the working name of an independent artists' book publishing imprint based in old York, it is signified as a common noun rather than a proper name. Since the imprint was established in 2002 by the English artist Simon Morris its activities have been concerned with cultures of administration, the imposition of scientific and aesthetic hierarchies upon language, the possibilities of heterological and heteroglossic collaboration, the ever-accelerating floods of textual over-production in an always-already digital age, the site and performance of writing, the subjectivation of readers, and kinds of writing that happen on the outside of literature (and other disciplines of knowledge) from inside contemporary art. The imprint works to unfold some of the historical and ethical lessons of DIY culture in the practice of publishing, such that those of us editorially involved with iam [another improper signifier; an acronym without capitals or stops] have worked collaboratively toward an understanding of 'publishing as praxis'. Rather than worrying about categories or registers, IAM [another improper signifier; all too capital but still unstopped] has taken the horizons of the publishable[1] as a direction for its concerns, and in doing so it has contributed proudly to the ecology of the culture of publishing that has bonded and inspired all of its editors: small press publishing.

The relative horizontality and patience of the culture of small press publishing means that working in its eco-system is less like standing on the shoulder of giants and more like drinking in the pub with them. Working toward a model of publishing as praxis has depended on carrying over these relatively horizontal, unstable, and unprofitable principles for collective work into the practice of editorship. The result is that Information As Material [another improper signifier; another deferral] has a focussed and centred editorial collective that holds open (like an umbrella rather than an axe) a space for a niche kind of writing to be self-published. information

as material (another improper signifier; all too lowly) is a self-publishing vehicle that enables a certain kind of unconventional but highly-literate writer to write books rather than just texts – to implicate the processes of reproduction in the conscious processes of artistic production (a.k.a. composition). That, really, is why our books are artists' books.

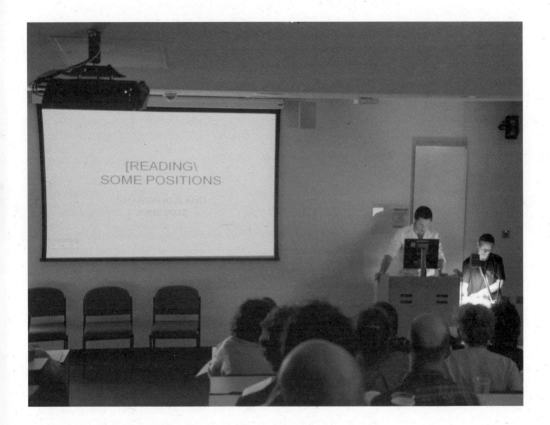

Editing at Information as Material (another improper signifier; the most common misuse – one that even we make use) is premised on what I would call 'concept envy.' If people submit proposals and one of us thinks 'fuck, I wish I'd thought of that', then it gets through the first round, after which we try to judge the capacity of the proposer to make the work, and in turn after that we try to judge our capacity to support the making of the work. The kind of work that we publish, or enable the self-publishing of, can appear to be formally erratic. But that appearance belies a focussed and unusual coherence.

What coheres the works that we publish is an approach to writing that I describe as 'conceptualist reading performances'; performances that engage with their formation as publishable units through an approach to reproduction that we call 'undesigning.'

These two descriptors – 'conceptualist reading performance' and 'undesign' – are working concepts. They are formed simultaneously by and though the praxis of (self-)publishing, which means that they are constantly being refigured by their ongoing use.
While 'undesigning' no doubt has a history of use before we stumbled upon it – I suspect that it has been used as a negative dialectical value in the discourse of Modern design, a discourse about which I know little – the term 'conceptual reading performance' adds together a set of overly familiar ideas into a new sum total. By this I mean that 'c.r.p.' signifies both i) a concept that really is just the sum of its parts, and ii) the value of that sum total as a label that may help to make an alter-history of writing historically intelligible.
The three constituent ideas – conceptualism, reading, and peformativity – are overly familiar because they have each become a broad catch-all term. What I want to do is specify what I mean by each of them. This should give each of them back a little bit of purchase, with which I can give at least a working context to what their sum value might refer to as i) an aesthetic practice and/or as ii) a niche historical category.

Exercising that second usage, as a niche historical category, is beyond my expertise because I am not a historian; but I would be curious to hear for what, if anything, it manages to give leverage should any historians try to use it retroactively. What interests me more immediately is the first usage: I want to explore what this approach (c.r.p.) can make it possible to write and to think in the context of contemporary art, and my want to do so is that of a (self) publisher.

[2]Osborne, Peter. (2007). *Where is the Work of Art?: Art, Architecture and the Space of the Post-Conceptual Work*. Multitudes: Transmission, pp. 87-112 [author's translation]

Conceptual artforms have a disputed identity for more reasons than it is relevant to discuss here, not least because they contend the very processes of definition.[2] In my compound descriptor, conceptualism signifies an approach to cultural production that privileges the value of concepts in the experience (both the making and the reading) of the cultural product over its morphological form, in a way that recognises the total interdependency of form, content, and context. The type of performativity that I am specifying in my compound descriptor is the performance of consciously composing a multiple conceptual product for a public. This involves harnessing a pre-consciousness that the thing you are composing will be made public through some process(es) of reproduction, such that reproduction is taken up as a precedent for production. By 'reading' I mean (somewhat crudely and somewhat speculatively) a sensitive response to something that is already in the world. The sensitivity that I am specifying is conceptual rather than sensorial (though, of course, it is mediated by sensations) – this kind of reading starts by trying to be

sensitive to the thing in the world at the conceptual level. The responsivity that I am specifying transforms that sensitivity into the kind of performance that I have outlined above, so that starting from a conceptual level, a reproducible reading is composed as a cultural product that prioritises the value of concepts over their morphological form.

Conceptualist reading performances do not try to objectify reading in a standard aesthetic sense – in the way that, for instance, portrait painting from Bellini to Balthus has made reading just another visual metaphor within characterisation. Rather, by demanding that reproducibility be an artistic dynamic of the art work – a precedent of artistic production – c.r.p.s negate the conventional primary-secondary statuses of production-reproduction, and instead explore an understanding of composition as a process of reproduction-as-production. Conceptually speaking this makes the reading's eventual object-status as a cultural product an artistic concern, i.e., the art work only legitimately 'becomes' whatever it is as an art work in its being reproduced and having a reproduced form. Objectification becomes a conscious performance; and objectivity is used as a compositional strategy to nuance the subjectivity of the reading experience (both that of the maker-reader and that of the reader-reader). C.r.p.s find conceptually sensitive ways to extend subjective readings through processes of reproduction-as-production.

In my experience, this happens as kind of re-opening. One finds a latent conceptual possibility in something and then takes the risk of drawing it out, so that the process of composition unfolds unpredictably as a process of conceptual extension or hyper-extension. This 'drawing out' leads to a previously impossible and specific unravelling. It is the author's job to take responsibility for this improbable unravelling as a cultural product. This is where 'undesigning' comes in as an editorial approach. The so-called 'undesigned' is neither i) the merely not-designed, nor ii) the merely not-yet-designed. It is the design that is designed to negate its own designerly affect; it is the design that is designed to absent itself, to remove itself, to only make itself present as a structural remove; it is the design that holds open a space for the art work to extend its artistic logics into the should-be territory of design. And undesigning does this in a conceptualist way by structuring a *specifically* responsive remove. According to this model 'design' is absented and in its remove conceptual extension is played out in ways that allow the art work to take responsibility for what would normally be design decisions. Of course there are morphological limits, but these limitations are put at stake, and the resolutions of that 'putting at stake' are made complicit in the specific textuality of the art work.

It was Johanna Drucker who pointed out to me recently that 'lots of people write texts… few people write books.' Sharon Kivland *does* write books, in consciously different sizes, lengths, and materials; and

she does so as an artist whose artistry has long involved academic scholarship and para-scholarship in the areas of art history, literature, politics, feminism, and psychoanalysis. Since 2006 information as material have been publishing three series of books by Kivland called *Freud on Holiday*, Reisen, and one untitled which the author thinks of as Freud at Work. Each book errs between autobiography, intellectual biography, travel writing, performance, and pure theory, as a kind of diary. Some books document different holidays once taken by Freud and recorded by him in postcards, journal entries, and passing comments; holidays that have been actually re-taken by Kivland. As a scholar, Kivland has pieced together fragments of Freud's history, of his memory; and as an artist she has re-lived his itineraries (three times for three books, to date, plus various appendices and other books that draw on Freud's œuvre) so as to re-take his journeys. What follows is an introduction to that series of books, with their play between the imagistic and the forgotten reconfigured as both the score for, and the trace of, a lecture.

[3]Refer to endnote.

Reading. Some Positions[3]

II

In a letter to Wilhelm Fliess concerning the interpretation of dreams, Freud writes:

[4]*The Complete Letters of Sigmund Freud to Wilhelm Fliess*. 1887–1904, trans. and ed. by Jeffrey Moussaieff Masson, Cambridge, MA: The Belknap Press of Harvard University Press, 1985, p. 365.

> the whole thing is planned on the model of an imaginary walk [...] then there is a concealed pass through which I lead the reader – my specimen dream with its peculiarities, its details, its indiscretions and its bad jokes– and then suddenly the high ground and the view and the question: which way do you want to go now.[4]

For a number of years now, I have been accustomed to take a short holiday, sometimes several, with my sister, who is four years younger than I. I have few relaxations apart from these holidays, and although these short breaks from my usual routine are directed by impulses other than the desire for rest and recreation I find that the moodiness to which I am subject seems to disappear while I am on holiday. It is usually my task to arrange the travel details. While I cannot claim to be an expert in the field, I take great pains to find the right train or the right flight, and at the keenest price. Finance is, of course, a constant anxiety, even when holidays are undertaken in a modest fashion. I book hotels carefully and find reasonably priced restaurants in advance. I try to note nice restaurants and interesting places for further trips. There is a particularly nice restaurant near the Freud Museum in Vienna but its name escapes me… is it the Excelsior? (no matter, if you read my last book you will find out what it is called, as I do myself when I follow a number of incidents of the forgetting of a proper name[5]).

On occasion my son has accompanied us, and indeed, I have taken some holidays with him alone. I am planning one now – indeed, have been planning it for years – a holiday that is proving rather difficult to organise. It is a holiday that continues to be deferred – Freud's last holiday to Rome, my last holiday of Freud's. It will cost me 10,000 euros. Whether planning or travelling, my child cannot be expected to be practical in these matters and resigns himself to my guidance just as my sister (who prefers to allow me to attend to reservations and routes) resigns herself to my itineraries. While my sister and son are on holiday, I am still on duty, so to speak. It is not that I have no interest in tourism, though I can understand why many people find it vulgar. Rather, as Nick Thurston has explained, I am following, as closely as I can, the holidays taken by Sigmund Freud. I call my holidays that are not quite holidays 'Freud on Holiday' – a somewhat frivolous title that I would ask you forgive. This distinguishes them from vulgar tourism and allows them to be eligible for financial support from external sources, to whom I must demonstrate my holidays – Freud's holidays – both as value for money and as scholarship, explaining my methodology and proving its outcomes and dissemination. I publish the accounts of my holiday, hoping they will be stimulating for the reader.

Almost every year Sigmund Freud went on holiday, often accompanied by his brother Alexander, an expert on railway transport, timetables, and travel tariffs. He made a distinction between the holidays he spent with his family during the month of August and those voyages he took later, most often in September, with complicated itineraries. Freud prepared

[5]Kivland, Sharon. (2011). *Freud on Holiday vol. III. The Forgetting of a Proper Name*. Athens and York: Cubearteditions and information as material (iam).

[6]Kivland, Sharon. (2007). *Freud on Holiday vol. I. Freud Dreams of Rome*. York: information as material (iam).

[7]Kivland, Sharon. (2007). *Freud on Holiday vol. II. A Disturbance of Memory*. Athens and York: Cubeareditions and information as material (iam).

[8]Kivland, 2011

[9]Kivland, Sharon. (2007). *L'Esprit d'escalier*. York: information as material (iam).
At this point I walked away from the lectern to show the audience my plimsolls, describing my discomfort at the Anna Freud Centre when I realised I was wearing such casual footwear in middle of giving a conference paper, and that my bag, containing a smarter pair of shoes, was still on the stairs of the museum.

[10]Kivland, Sharon. (2008). *An Agent of the Estate*. York: information as material (iam).

[11]Kivland, Sharon. (2009). *Afterwards*. Warwick Arts Centre, Mead Gallery.

[12]Kivland, Sharon & Morlock, Forbes. (2009). *Freud and the Gift of Flowers*. York: information as material (iam).

carefully for his trips, attentively consulting tourist guides and other travel literature concerning the places he intended to visit, especially those referring to the sites of classical antiquity, and including, of course, the famous *Baedeker*. My holidays – Freud's holidays – have led me to a dream of Rome,[6] to a feeling of melancholy in Trieste and a disturbance of memory in Athens,[7] and the forgetting of a proper name in several locations.[8] As well as these occurrences, I have forgotten my shoes on the stairs of the Freud Museum in London and I thought of witty and amusing remarks too late on the steps of the Freud Museum in Vienna.[9] I have offered a buyer's guide to some of the dwelling-places of psychoanalysis (while reminding the reader that the ego is not master in its own house), with some detours through stations and board games.[10] I brought a man back to life in one conference paper and boasted about it, while describing the phenomenon of 'deferred action', when impressions, experiences or memory traces gain significance as a result of re-experiencing the event.[11] I collected the bouquets Freud did not receive while my co-author Forbes Morlock traced the theme of the gardenia in Freud's life, including the time Freud felt great happiness, in Rome, at the Hotel Eden, when he could afford a gardenia for his buttonhole every day.[12]
(These last four books do not come under the rubric of 'holiday'. Rather, I think of these accounts as *work* in a foreign country. Yet I insist they must be thought of as part of my Freudian *œuvre*.) To undertake my holiday work efficiently I have read many rail and ferry timetables of Europe. I know a great deal about rolling stock. I am careful to follow city maps and I try (in vain) to stay to described routes and rights of way, to stick to the itinerary. I have consulted a number of travel guides, including the famous Baedeker. I have referred to my impossible reconstructions as an act of ventriloquism, and

indeed, as far as speech is concerned, this is true.
I read closely, attentively. I follow the holiday correspondence of Freud to the letter. The fifty-six letters and hundred and eighty-nine postcards of his travel correspondence with his family between 1895 and 1923 reveal his enjoyment of these holidays, his pleasure in his liberty, in getting a bargain, in the blue skies and the southern warmth, in the beauty of the landscape, in wine and food. From this correspondence descriptions of the weather, descriptions of what he ate and drank (and the state of his digestion) have been collected in the appendices I and II: *Freud's Weather* and *Freud's Dining*, to be joined later this year by III and IV, *Freud's Hotels* and *Freud's Shopping*.

To these collections I add another set: *Reisen* is a series of occasional pamphlets, which refer to the trains, train journeys, railway-lines, stations, station platforms, railway timetables, ticket collectors, and train compartments in the life and work of Sigmund Freud. The first of these modest booklets contains short extracts from *The Interpretation of Dreams*, published in 1900, edited, to a certain extent, in an attempt to retain only references to trains. I imagined that many more trains or railways had occurred in the dreams recounted therein and I was disappointed that there were not more description of the

trains and routes, both main and branch lines, of the Staats-Eisenbahn-Gesellschaft. Still, *un train peut en cacher un autre*. The second contains details of some of the train journeys of Freud's holidays, gleaned from his correspondence home, with reference to contemporary editions of *Cook's Continental Time Tables, Tourist's Handbook and Steamship Tables*,

[13] The photographs that run throughout this essay are part of a larger project, also entitled *Reisen*, and some of the vaporous emissions (the lovely smoke trails of steam trains) serve as frontispieces for these small pamphlets.

[14] Derrida, Jacques & Malabou, Catherine. (1999). *La contre-allée*. Paris: la Quinzaine/Louis Vuitton, collection 'Voyager avec'.

supplemented by consultation of the European rail timetables of the present day. I am contemplating two further pamphlets: one that will address the nasty surprise Freud has when he sees his reflection in the mirror on the door of his railway compartment but for a moment does not recognise himself, and another that takes up the differentiation between the sexes, induced by the stopping-place of a train along a railway platform (though this may prove a somewhat Lacanian *divertissement*).[13]

I cannot claim that I accompany Freud, of course. Nor can I insist that he accompanies me, as is the conceit of Jacques Derrida, who travels divided – if I understand him correctly –

[15] I may have stepped forward once again, leaving my position at the lectern.

[16] I then read a short extract from what exists already in preparation for this next book, illustrated by a selection of images, including some photographs taken by Lucia Farinati and perhaps rather too many pictures of men in leather shorts. The text moved from Vienna to Lavarone with ease, and there was reference to the gathering of mushrooms, as well as a tendency to dwell on menus. I thanked Lucia Farinati, of course, and also Beth Williamson, who convened the panel 'Walking Otherwise. One foot after another' at the Art Historians Conference in March 2012, at which an earlier draft of the text was performed.

between the patriarchal, authoritarian figure of Heidegger and the fraternal, feminine figure of Montaigne. Derrida *voyages*; I do not recall that the word 'holiday' appears in his text, La *contre-allée*, which is co-published by Louis Vuitton.[14] This should come as no surprise, for Louis Vuitton has fashioned its legend of travel adventure by creating luggage that is as elegant as it is innovative, made with a sleight of hand and a keenness of eye that no machine could ever replace. Louis Vuitton has also published a series of travel scrapbooks so memories will never fade, illustrated by renowned artists to capture the atmosphere of their chosen cities and containing some blank pages for personal notes and impressions. Each comes with a wooden pencil and a collection of postcards, should one not have time to purchase one's own. Forgive me, I am digressing.[15]

My next holiday will lead me to the Hotel du Lac (my room is booked), to Trentino and Lavarone, to alpine walks and mushroom gathering (I have been told to bring my Wellington boots), to several Lucias (dead and alive, the latter who will meet me at the station and drive me to the mountains), to Gradiva, a woman with an uneven pace. What cannot be written here now may be read elsewhere next year.[16]

Endnote:

We entitled our presentation 'Reading. Some positions', for positions were to be taken, quite literally, standing at a lectern, in front of a screen, in the dark, reading out loud, speaking in the dark. There was an audience, watching us read in turn, with all the digressions (unconscious and planned) of a reading, the tics, the unnecessary gestures, odd pauses for breath or thought, and moments of supposed improvisation, affording some light relief from reading. Yet as Nick Thurston has suggested above, reading is also a way of thinking, though when reading, I am often trying to escape thought entirely. I read and re-read the works of Sigmund Freud and the secondary literature, and write my versions of this protracted reading. My books, or most of them anyway, have usually started as conference papers, so I am obliged to write something in order to read so that I may rewrite, rethinking and revising. What has preceded is a version of what I read in the dark, illuminated by a projected collection of images, my own, those of others, replaced here by the steamy emissions of trains, from Reisen. (While some despise Power Point, I must admit to a great love for it, but on occasion, I do add the click of a slide-projector in an excess of nostalgia for what has been lost.) What is not reproduced is the reading – part two, one might say – of what I read, for that is being rethought, rewritten, even as I write. Indeed, that was no more than a draft, one that was arrested without conclusion. As an aside (but it is interesting), Freud had a most particular way of reading, which is described by Michael Molnar in an essay in the collection *Reading Freud's Reading*, edited by Sander Gilman (who once gave me a cheer at the end of a reading I performed). The book is a tour of Freud's library (I merely take a tour of his holidays), a consideration of what and how he read. The essay is concerned with Freud's light reading, to which he turned later in life; it starts with a description given by Marthe Freud of the way Freud leant in a diagonal position across the chair, one leg slung over its arm, the book held high and his head unsupported. Felix Augenfeld designed a chair for Freud with this in mind, a chair with a narrow back and a broad seat. Readers of this must imagine me, standing to attention at the lectern, notes neatly arranged, and with the occasional digression, a lateral move, both physical and thought, and with the caveat that this is no more than an introduction to a series of books, including a book that is as yet unwritten.

Durational Works
& Installations

Sylvia Schimag

John Cage's *'Empty Words'*

A mix of words, syllables, and letters obtained by subjecting the Journal of Henry David Thoreau to a series of *I Ching* chance operations. What was interesting to me was making English less understandable. Because when it's understandable, well, people control one another, and poetry disappears. A transition from language to music. It's bewildering at first, but it's extremely pleasurable as time goes on. And that's what I'm up to. *Empty Words* begins by omitting sentences, has only phrases, words, syllables and letters. The second part omits the phrases, has only words, syllables and letters. The third part omits the words, has only syllables and letters. And the last part has nothing but letters and sounds (John Cage interviewed 8th August, 1974).

Durational performance,
Saturday 9 June 2012
09:00 to 20:30
Keyworth Lobby.

Empty Words I – 09:00–11:30
Empty Words II – 12:00–14:30
Empty Words III – 15:00–17:30
Empty Words IV – 18:00–20:30

Produced by Antoine Beuger and Wandelweiser

Sylvia Schimag

Amanda Couch

Reflection in Digestion

Durational performance for BOOKLIVE! international symposium, Saturday 9 June 2012, 09:00 to 19:30, Keyworth Lobby, London South Bank University.

Reflection on Digestion is an epic work. As book, it is nine metres, folded back and forth into an eighteen-page concertina form. Its covers are of undyed calfskin with gold hot foil embossed lettering, and its pages are made of 410gsm white Somerset satin paper relief printed from photo polymer plates.

It is book but it is also performance: 37 hours of scribing in the form of *Reflection in Digestion*, which took place on the second day of the BOOKLIVE! symposium and four subsequent days in the Wimbledon College of Art library.

The bodily act of the scribe originated the manuscript, which was then transferred and translated through digital and mechanical technologies with bookRoom press at UCA Farnham, and then hand-made, to produce an edition of three book works.

The scribed text stems from a body of knowledge encountered whilst on a post-graduate course in education. Writing, knowledge and the body are explored, and the metaphors of reflection and digestion consider process, processing, and ways of knowing and becoming. 'Digestion' stems from the word 'digest', which can both refer to an arrangement of written work; and to the processing or making sense of knowledge and experience, as well as to break down and absorb food.

[1] Bachelard, Gaston. (2002). *The Myth of Digestion In: Formation of the Scientific Mind*. Manchester: Clinamen:

[2] Hillman, David. (1996). *Hamlet, Nietzsche and Visceral Knowledge In: The Incorporated Self: Interdisciplinary Perspectives on Embodiment*. O'Donovan-Anderson (ed.). London: Rowman & Littlefield.

Gaston Bachelard asserts in his essay *The Myth of Digestion* that bodily awareness, and in particular digestion, 'lies at the root of the myth of inwardness.'[1] This 'interiorisation' helps us to postulate an 'interiority.' Nietzsche, as argued by David Hillman in *Hamlet, Nietzsche and Visceral Knowledge*[2] speaks specifically of 'entrails' and his sensitivity to them' as a means with which to understand the world. The body, particularly the innards, are 'a principle of interpretation[…] philosophy as a kind of vivisection.'

Reflection on Digestion's concertina configuration makes reference to the image of the digestive system and connotes the meaning of the words 'reflection' and 'reflexive' coming from the sense of a physical

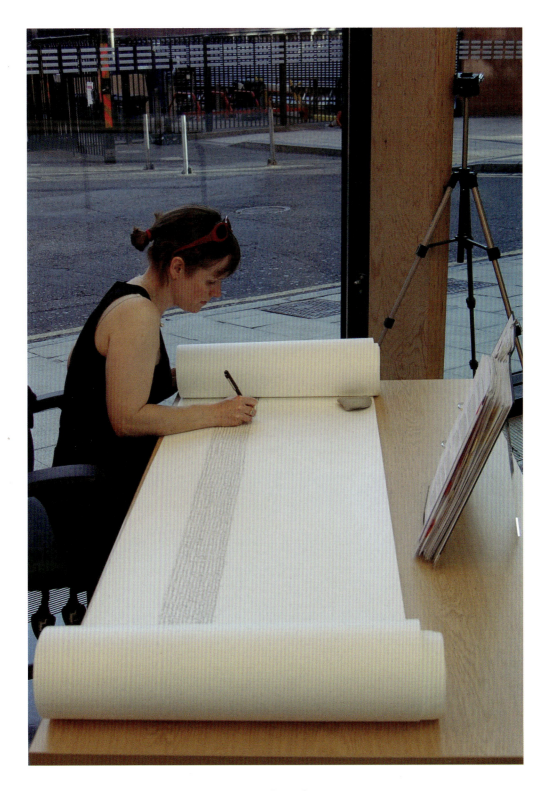

and metaphorical bending or turning back paralleling the visual image of the gastrointestinal tract with its nine metres of twists and turns crammed into the body's cavity.

Alimentary undulations are further mirrored in the loops and garlands of the handwriting itself which is a joined up text, each word tied to the previous, the next, and to the subsequent line, so that it is a kind of *Boustrophedon,* a continuous line running from left to right and right to left from the beginning of the book to the end. This continuous script refers to Latin texts from the early Christian era, when there were no spaces between words in a manuscript. In my *scripto continua*, the language is not easily legible enabling the lettering to hover between word and image, content and form.

The performative aspect of *Reflection in Digestion* is also embedded in the experience of the audience. It reconnects the reader to a corporeal relationship with the book and reading, in that they are required to negotiate the monumental, physical nine-metre form of the book, as well as the awkward image-text within, reconstituting a relationship arguably severed by the invention of the printing press.

[3] Carruthers, Mary. (1997). *Reading With Attitude: Remembering the Book.* In: *The Book and the Body.* Frese and O'Brien O'Keeffe (eds.). Notre Dame: University of Notre Dame Press.

The body and metaphors of digestion are deeply embedded in the history of the book, according to Mary Carruthers. Reading, she writes in *The Book of Memory* [3], was 'a bodily performance' rather than simply the decoding of words on a page. 'The medieval scholar's relationship to his texts is quite different from modern objectivity. Reading is to be digested, to be ruminated, like a cow chewing her cud'.

Reflection on Digestion is funded by a University for the Creative Arts Research Award.

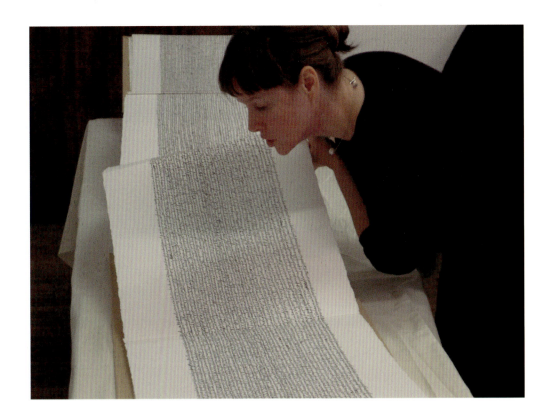

Above: bookRoom launch and reading of *Reflection in Digestion* at the Small Publishers Fair, London 2012.

Paul Jeff
& Laura Jenkins

The IPCRES Reading Ensemble

Participatory event for BOOKLIVE! international symposium,
Friday 8 June 2012, Keyworth Lobby, London South Bank University.

IPCRES – International Project Centre for Research into Events and Situations

The IPCRES Reading Ensemble explores the act of reading and walking at the same time as an embodied practice designed to illuminate the threshold between potential universes, internal and external. Part of this experiment is to set up an approximation of the CERN Large Hadron Collider substituting 'readers' for particles.

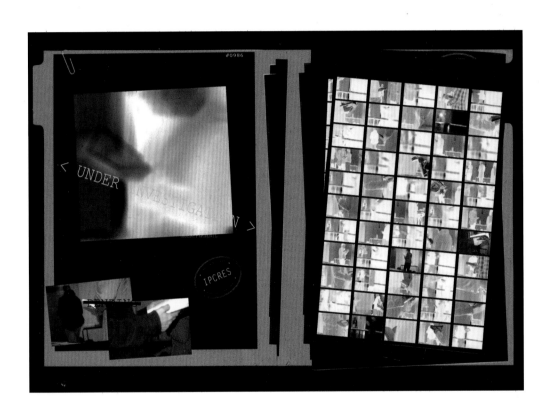

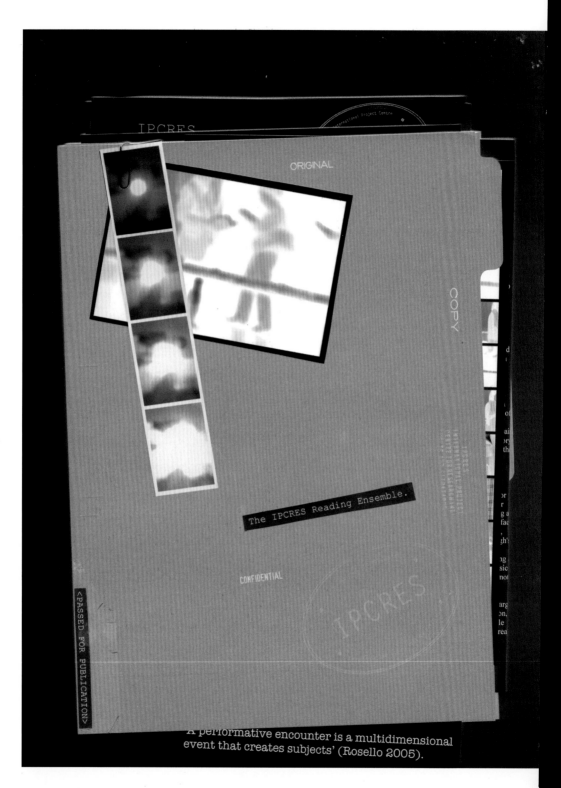

IPCRES

MIS ION BRIEFING
S

0986. The IPCRES Reading Ensemble.

Book Live! International Symposium. London South Bank Univ, 8.6.12.

I will not make poems with reference to parts/ But I will make poems with reference to ensemble - Walt Whitman.

A participatory 'reading/walking' event exploring the inter-connectedness of body and mind. The perception of moving through multiple universes at the same time, one a shared physical space, others more temporal and virtual perhaps, and accessed via an experience of parallel durations, reverie and affect. An evocation of the spirit of the flaneur, psychogeography and the situationist derive; the experience of reading conjures up worlds within worlds, it is amplified here through mobility and the shared experience.

The experiment requires that operatives set off walking and reading at the same time, an interesting experience in its own right, thereby exploring the inter-connectedness of body and mind. The book and the experience of reading; Walking and reading at the same time forms a complex threshold between worlds, making manifest the intrinsic links between body and soul, the thin membrane between universes.

We will walk a circular path initially in the same direction, settling into the rhythms of our individual books and the external rhythms we sense around us. These perambulatory readings are to be accompanied by a 'soundscape' drifting in loudly from nearby, thus determining the duration of the event. Part of this soundscape will be the distinctive voice of William Burroughs reading his short story *The Priest they Called Him* to the guitar feedback of Kurt Cobain. At a certain point some participants will be turned around converting the experiment into a 'Large Hadron Collider'. Particles fired around both ways in order to promote collisions, each collision a quantum metaphor for a new universe, Senior IPCRES officials will 'record' the 'collisions' via a science-fictive non-photographic process.

As Antonio Damasio remarks, **the mind is embodied... not just embrained.**

As Walt Whitman promised his readers, **Your very flesh shall be a great poem.**

* ALL PARTICIPANTS TO BRING A BOOK *

IPCRES Proclamation *15

Paula Roush
& Maria Lusitano

*A field
(of interconnected realities)
or The week of
mash-up goodness (2010-12)*

Installation for BOOKLIVE! international symposium, Saturday 9 June 2012, Keyworth Lobby, London South Bank University.

1st edition of 10, 5 newsprint volumes, colour, digital print, 29 × 38 cm, in a grey-board folio with DVD, HD, 34'45' colour, msdm publica(c)tions.

The project started in 2010 as the re-enactment of the artists' book *Une Semaine de Bonté (A Week of Goodness, 1934)* by Max Ernst. This was the first collage-novel to explore the unconscious as a series of traumatic tableaux in the book format, and a pioneering work in the ontology of the artists' book. Departing from its materiality as a paper printed and bound western codex, we re-enacted it developing an idiosyncratic form of video, drawing and collage.
We relied on webcams to collaborate in double video stream across time and space and develop a virtual space for the book.

The new publication and accompanying video piece (2012) extend our ongoing research on the study of the modernist collage-novel. The main subject of the work is now Valentine Penrose and her book *Dons des Féminines (1951)*. This pioneering collage-poem is both a re-enactment of *Une Semaine de Bonté* and a critique of patriarchal hegemony evoked in Ernst's work. Its poetic depiction of female love, combining elements of neo-gothic and surrealist verse and collage make it into an early precedent of the *écriture feminine* where the author experiments with a language of desire and transgression.

Valentine Penrose's relationship to Max Ernst, Anthony Penrose and particularly to Alice Rahon – to whom it is speculated that *Dons des Féminines* refers to – have all been scrutinised by art historians and literary critics alike, with the rigor of detectives when dealing with the scene of a crime. Whilst this attention has made Dons des Féminines into one of the most intriguing feminist and queer publishing case studies, there are still many gaps that we found most stimulating and decided to look closer into.
The resulting work combines historical archive and speculative fiction, intertextuality and collage.

The newsprint publication uses Max Ernst's feuilleton Une *Semaine de Bonté* as a structuring device to serialise the five volumes following the days of the week.

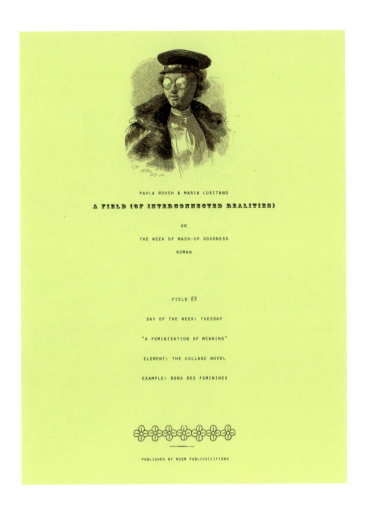

Field #1 is for the first day of the week, Sunday, and its element is *The winged domino*. It presents a selection of historical portraits where Valentine Penrose posed as the artist's model. It is subtitled *The muse's productive mimesis* and the centrepiece is *The wings of history* that we consider to be a series of genealogical portraits with a disturbance of meaning.

Field #2, the day of the week is Monday and the element is *Gay pulp (or the penny dreadful),* mimicking Ernst and Penrose's collage method that used cut outs from popular and alternative press. The example is *Valentine and Alice become mothers,* a fictional narrative, that situates them in Lisbon in the 1980s, living together and trying to have a child through a sperm donor. Vintage lesbian pulp is weaved with an intertextuality a *deux* found in the writings of Valentine Penrose and Alice Rahon.

Field #3, the day of the week is Tuesday, the element is
The collage-novel and the example is *Dons des Féminines*.
Traces from *Dons des Féminines* are projected onto the skin, exploring the moment when the virtual page disappears into the body.
It is subtitled A *feminisation of meaning*, and functions as a dialectical speculation on time, memory and the future of the book.

Field #4, the day of the week is Wednesday and the element is
The western codex. The example is *Une Semaine de Bonté*.
Subtitled *Une mise-en-scéne of the unconscious*, it juxtaposes ruins of the Victorian domestic interior found in Max Ernst's collages with other outdated domestic and gendered elements found in vernacular press. This volume explores the tension between the original and the copy and the lack of differentiation introduced by industrial printing.

Field #5 combines the three remaining days. For Thursday, the element is *The will of the work of art* and this is represented with the

text *Ghostly edges: the uncanny and after life in Max Ernst's collage novel Une Semaine de Bonté;* For Friday, the element is *Photography's archival order* and the example is *The research scrapbook,* a collection of visual material cut out and mounted on a four page spread. For Saturday, the element is *The killing of aesthetic ideals* and the example is the text *Out there in the east: desire and gifts in Valentine Penrose's collage-poem Dons des Féminines.*

The video essay that is part of this project is a thirty-six-minute narrative collaged with fragments of film, painting, illustration and literature relating to the female gothic. Its departure point is *Dons des Féminines* and the backdrop story is Valentine's travels in India in the company of Alice Rahon. The visual essay narrates the way through which the *apparitional* female *monster* has been depicted in visual and literary representations, and how these have influenced and contributed to current discourses regarding gender and the construction of the queer identity.

Marcus Kaiser

A Possible 'Book-Work'

Installation with laptop and book for BOOKLIVE! international symposium, Saturday 9 June 2012, Keyworth Lobby, London South Bank University.

A sample of the infinity between reality and the quotation of reality in books and the quotation of quotation of reality in books… as the reality of books. This 'Book-Work' was made on the 6th of June on the way to the symposium on a Brussels to London Eurostar.

Rahel Zoller

The Inner Monologue of a Book

Edition of 232 produced for BOOKLIVE! international symposium at London South Bank University.

140 x 210mm, 8 pages, three-fold pamphlet stitch.

The Inner Monologue of a Book is a concept that tries to behold the state of the codex from a unique perspective. The monologue reads the thoughts of a book, as it contemplates whether the codex will still survive in its traditional form or whether the e-book, its younger relative, will take its place. These are the reflections of a self-understanding book, who looks back onto the great triumphs that bound paper and text have achieved over centuries.

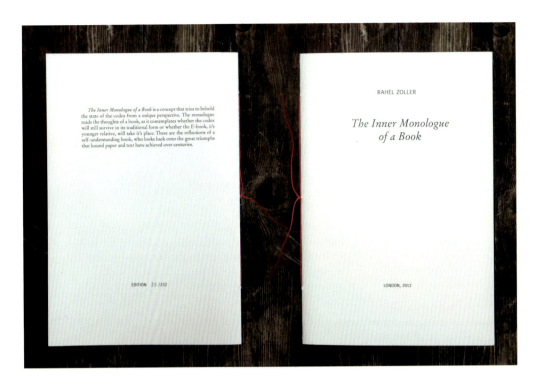

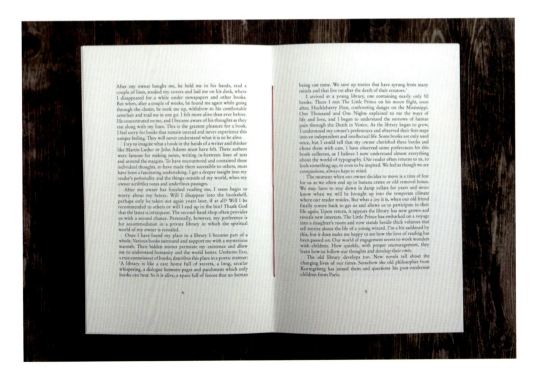

Christoph Nicolaus & Carlo Inderhees

'garonne-für sich'

Installation and performance for BOOKLIVE! international symposium, Saturday 9 June 2012, 19:00 to 20:00, Keyworth Lobby, London South Bank University.

'*garonne-für sich*' is the result of the interaction of two works '*garonne*' a series of video works by Christoph Nicolaus which provide the setting for '*für sich*' a composition for one cello by Carlo Inderhees, usually performed by Marcus Kaiser. The work is 'alive' only for one hour everyday, whether a performance takes place or not.

Accompanying the work is a publication containing one hand stitched book and two folders of loose printed sheets. The book contains a typed timetable, as a list in three columns of every hour the work can come alive each day since the work began on the 16.07.98 between 22:00-23:00.

The first folder contains the musical scores of '*für sich* (Violoncello 1-24)'. Each piece lasts sixty minutes and consists of the continuous repetition of a note and a silence in equal amount, each piece having a different rhythm: there are pieces with one minute sound followed by a silence of one minute, some with two minutes, three minutes, five minutes, ten minutes, fifteen minutes and thirty minutes. The sound level is very low, almost imperceptible.

The second folder contains a long list of location, time and date of each '*garonne*' video, over 200 videos of rivers all over the world filmed twice for eighty minutes: vertical from a bridge, with autofocus and closely zoomed; once flowing towards the camera, once flowing away from it. No sound. Even though the videos have all been shot the same way, each is unique: differences in é, light, sharpness, speed of flow, sometimes it rains, sometimes it snows, sometimes there is wood, leaves, ice.

The two works '*garonne*' and '*für sich*' have their own individual time flow on top of the twenty five hour rhythm of the piece as a whole. There is also the different times of the running water (from nearly standing to fast sweeping), the dates and seasons when Christoph Nicolaus is going to film and the open-ended nature of the project which carries on in the future. And finally there is the finished structure of the cello pieces and even if some of the rythms seem contrary, they all belong together to form '*garonne-für sich*'.

Reference images

Joachim Schmid

O Campo, 2010.

Mishka Henner

San Fernando de Henares, Madrid, Spain

SP90, Rivolta d'Adda, Cremona, Italy

Images from the BOOKLIVE! international symposium

The BOOKLIVE! international symposium

Biographies

Amanda Couch
Artist & Lecturer in Sculpture & Film, UCA Farnham (UK)

Reflection in Digestion
Reading, in medieval times, was 'a bodily performance'. Similarly in this durational performance and epic book project, Amanda reconnects the body (of both writer and viewer) with writing through the action of the scribe, thus reconstituting a relationship arguably severed by the invention of the printing press.

Amanda's practice is interdisciplinary in nature, straddling the domains of sculpture and performance, the live and the recorded image, process, research and writing. Essentially, she makes images, objects, experiences which are both visceral and narrative; implicit in them is a dialogue about time, being and understanding… being made, making and becoming.

www.amandacouch.co.uk

Andreas Schmidt
German-born, London based photographer/artist (UK)

The Speed of Books
Investigating traditional and current publishing models, Schmidt compares these models by talking about his own work in both fields. For more than three years now Schmidt has been experimenting with print on demand technology to produce a set of artists' books that aim to re-define the definition and nature of photography and push the boundary of what a book can be in our current times. Andreas is a founding member of ABC, Artists' Books Cooperative.

www.andreasschmidt.co.uk
abcoop.tumblr.com

Dr **Andrej Blatnik**
Writer & Lecturer in Creative Writing & Book Studies at the Faculty of Arts, Ljubljana (Slovenia)

Mass-Produced, Media-Produced, Handmade: Books in the Twenty-First Century
Almost everything is now accessible in an instant (legally or illegally) and the aura of the work, as something that is not easy to reach, has shifted to the pseudo-aura of the author. How does this contemporary instant accessibility of art and literature affect the position of aura; that special something in the literary field? Has it shifted from the work to the author? How does this phenomenon affect the literary field? Andrej has published twelve books in Slovenian, including three books of theory. Twenty have been translated in English, German, Spanish, French, Czech, Slovakian, Hungarian, Macedonian, Turkish, and Croatian. His latest collection of short stories was published in England as *You Do Understand* by Dalkey Archive Press in 2010. He has won major Slovenian literary awards and tours the world reading his fiction. He enjoys travelling on a shoestring.

www.andrejblatnik.com

Annabel Frearson
Artist

Frankenstein2…
A presentation on a series of artworks and a novel in progress created using all and only the words from Mary Shelley's *Frankenstein* (1831). To date, extracts have been produced as performed readings, posters, magazine articles, a 16mm film, and a recently launched album of pop songs (called *Bad Brain Call*).

www.annabelfrearson.com

Dr **Arnaud Desjardin**
Artist & runs The Everyday Press (UK)

The Book on Books on Artists Books
A presentation on books on artists' books, and the general problematic of dissemination and distribution of artists' books in the present climate of online migration. Rather than focusing on what the future of artists' books may be, Arnaud looks at their current modes of circulation and dissemination.

Arnaud runs The Everyday Press, an independent publisher of artists' books since 2007.

www.theeverydaypress.net

—
Dr **Barnaby Dicker**
Researcher, lecturer, filmmaker, artist & curator (UK)
Matt Hulse
Film, sound, performance, word & community artist (UK)

The *Dummy Jim* Cycloscope
A duologue discussing the book related dimensions of Dummy Jim, Hulse's soon to be released second feature – a film based on the 1955 book *I Cycled into the Arctic Circle* written by James Duthie, a profoundly deaf Aberdeenshire man (affectionately known as Dummy Jim), who cycled solo on a 6,000 mile return trip to the far north of Europe in 1951.

Matt is an artist working with film, music, sound, performance, word and community. His work is formally innovative, playful, sometimes collaborative, and typically crosses or combines genres, techniques and platforms.

Barnaby is a researcher, artist, filmmaker and curator. He is also Historiographic Officer at the International Project Centre for Research into Events and Situations (IPCRES), Swansea Metropolitan University. His research revolves around conceptual and material innovations in and through graphic technologies and arts.

www.dummyjim.com

—
Christoph Nicolaus
Visual Artist & Curator (Germany)

"garonne-für sich"
This one-hour performance by Marcus Kaiser and video installation is the result of the interaction of two works; "garonne" a series of video works by Christof Nicholas which provides the setting for "fur sich" a composition for one cello by Carlo Inderhees. The work is 'alive' for only one hour every day, whether a performance takes place or not. The two works "garonne" and "fur sich" have their own individual time flow on top of the twenty-five hour rhythm of the piece as a whole.

Christoph Nicolas is a visual artist and curator based in Munich. He also plays the stone harp. He explores Time and the passing of time using video, pencil and sun drawing, polaroids, sculpture... always using these medias in the most basic way. Most projects consists of the repetition over long period of time, of the same ritual, the same gesture, the same process. In his curatorial work he organizes exhibitions, concerts, performances and readings mostly in public buildings before or while they are rebuild: he is interested in the potential of their transitory state.

—
Daniela Cascella
Writer & Independent Researcher (UK)

En abîme: a Reading
A reading with sounds, images and silences. A book is rewritten and reinvented across autobiographical narratives of places, pictures, songs. Through densities of prose and moments of stillness the text zooms in and out of Rome as archival fiction, opens up to visuals and images, morphs into abstraction.

Daniella is a writer with a background in sound art, literature and the visual arts. For over ten years her research has focused on sound and listening across a range of publications and curated projects. Her most recent work explores Writing Sound in connection to landscape and memory, non-linear narratives, and fictional tropes in writing criticism.

www.danielacascella.com

—
David W Speck
Artist (UK)

Brecht, George. (1961) *TWO EXERCISES*. Arr. Speck, David W. for Terminal in C. (2010). London: David W. Speck.
A reading of Speck's arrangement for computer terminal in C of George Brecht's 1961 score followed by a presentation of the paper contained in this book.

David W. Speck lives and works in London.

Didier Mathieu
Publisher, Curator and Director of centre des livres d'artistes (France)

From site to (web)site
Archiving, collecting and disseminating form the viewpoint of a collector.

The centre des livres d'artistes (cdla) is the home of a growing collection of artists' books (among the three main ones in France), an exhibition space dedicated exclusively to this type of publications, a research centre and a publisher.

www.cdla.info

–

IPCRES – International Project Centre for Research into Events and Situations
Dr **Paul Jeff**, Director of IPCRES, Swansea Metropolitan University (UK)
Laura Jenkins, PhD Research Assistant, IPCRES (UK)

The IPCRES Reading Ensemble
A participatory 'reading/walking' event exploring the inter-connectedness of body and mind, through an evocation of the spirit of the flâneur, psychogeography and the situationist derive; as the experience of reading conjures up worlds within worlds, it is amplified here through mobility and the shared experience.

IPCRES is an academic research centre set up to enquire into durational non-representational practices. Its central premise is to conduct experiments into mobile and mutable forms of imaginative engagement with the visual arts, in particular explorations into the possibilities of the 'performative encounter' as a manifestation of philosophical thought. The IPCRES Reading Ensemble explores the act of reading and walking at the same time, as an embodied practice designed to illuminate the thresholds between virtual universes, both internal and external.

www.ipcres.com

–
Joan Fontcuberta
Photographer, artist, visiting professor in various American and European institutions, lately at the Pompeu Fabra University in Barcelona (Spain)

A Bio-Optically Organised Knowledge Device Called 'BOOK'
Fontcuberta's work makes able use of narrative, wordplay, and visual arrangement to press questions about photographic truth and representation. Complementing a history of painstaking photomontage and other fabrication, he also produces straight images of chance encounters and curious juxtapositions. One of Spain's most prominent and innovative artists, Joan is best known for exploring the interstices between art, science, and illusion. Where science reaches its limits in his works, the imagination frequently finds a creative space in which to flourish. Widely exhibited internationally he is the founder and editor of *PhotoVision* magazine, and has written several books on the history, aesthetics, and teaching of photography. His own photographic work has been published in over a dozen monographs, including *The Artist and the Photograph* (2000), *Twilight Zones* (2000), and *Sputnik* (1997).
In 2011 Fontcuberta invited a group of curators (Martin Parr, Clément Chéroux, Erik Kessels and Joachim Schmid) to work together in the survey exhibition 'From Here On' which dealt with the connections of photography, Internet and social networks and was premièred in the International Photography Festival in Arles.

www.fontcuberta.com

–
Marco Bohr
Photographer, Researcher in Visual Culture & Lecturer in Visual Communication at Loughborough University (UK)

Appropriation, Surveillance and Voyeurism in Self-Published Photobooks
An analysis of the emerging phenomenon of photographers collecting images from Google Earth and Google Street View for the purpose of self-publishing these images as photobooks.

Marco is a photographer and researcher in visual culture. He completed his PhD at the University of Westminster in 2011 investigating the emergence of a new generation of female photographers in Japan during the 1990s. His blog on photography theory and visual culture can be found at www.visualcultureblog.com

Marcus Kaiser
Gardener, visual artist, composer and cellist (Germany)

A Possible 'Book-Work'
The infinity between reality and the quotation of reality in books and the quotation of quotation of reality in books... as the reality of books.

Marcus studied cello at Robert Schumann Musik School in Düsseldorf followed by an MA under Klaus Rinke at Kunstakademie Düsseldorf. He belongs to the composer group wandelweiser and since 1997 has established his interdisciplinary activities in the kaiserwellen studio in Düsseldorf. In 2001 he won the city prize of Düsseldorf.
'If I should say something about my art, my favourite would be it is like a garden – something shifting in the shadow – something in the sun – growing from my discretion. In a garden you can move freely – romp around – destroy – have love-affairs – sweep old leaves. A garden lasts a long time.'

www.opernfraktal.de

Mark Sanderson
Senior Lecturer in Visual Theory, UCA Maidstone (UK)

The Text that Reads Itself
The idea of a text that 'performs its own reading' may not be entirely new, but it presents itself in a vivid new form, now supercharged by technology. Sanderson explores the divide that is opening up between conventional reading and a new and enhanced form of reading that could be described as 'hypertextual'.

Paul Soulellis
New York-based artist & Creative Director of Soulellis Studio (USA)

Weymouths
Weymouths celebrates memory, geography and cultural identity through site-specific books that draw upon the linked histories of Weymouth, Dorset (UK) and Weymouth, Massachusetts (USA). Project commissioned by the cultural Olympiad.
Paul Soulellis is a New York-based artist and creative director, maintaining his studio in Long Island City, NY. His book works explore place, image and identity.
Most recently, he created Library of the Printed Web, a curatorial project organised around artists who use screen capture, image grab, site scrape and search query to develop printed matter from content found on the web. The growing collection, housed in a wooden display crate, was presented at The Book Affair, at the opening of the 55th Venice Biennale.

www.soulellis.com

Paula Roush
Lisbon-born artist based in London & Senior Lecturer London South Bank University (UK)
Maria Lusitano
Portuguese artist based in London

A field (of interconnected realities) or The week of mash-up goodness (2010-12)
The work explores re-enactment as a contemporary art strategy in reference to two collage-novels: Max Ernst 's *Une Semaine de bonte* (1934) and Valentine Penrose's *Dons des feminines* (1951).

Paula Roush's work explores the intersection of open culture and publishing technologies. paula teaches art and gender theory, artists' publications, self-publishing and the impact of technology in photographic publishing practices.

www.msdm.org.uk

Maria Lusitano borrows research methodologies from history and visual anthropology in order to develop ways to tell stories. She works both with drawing, artist publications and video. Her current interests concern memory, gender theory, concepts of time and untold history.

www.marialusitano.org

Dr **Peter Jaeger**
Reader, Dept of English and Creative Writing, Roehampton University (UK)

John Cage, Chronobiology, and the Discourse of the Analyst
Drawing on Jacques Lacan's theory of the four discourses and the emerging study of chronobiology,
Peter considers how John Cage's writing 'translates' a living body into writing, thereby rearticulating the body itself as a form of book.

Peter Jaeger is a Canadian poet, literary critic and text-based artist now living in the UK. His published work includes the poetry books *Power Lawn* (Coach House Books 1999), *Prop* (Salt 2007), *Rapid Eye Movement* (Reality Street Editions 2009), and *The Persons* (information as material 2011). His book *John Cage and Buddhist Ecopoetics* is coming out from Bloomsbury at the end of 2013. Jaeger teaches poetry and literary theory at Roehampton University in London.

Rahel Zoller
Artist & Designer (UK)

The Inner Monologue of a Book
The Inner Monologue of a Book is a concept that tries to behold the state of the codex from a unique perspective. The monologue reads the thoughts of a book, as it contemplates whether the codex will still survive in its traditional form or whether the e-book, its younger relative, will take its place.
'The state of the codex book in contemporary society is a current theme in my work and I am deeply interested in latest innovations happening within publishing. I believe now, in this digital age, the book is shifting from an inevitable cultural experience to a specialized one. This notion has driven many of the ideas in my work and inspired me to work with different concepts of language, translation, reading and writing.'

www.rahelzoller.com

Dr **Romi Mikulinsky**
Lecturer at the Bezalel Academy of Arts and Design, Jerusalem & Honorary Research Fellow at Macquarie University in Sydney (Tel Aviv/ Sydney)

Reading and Writing in the Digital Age
Romi Mikulisky is a researcher, writer and lecturer. Her dissertation was dedicated to photography, memory and trauma in film and literature at the University of Toronto's English department. Among her fields of research are the future of reading and writing and the various interactions between words and images, texts, codes and communities in the networked society. Romi has worked with various start-up companies and media websites and has, until recently, served as the director and creative director of The Shpilman Institute for Photography in Tel Aviv (The SIP).

rominating.tumblr.com
vertigious.tumblr.com

Sarah Bodman
Senior Research Fellow for Artists' Books & Programme Leader MA Multidisciplinary Printmaking, UWE (UK)

New Pages: Celebrating the Book as a Democratic Multiple in a Variety of Twenty-First-Century Forms
A showcase of how artists are exploring and utilising the tools available to create books for e-readers through hypertext and print on demand, and how small publishers are embracing the potential of small-scale publishing of affordable, inventive paper-based books.

Sarah produces book works through etching, letterpress, pulp-printing, laser cutting, digital and video. She is willing to explore any process that best suits the work being made, from a typewriter to free download. Work in numerous collections including: British Library; Tate Britain; V&A; MoMA, New York; Art Institute of Chicago; Brooklyn Museum of Art; Visual Studies Workshop, New York.

www.bookarts.uwe.ac.uk

seekers of lice
Artist & Writer (UK)

Invent the Present: Footnotes
A performance lecture with two screen projections: one of still images of art works and the other a film of a walk through London streets with a hand-held camera. The lecture circles around revolutionary moments in literature and modes of production and how these have affected composition, content, execution, dissemination and reading modes.

seekers of lice proposes art as an insect bite, infecting the blood through proximity, anecdote, annexation, colonisation, infection and inoculation: scratch the itch & itch the scratch. Work includes interventions in public places, performance lectures, exhibitions and book publishing. seekers of lice has published thirteen books and pamphlets, and has work in various collections including Tate Library, Tate Britain; MoMA Library; Joan Flasch Artists' Book Collection and Centre for Fine Print Research, UWE. Recent books include Theatre of Objects (VerySmallKitchen 2012) and limber (Knives Forks and Spoons Press 2013).

Sharon Helgason Gallagher
Founder/executive director of D.A.P. Distributed Art Publishers, Inc. and ARTBOOK (New York)

What Shall We Want to Have Called a 'Book'?
On entering the artists' book arena, an outsider would soon be struck by the intensity of the debate within the field about just what an artists' book is and isn't, about which kinds of objects merits the name 'artists' book' and which don't. At a time when the mainstream publishing industry is struggling to define what the book might be in the digital future, Sharon suggests that the broader publishing community can learn from not only the inventiveness of artists' books themselves but also from the very structure of this debate about definition and naming.

Sharon is the President and Executive Director of ARTBOOK and of D.A.P. in New York, a publishing and distribution company she co-founded in 1990. D.A.P. has represented more than 13,000 books in the visual arts over the last two decades. D.A.P.'s museum publishing clients include the Museum of Modern Art, the Guggenheim, The Museum of Fine Arts, Boston, and the Walker Art Center. Sharon has lectured extensively to the museum and publishing communities and in 2011, she was honoured as one of the 30 influential women leaders in visual arts over the last 30 years by ARTTABLE. She is a graduate of Yale University, summa cum laude, and holds a Masters degree in Philosophy from Columbia where she was a University Fellow.

www.artbook.com

—

Dr **Sharon Kivland**
Artist and Writer, Reader in Fine Art at Sheffield Hallam University, & Research Associate of the Centre for Freudian Analysis and Research (UK)
Nick Thurston
Artist, author, co-editor of information as material (iam) & academic in the School of Fine Art, History of Art & Cultural Studies at University of Leeds (UK)

Reading: Some Positions
Sharon Kivland propose a reading, which is also a lecture, in relation to her series on Freud's Holidays and related books, all published by iam; with two co-published by Cube Art Editions, Athens. These books always start as conference papers, as readings, before they become, so to speak, 'reading'.

Sharon Kivland is an artist and writer working in London and France. Reader in Fine Art at Sheffield Hallam University, she is also a Research Associate of the Centre for Freudian Analysis and Research, London. She describes herself as a keen reader, considering what is put at stake at the intersection of art, psychoanalysis, and politics. She has described her practice is one of stupid refinement, trapped in archives, libraries, the arcades, and the intersection of public political action and private subjectivity. For some years she has been following Sigmund Freud on holiday.

www.sharonkivland.com

Nick Thurston is the author or co-author of five books. He has exhibited across Europe and North America and written critically about art and poetics. His writings have been translated into French, German, Italian and Spanish.

www.nickthurston.info
www.informationasmaterial.org

—

Susan Johanknecht
Proprietor of the Gefn Press & Course Leader in MA Book Arts at Camberwell College of Arts (UK)
Katharine Meynell
Artist (UK)

Poetry of Unknown Words
A collaborative book, a development, transcription and homage to Iliazd's La Poesie de mots inconnus (1949). The sense of an 'unknown' plays on the archive and feminist notions of 'hidden from history', exploring content through technologies and materiality past and present.

Susan and Katharine have a long collective engagement with making artists books under the Gefn Press imprint. S. Johanknecht & K. Meynell have co-authored and co-edited edited several books, *Seas of the Moon* (Gefn Press) *Emissions* (Bookworks and Gefn Press) *Eat Book* (Gefn Press and Janus Press) *Volumes (of Vulnerability)* and *Cunning Chapters*. Their work has been exhibited internationally, including at The British Library, Victoria & Albert Museum, The Dean Clough Galleries, Halifax; Mills College, California.

Their work together focuses on the overlaps between artwork and multiple publication, often bringing together an unusual combination of writers, poets, performance artists and expanded interdisciplinary form.

www.gefnpress.com

Dr **Stefan Szczelkun**
Artist, Senior Lecturer at University of Westminster & Editorial Board at Mute (UK)

Agit Disco
The *Agit Disco* project collects playlists that have been made to reflect the diverse political effects of music on peoples' lives. Starting its life as a wiki website it has now been published by Mute Books.
Stefan is an artist and academic. In the 1980s he ran Working Press publishing books by and about working class artists. He is the author of *Conspiracy of Good Taste: William Morris, Cecil Sharp, Clough Williams Ellis and the repression of working class culture in the 20th century* (1993).

www.stefan-szczelkun.org.uk

Sylvia Schimag

John Cage's Empty Words
(produced by Antoine Beuger and Wandelweiser)
Sylvia has made a name for herself with readings of texts ranging from Avatamsaka Sutra, the biblical Song of Songs and roman philosopher Lucretius through innovative sixteenth century French and Spanish poetry to Emily Dickinson, Gerard Manley Hopkins, Fernando Pessoa as well as living poets like John Ashbery, Rosemarie Waldrop, Mei-Mei Berssenbrugge and Oswald Egger. Composers like Antoine Beuger, Jürg Frey, Michael Pisaro and Christian Wolff have written works for her. Edition Wandelweiser Records recently released her recording of Empty Words.

www.leseweisen.de
www.wandelweiser.de

Co-chairs & Co-editors

Emmanuelle Waeckerlé
Reader in Photography and Relational Practices and Director of bookRoom at UCA Farnham (UK/France)

Emmanuelle lives between London and St Yrieix la Perche where she is part of the small team running the centre des livres d'artistes.
Her practice explores language and connecting issues of place and identity. Through her continuing commitment to both education and practice based research she tries to foster new enquiry across and between photography, performance art and the book, developing along the way collaborative projects both at local and international levels, in academic and non-academic contexts. Her work has been exhibited and performed nationally and internationally and her artist books are held in private and public collections including Bibliotheque Nationale de Paris, Tate Britain, V&A, and The Poetry Library in London.

www.ewaeckerle.com

Prof **Richard Sawdon Smith**
Professor of Photography & AIDS Cultures, Head of the Arts & Media Department at London South Bank University (UK)

Richard is on the Editorial Advisory Board of the *Journal of Photography and Culture*. He was winner of the John Kobal Portrait Award 1997. He is Co-editor of *Langford's Basic Photography* (2007/2010) and his photographs and writing are published in a variety of books including; *Spaces Between Us: Poetry, Prose and Art on HIV/AIDS Cultures* (2010) K Norman Ellis (ed); *Cultures of Exile* (2004) Wendy Everett (ed); *Male Bodies: A Photographic History of the Nude* (2004) Emmanuel Cooper; *Art & Photography* (2003) David Campany; *Pandemic: Facing AIDS* (2003) Umbrage Books; *Representations of HIV and AIDS: Visibility Blue/s* (2000) Gabriele Griffin and *Vile Bodies: Photography and the Crisis of Looking* (1998) Chris Townsend. His work has been exhibited widely nationally and internationally.

www.richardsawdonsmith.com

bookRoom

bookRoom focuses on critical and practice based research into the concept of the book as art work in digital, analogue and hybrid formats and supports production, debate and dissemination of on the page works, in a supportive environment.

bookRoom aims to develop and promote innovative research at the interface of Photography, Design and Digital Media and to disseminate resultant knowledge through publications, exhibitions, conferences and teaching.

bookRoom was established as a research cluster in 2004 attached to the Photography department at the University for the Creative Arts, one of the UK's leading providers of specialist art and design education, offering strengths in art, design, architecture, media and communication.
Since 2009 the cluster acts as an umbrella for a number of interrelated activities: publications, conferences, residencies and a collection.

bookRoom press was established in October 2010 to provide unique facilities combining traditional print and production technology with the latest digital developments to encourage research, experimentation and innovation in the field.

www.thebookroom.net

CM
CR

The Centre for Media & Culture Research (CMCR) supports high-quality research across several areas of arts, media and culture, with a particular focus on the themes of cultural memory, transcultural networks, and critical media practice. In the 2008 Research Assessment Exercise 85 percent of our research activities were assessed at International standard or above, with World Class and Internationally Excellent work in the areas of cultural memory, media and war, news, and new media. Our recent/current work includes projects on global memory, electronic dance cultures, and the emotional engagements of environmentalist film, an AHRC-funded project with Tate Britain developing new understandings of museum audiences, and practice-based research on artists' books, experimental film, and photographic self-portraits. The CMCR has a regular programme of seminars, lectures, exhibitions and conferences, and provides a stimulating research environment for Visiting Professors and Research Fellows. Our resources include a theatre, a Digital Gallery, and a Media Centre.

cmcr-lsbu.blogspot.co.uk

London South Bank University

We would also like to thank Colin Sackett for stepping in on behalf of RGAP, London South Bank University and the University for the Creative Arts for their financial and administrative support.

The Book is Alive!
First Edition of 500
Copyright © bookRoom 2013 and respective contributors.
ISBN 978–0–9569024–5–0

Editors:
Emmanuelle Waeckerlé
Richard Sawdon Smith

Translator:
Gemma Echevarria Ferrer
(English translation of Joan Fontcuberta's interview answers)

Proofreading:
David Rule

Design:
Studio Mothership

Typeset in Avenir & Caslon Pro
Printed in England

Photography:
Clair Anderson
Arabella Packford
Emmanuelle Waeckerlé

Published by:
RGAP
Artspace, 21 Brown Street,
Sheffield, S1 2BS, United Kingdom
www.rgap.co.uk

Distributed by:
Cornerhouse Publications
70 Oxford Street,
Manchester, M1 5NH, United Kingdom
www.cornerhouse.org